Renzo Piano
and Building Workshop

Renzo Piano
and Building Workshop

Buildings and Projects 1971-1989

Introduction by Paul Goldberger

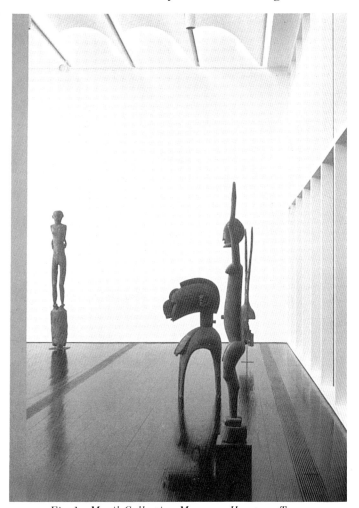

Fig.1. Menil Collection Museum, Houston, Texas.

RIZZOLI
NEW YORK

Front cover: Menil Collection Museum, Houston, Texas.
Photo: Hickey-Robertson.

Back cover: Centre Pompidou, Paris.
Photo: G. Berengo Gardin.
(on hardcover edition only)

**This book is a joint work prepared in
the Genoa office of Renzo Piano.
Shunji Ishida and Carla Garbato are
responsible for the texts of the
projects, and together with Giorgio G.
Bianchi chose the photographs and
their composition, with the additional
assistance of Enrico Piazze.**

First published in the United States of America in 1989 by
RIZZOLI INTERNATIONAL PUBLICATIONS, INC.
300 Park Avenue South, New York, NY 10010

Library of Congress Cataloging-in-Publication Data

Piano, Renzo.
Renzo Piano: buildings and projects, 1971–1989 / introduction by
Paul Goldberger p. cm.
Bibliography: p.
Includes index.
1. Piano, Renzo—Themes, motives. 2. Architecture. Modern—
20th century—Italy. I. Title.
NA1123.P47A4 1989 720'.92—dc20 89–45430
ISBN 0-8478-1152-2. ISBN 0-8478-1124-7 (pbk.)

Designed by Abigail Sturges Graphic Design
Set in type by Rainsford Type
Printed and bound in Japan

Contents

Introduction
Paul Goldberger

Like any artist who produces a celebrated work early in his career, Renzo
Piano has in many ways been more confined than liberated by the Centre
Beaubourg in Paris: for more than a decade now, he has been known
primarily as the architect who, with Richard Rogers, installed this high-tech
spoof at monumental scale into the heart of Paris. While Rogers has
continued to explore the esthetic directions set at Beaubourg, replacing that
building's irony with an elegant, utterly unironic precision, Piano has moved
toward other kinds of work—toward an architecture that does not so much
reject Beaubourg as move far beyond it to embrace a far wider range of
building types and responses to urban situations. If the pages that follow
prove anything, it is that the free association test that brings the word
"Beaubourg" to mind as soon as we hear the clue "Piano" has by now long
since run its course: there is far too much diversity, and far too much
subtlety, to Piano's work to justify the automatic label of Beaubourg.

If there is anything that joins Beaubourg to Piano's more recent work—
projects such as the gently intense Menil Collection, the museum in
Houston; the 60,000-seat football stadium at Bari, and the research center
being made out of the old Fiat factory at Lingotto, near Turin, one of the
great pieces of monumental industrial architecture of the 20th century—it is
the presence in all of these projects of a light, tensile quality and an
obvious love of technology. But where the expression of technology at
Beaubourg was broad and more than a little satirical, in the buildings since
Beaubourg it has been straighter, quieter, and vastly more inventive. As
Piano has mellowed, he has become calmer, yet sharper and crisper as well.

No building shows this better than the Menil Collection, completed in 1987.
This 402-foot long, two-story high box of steel, wood and glass is so
understated at first glance that it seems merely a 1950's American modern
beach house raised to civic scale. But the building turns out to be a brilliant
and profound melding of postwar American modernism, traditional American
small-town urbanism, and contemporary technology, all put superbly to the
service of a demanding and sensitive museum program. The building stands
among small houses and respects their scale without indulging in patronizing
imitation of it; it is an institution first and foremost, but a remarkably
serene, restrained and self-assured one.

The extent to which it relates comfortably to its surroundings should not
come as a total surprise; Beaubourg, while hardly literal in its response to
its context, in fact does fit decently, if unconventionally, into the Parisian
cityscape, if only because the enormously complex pattern of pipes and
ducts on the facade creates a degree of texture that allows the building to
communicate with the older Parisian structures around it. Since Beaubourg,

however, Piano has become all the more concerned with the question of context, and eager to prove the extent to which it is possible to show respect for an urban fabric without literally imitating existing buildings. His goal, it would seem, is to show that a modernist intervention need not be a harsh intrusion—that it is possible for an architect to work within the modernist vocabulary without indulging in the fallacy so common to the International Style of viewing the city as little more than a podium for abstract forms. For Piano, the existing city is a critical, living presence, and he seeks not to mute it but to bring it into dialogue with his own forms of the late 20th century. And so, too, on the smaller scale of an individual building with such reconstruction projects as the Fiat factory at Lingotto, which Piano has described as an attempt to insert "a modern building into a fragile body—a suspension between memory and future," and the project for the rehabilitation of Palladio's Basilica in Vicenza.

Renzo Piano is rare among serious contemporary architects for two reasons. First, he deeply loves the process of building. It is no accident that he calls his office the Building Workshop; he is as interested in the act of building as in the final product that act yields. He caresses materials as has no Italian architect since Carlo Scarpa, and his work is something of an ode to craftsmanship. But Piano's craftsmanship is of the computer as much as of the hand; his materials are metal and glass more than they are wood and stone. His work now uses technology far more than it did when the Beaubourg, so often viewed as a temple of high-tech, was being designed, for now Piano does not so much exaggerate technology for visual effect as exploit it with a narrow, focused intensity. His priority is not to create the most dramatic structure or space, but to make works that bespeak the most advanced processes of their time with a quiet self-assurance. For Piano technology is delicate and refined. His buildings are not usually visually spectacular, but they have the strength and clarity of a laser.

The other thing that distinguishes Piano from most of his peers is his utter lack of interest in ideology or theory. He, as much as anyone practicing today, stands as proof that it is possible for an architect to produce a serious, intellectually consistent body of work without wrapping himself in the mantle of dogma. "My interest in technics kept me away from academics," Piano has said, and while this may be true, it is only a part of the story. Piano's stubborn refusal to write, to produce even a brief theory to justify his work, frustrates many of his colleagues, who seem unwilling to accept the notion that an architect can be as serious as Renzo Piano and remain as utterly indifferent to expressing his work in verbal terms. In Vittorio Gregotti's discussion with Piano (page 232) Gregotti even goes so far as to refer to Piano as possessing an "apparently, [though] only apparently,

anti-intellectual stance" and suggests that this is in part responsible for Piano's success with such corporate clients as Fiat, Schlumberger and IBM. "Some have openly said that they trust me because I am less neurotic," is how Piano deftly responds.

It is disingenuous, of course, for Piano to present himself as merely a builder, as a craftsman who would rather build than think. When he speaks of architecture as being primarily a service—"You make good architecture every day, like the shoemaker makes good shoes every day"—he is merely revealing how desperately he wants his buildings to be real objects rather than conceptual ideas. The design of that physical thing as created by Piano is neither casually conceived nor indifferently built; Piano is no more like a shoemaker than is Norman Foster. But he is an architect who believes profoundly in the extent to which architecture is a matter of problem solving, and in the value of the constraints of a real program. "When you are totally free, you are lost," he has said, and if his words put him in a catgory that seems too accepting of reality, his work proves otherwise. Renzo Piano accepts reality not to capitulate to it, or to be cowed by it, but to exploit it, to use it in the making of art.

Index of Buildings and Projects 1964–1989

Reinforced Polyester Space Frames
Genoa, 1964–1965
Architect: Renzo Piano Architect/Studio Piano.

Woodworking Shop
Genoa, 1965
Architect: Renzo Piano Architect/Studio Piano.
Design Team: M. Filocca, R. Foni, L. Tirelli.
Contractor: E. Piano Contractors.

Mobile Structure for Sulfur Extraction
Pomezia (Rome), 1966
Architect: Renzo Piano Architect/Studio Piano.
Contractor: E. Piano Contractors.

Prestressed Steel and Reinforced Polyester Structure
Genoa, 1966
Client: IPE.
Architect: Renzo Piano Architect/Studio Piano.
Design Team: F. Marano.
Contractor: E. Piano Contractors.

Structural Shell System
Milan, 1967
Client: Milan Triennale.
Architect: Renzo Piano Architect/Studio Piano.
Design Team: O. Celadon, G. Fascioli, F. Marano.

Office Workshop for the Renzo Piano Studio
Genoa, 1968–1969
Client: Renzo Piano.
Architect: Renzo Piano Architect/Studio Piano.
Design Team: G. Fascioli, T. Ferrari, F. Marano.
Contractor: E. Piano Contractors.

Open-Plan Home
Garonne, Alessandria (Italy), 1969
Architect: Renzo Piano Architect/Studio Piano.
Design Team: G. Fascioli, T. Ferrari, F. Marano.
Contractor: E. Piano Contractors.

Italian Industry Pavilion at the Osaka Expo
Osaka, 1969–1970
Client: Italpublic, Rome.
Architect: Renzo Piano Architect/Studio Piano.
Design Team: G. Fascioli, T. Ferrari, F. Marano.
Consultants: Sertec Engineering.
Contractor: E. Piano Contractors.

B & B Italy Office Building
Novedrate, Como, 1971–1973
Client: B & B Italy S.p.A., Como.
Architect: Renzo Piano Architect/Studio Piano & Rogers.
Design Team: C. Brullman, S. Cereda, G. Fascioli, F. Marano.

Centre Georges Pompidou
Paris, 1971–1977
Client: Ministry of Cultural Affairs and Ministry of National Education.
Design Team: Renzo Piano and Richard Rogers; G. F. Franchini, competition, program, interiors; W. Zbinden with H. Bysaeth, J. Lohse, P. Merz, P. Dupont, substructure and mechanical services; L. Abbott with S. Ishida, H. Naruse, H. Takahashi, superstructure and mechanical services; E. Holt, facades and galleries; A. Stanton with M. Dowd, R. Verbizh, internal/external audiovisual systems; C. Brullmann, environment and scenographic space; B. Plattner, coordination and site supervision; M. Davies with N. Okabe, K. Rupard, J. Sircus, IRCAM; J. Young with F. Barat, H. Diebold, J. Fendard, J. Huc; H. Schlegel, interiors; F. Gouinguenet, C. Spielmann, C. Valensi, secretarial.
Engineers: Ove Arup & Partners: P. Rice, L. Grut, R. Peirce, structure; T. Barker, plant engineering; M. Espinosa, cost control.
Building Contractors: Y. Thaury, job engineer, GTM; Krupp, Mont-a-Mousson, Pohlig, structure; CFEM, facades; OTIS, elevators and escalators; Voyer, secondary structures; Industrielle de Chauffage, Saunier Duval, heating installations.

One-Family Homes
Cusago (Milan), 1972–1974
Client: Lucci, Giannotti, Simi, Pepe.
Architect: Renzo Piano Architect/Studio Piano & Rogers.
Design Team: C. Brullman, G. Fascioli, R. Luccardini, F. Marano.
With the collaboration of R. & S. Lucci.

Institute for Music and Acoustic Research
Paris, 1973–1977
Client: IRCAM, Paris.
Architect: Renzo Piano Architect/Studio Piano & Rogers.
Design Team: M. Davies, N. Okabe, K. Rupard, J. Sircus, W. Zbinden.
Consultants: Ove Arup & Partners; V. Peutz, acoustics; G. C. Francois, scenographic.

Industrialized Construction System
Perugia, Italy, 1978
Client: Vibrocemento, Perugia S.p.A.
Architect: Renzo Piano Architect/Piano & Rice Associates; associated engineer: Peter Rice.
Design Team: S. Ishida, N. Okabe, associated architects; E. Donato, G. Picardi, H. Bardsley, F. Marano.
Consultants: Vibrocemento Perugia; R. Jascone, coordinator.

Il Rigo Quarter
Corciano, Perugia, 1978–1982
Client: Town of Corciano.
Architect: Renzo Piano Architect/Piano & Rice Associates; associated engineer: Peter Rice.
Design Team: S. Ishida, N. Okabe, associated architects; L. Custer.
With the collaboration of H. Bardsley, O. Di Blasi, O. Donato, F. Marano, G. Picardi.
Consultants: Edilcooper, RPA Associates, Vibrocemento Perugia.

Fiat VSS Experimental Vehicle
Turin, 1978–1980
Client: Fiat Auto S.p.A. Turin Idea Institute.
Architect: Renzo Piano Architect/Piano & Rice Associates; associated engineer: Peter Rice.
Design Team: S. Ishida, N. Okabe, B. Plattner, associated architects; L. Abbott, A. Stanton, R. Verbizh.
With the collaboration of Idea Institute, S. Boggio, F. Conti, W. De Silva, O. Di Blasi, M. Sibona.
Consultants: T. Barker, M. Manning, Ove Arup & Partners; S. Brown Associates, acoustics; G. Trebbi, Idea Institute, coordination.

Educational Television Program: The Open Site
1979
Client: Radiotelevisione Italiana Channel Two Program directed by G. Macchi and Produced by V. Lusvardi.
Architect: Renzo Piano Architect/Piano & Rice Associates.
Design Team: S. Ishida, N. Okabe, associated architects; R. Biondo, M. Bonino, G. Fascioli, R. Gaggero, G. Picardi, S. Yamada.
With the collaboration of Magda, texts and screenplay; Arduino.

An Experiment in Urban Reconstruction
Otranto (Bari), 1979
Client: UNESCO, S. Busutill, W. Tochtermann.
Architect: Renzo Piano Architect/Piano & Rice Associates; associated engineer: Peter Rice.
Design Team: S. Ishida, N. Okabe, associated architects; E. Donato, G. Fascioli, R. Gaggero, R. Melai, G. Picardi, R. Verbizh.
With the collaboration of F. Marano, F. Marconi, M. Fazio, G. Macchi, R. Biondo, M. Bonino.
Consultants: P. Bechmann, Ove Arup & Partners; Idea Institute; G. P. Cuppini, G. Gasparri; Ediltech; CINEMA (M. Arduino), film. Coordination and administration: G. Dioguardi.

Design for Restructuring the Island of Burano
Burano (Venice), 1980
Client: City of Venice.
Architect: Renzo Piano Architect/Piano & Rice Associates; associated engineer: Peter Rice.

Design Team: S. Ishida, associated architect; H. Bardsley, M. Calvi, L. Custer, C. Teoldi.
Consultants: P. Chombard de Lauwe, University of Venice: Coordination of the Fondazione; Tre Oci: G. Macchi, A. Macchi.

Renewing the Old Del Molo Quarter
Genoa, 1981
Client: City of Genoa.
Architect: Renzo Piano Architect/Building Workshop, Genoa.
Design Team: S. Ishida, associated architect; A. Bianchi, E. Frigerio, F. Marano, A. Traldi.
With the collaboration of F. Icardi, R. Melay, E. Miola, R. Ruocco.
Consultants: Tekne Planning (V. Podesta, G. Amadeo), planning; F. Pagano, legal consultancy; CINEMA (M. Arduino), film.

Reuse of the Palazzo a Vela for the Calder Exhibition
Turin, 1982
Client: City of Turin, G. Carandente, curator.
Architect: Renzo Piano Architect/Building Workshop, Genoa.
Design Team: S. Ishida, associated architect; O. Di Blasi.
With the collaboration of G. Fascioli, F. Marano, P. Terbuchte, A. Traldi.
Consultants: Ove Arup & Partners, engineers; Tensoteci, tensostructures; Piero Castiglioni, lighting; Pier Luigi Cerri, graphic arts.

New Administrative Offices Center in Torrespaccata.
Centocelle (Rome), 1982
Client: Brioschi Finanziaria S.p.A., Milan.
Architect: Renzo Piano Architect/Building Workshop, Genoa.
Design Team: S. Ishida, associated architect; F. Marano, M. Mattei, F. Santolini, A. Traldi, R. V. Truffelli.
With the collaboration of F. Clerici, Studio Alfa.

IBM Travelling Pavilion
1982–1984
Client: IBM Europe.
Architect: Renzo Piano Architect/Building Workshop, Genoa.
Design Team: S. Ishida, associated architect; A. Traldi.
With the collaboration of O. Di Blasi, F. Doria, G. Fascioli.
Consultants: Ove Arup & Partners (P. Rice, T. Barker); N. Okabe, coordination; P. Vincent, J. B. Lacoudre, assisted.

Consultation for the Rehabilitation of the Lingotto Factories
Turin, 1983
Client: Fiat S.p.A.
Architect: Renzo Piano Architect/Building Workshop, Genoa.
Design Team: S. Ishida, associated architect; E. Frigerio, P. Terbuchte, R. V. Truffelli.
With the collaboration of O. Di Blasi, C. Di Bartolo, M. Carroll, F. Doria, G. Fascioli, R. Gaggero, D. L. Hart, A. Traldi.
Consultant: E. Miola, model maker.

Enlargement and Urban Insertion of the Valpolcevera Purification Plant
Genoa, 1983
Client: City of Genoa.
Architect: Renzo Piano Architect/Building Workshop, Genoa.
Design Team: S. Ishida, associated architect; M. Carroll, D. L. Hart, F. Marano.
With the collaboration of P. Beccio, F. Icardi, L. Ruocco.

The Menil Collection
Houston, 1981–1986
Client: Menil Foundation, Mrs. De Menil, president; W. Hopps, director; P. Winkler, vice director.
Architect: Renzo Piano Architect/Piano & Fitzgerald, Houston.
Design Team: S. Ishida, associated architect; M. Carroll, F. Doria, M. Downs, C. Patel, B. Plattner, C. Susstrunk.
Consultants: Ove Arup & Partners (P. Rice, T. Barker, A. Guthrie, N. Nobel, J. Thornton), engineers; Haynes & Waley Assoc., structural engineers; Galewsky & Johnston, mechanical engineers; R. Jansen, fire prevention.
Contractor: E. G. Lowery.

Scheme for the Exposition Universelle, 1989
Paris, 1982
Client: Ministry of Cultural Affairs.
Architect: Renzo Piano Architect/Paris Atelier.
Design Team: N. Okabe, associated architect; B. Plattner, partner-in-charge; J. F. Schmit, B. Vaudeville.
Consultants: Ove Arup & Partners (P. Rice, J. Thornton).

Rehabilitation of the Schlumberger Factories
Paris, 1981–1984
Client: Compteurs Montrourge (Schlumberger Ltd.).
Architect: Renzo Piano Architect/Paris Atelier.
Design Team: N. Okabe, B. Plattner, associated architects.
With the collaboration of S. Ishida, principal-in-charge; M. Alluyn, T. Hartman, J. Lohse, G. Saint-Jean, J. B. Lacoudre, A. Gillet, A. Laville, G. Petit, D. Rat, S. Smith, C. Susstrunk, P. Vincent.
Consultants: R. Duperrier, F. Petit; GEC, cost control; P. Rice, tensostructures; A. Chemetoff, landscape architect; M. Massot, C. Pierdet; M. Dowd, J. Huc, interiors.
Contractors: GTM, Albaric Rontaix, general enterprises; Bateg (Campenon-Bernard).

Genoa Subway
Dinegro Station, Genoa, 1983
Client: Ansaldo Trasporti S.p.A.
Architect: Renzo Piano Architect/Building Workshop, Genoa/Alain Vincent, associated engineer.
Design Team: S. Ishida, associated architect; D. L. Hart, project architect; F. Marano, V. Tolu.

With the collaboration of E. Baglietto, G. Fascioli, C. Manfreddo.
Consultants: Mageco s.r.l., station structures; Inco S.p.A., Reico S.p.A., line structure; Aerimpianti S.p.A., engineers; E. Miola, model maker.
Contractor: Imprese Riunite s.c.r.l.

Genoa Subway
Caricamento and Darsena Stations, Genoa, 1983
Client: Ansaldo Trasporti S.p.A.
Architect: Renzo Piano Architect/Building Workshop, Genoa/Alain Vincent, associated engineer.
Design Team: S. Ishida, associated architect; D. L. Hart, project architect; C. Manfreddo, project architect; F. Marano.
With the collaboration of E. Baglietto, V. Tolu.

Study for the Area Pietra
Omegna, Novara, 1983
Client: Town of Omegna.
Architect: Renzo Piano Architect/Building Workshop, Genoa.
Design team: S. Ishida, associated architect; E. Frigerio, D. L. Hart, F. Marano.
With the collaboration of M. Calosso, F. Santolini.
Consultants: Studio Ambiente, urban study.

Genoa Subway
Brin Station, Genoa, 1983
Client: Ansaldo Trasporti S.p.A.
Design Team: S. Ishida, associated architect; M. Varratta, project architect; D. Defilla, F. Marano.
With the collaboration of M. Mallamaci, D. Peluffo, V. Tolu.
Consultants: Mageco s.r.l., station structures; Inco S.p.A., Reico S.p.A., line structure; Aerimpanti S.p.A., engineer; E. Miola, model maker.
Contractor: Imprese Riunite s.c.r.l.

Rehabilitation and Enlargement of the Centre Georges Pompidou
Paris, 1983
Client: Centre Georges Pompidou.
Architect: Renzo Piano Architect/Building Workshop, Genoa.
Design Team: N. Okabe, associated architect; J. Lohse, B. Vaudeville, P. Vincent.
Consultants: Albion (E. Lenglume), structures; GEC (R. Duperrier, F. Petit), cost control; Inex (M. Jorgacevic, C. H. Reiss), thermal aspects; Cegef (E. Picard), engineers; P. Castiglioni, lighting.

Genoa Subway
Genoa, 1983
Client: Ansaldo Trasporti S.p.A.
Architect: Renzo Piano Architect/Building Workshop, Genoa/Alain Vincent, associated engineer.

Design Team: S. Ishida, associated architect; M. Carroll, O. Di Blasi, E. Frigerio, D. L. Hart, C. Manfreddo, F. Marano, M. Varratta.
With the collaboration of D. Defilla, G. Fascioli, N. Freedman, M. Mattei, D. Peluffo, V. Tolu.
Consultants: Mageco s.r.l., station structures; Inco S.p.A, Reico S.p.A., line structure; Aerimpianti S.p.A., engineer; E. Miola, model maker.
Contractor: Imprese Riunite S.c.r.l.

Musical Space for the *Prometeo* Opera by L. Nono
Venice, Milan, 1983–1984
Client: Ente Autonomo Teatro Alla Scala.
Architect: Renzo Piano Architect/Building Workshop, Genoa.
Design Team: S. Ishida, associated architect; C. Avagliano, D. L. Hart, A. Traldi, M. Visconti.
Consultants: M. Milan, S. Favero, structures; L. Nono, music; M. Cacciari, texts; C. Abbado with R. Cecconi, director; Experimental Studio der Heinrich-Strobel-Stiftung des Sudwestfunks E.V., live electronics; L. Nono, H. P. Haller with R. Strauss & B. Noll; Laboratorio Per L'informatica Musicale della Biennale (LIMB) Centro di Sonologia Computazione (CSC) of Padua University, L. Nono, A. Vidolin with S. Sapir and M. Graziani, other electronics.
Contractor: F.11i Dioguardi S.p.A.

Building for the Artificial Snow Plant
Sestrieres, Turin, 1984
Client: Sporting Club Sestrieres S.p.A.
Architect: Renzo Piano Architect/Building Workshop, Genoa.
Design Team: S. Ishida, associated architect; E. Frigerio, F. Marano.
With the collaboration of G. Fascioli, D. L. Hart, M. Mattei, M. Varratta.
Consultants: York S.A., engineer; Societa Fra Operai E Muratori del Comune di Cesena, general contractor; F.11i Vaccarini, metal structures.

Olivetti Office Building
Naples, 1984
Client: Congivest S.p.A., G. Di Meglio, general coordinator.
Design Team: S. Ishida, associated architect; M. Carroll, M. Cucinella, O. Di Blasi, F. Santolini.
With the collaboration of G. Fascioli, F. Marano, M. Varratta.
Consultants: S. Cirillo, structures; Cogeco Naples S.p.A., main contractor; R. Cecconi, project coordination.

Booth for Ansaldo
Genoa, 1984
Client: Ansaldo S.p.A.
Architect: Renzo Piano Architect/Building Workshop, Genoa.
Design Team: S. Ishida, associated architect; M. Carroll.

Sailboat
Genoa, 1984
Client: Building Workshop.
Architect: Renzo Piano Architect/Building Workshop, Genoa.
Design Team: Cantieri Navali Mostes.

Study for the Rehabilitation of Sestrieres Tourist Site
Sestrieres, Turin, 1984
Client: Saes S.p.A.
Architect: Renzo Piano Architect/Building Workshop, Genoa/Paris
Atelier/associated engineer: Alain Vincent.
Design Team: S. Ishida, N. Okabe, B. Plattner, associated architects; E. Frigerio, T. Hartman, J. B. Lacoudre, F. Marano.
With the collaboration of M. Mattei, R. V. Truffelli, M. Varratta, M. Visconti, N. Prouve, P. Vincent.
Consultants: A.I. Engineering s.r.l., structures; A.I. Studio s.r.l., urban study.

Gulf Center
Lissone, Milan, 1984
Client: Ahmed Idris Nasreddin.
Architect: Renzo Piano Architect/Building Workshop, Genoa.
Design Team: S. Ishida, associated architect; F. Marano, F. Santolini, A. Traldi.

A Leisure Center
Cremona, 1984
Client: Acciaieria Arvedi.
Architect: Renzo Piano Architect/Building Workshop, Genoa.
Design Team: S. Ishida, associated architect; O. Di Blasi.
With the collaboration of G. Fascioli, F. Santolini.
Consultants: A. Stanton, documentation.

The Kenya Energy Laboratory
Nairobi, Kenya, 1984
Client: Kenya Ministry for Energy.
Architect: Renzo Piano Architect/Building Workshop, Genoa.
Design Team: S. Ishida, associated architect; M. Carroll.
With the collaboration of F. Doria, G. Fascioli, F. Santolini.
Consultants: Studio Phoebus, structures and plant; E. Miola, model maker.

Columbus International Exposition, 1992
Genoa, 1984
Client: City of Genoa.
Architect: Renzo Piano Architect/Building Workshop, Genoa/associated engineer: Alain Vincent.
Design Team: S. Ishida, associated architect; R. V. Truffelli, G. G. Bianchi, M. Carroll, O. Di Blasi, D. L. Hart, C. Manfreddo, F. Marano, M. Varratta.
With the collaboration of M. Allevi, E. Baglietto, D. Campo,

R. Costa, D. Defilla, G. Fascioli, P. Maggiora, L. Pellini,
E. Piazze, A. Pierandrei, S. Smith, S. Vignale.
Consultants: S. Baldelli, A. Grasso, surveyors; F. Doria, E. Miola, model makers.

Design for Indesit Home Appliances
Italy, 1984–1985
Client: Indesit Elettrodomestici S.p.A.
Architect: Renzo Piano Architect/Paris Atelier.
Design Team: N. Okabe, associated architect; J. B. Lacoudre.
With the collaboration of N. Prouve.
Consultants: D. Laville, model maker; Peutz Associes,
H. Straatsma, Y. de Querel, acoustic engineering; S. Boggio, industrialization.

Office Building
Montecchio Maggiore, Vincenza, 1984–1985
Client: Lowara-Montecchio Maggiore.
Architect: Renzo Piano Architect/Building Workshop, Genoa.
Design Team: S. Ishida, associated architect; O. Di Blasi.
With the collaboration of G. Fascioli, D. L. Hart, M. Mattei,
M. Varratta.
Consultants: M. Milan, S. Favero Engineers, main contractor, structures; Studio SIRE, engineering.

Credito Industriale Sardo Main Office
Cagliari, 1985
Client: Credito Industriale Sardo.
Design Team: S. Ishida, associated architect; M. Carroll, F. Marano.
With the collaboration of G. G. Bianchi, M. Calosso, O. Di Blasi, D. L. Hart, C. Manfreddo, F. Santolini, M. Varratta.
Consultants: S. Vignale, model maker.

Calabrese Administrative Offices Center
Bari, 1985
Client: Calabrese Veicoli Industriali S.p.A.
Architect: Renzo Piano Architect/Building Workshop, Genoa.
Design Team: S. Ishida, associated architect; E. Frigerio, F. Marano.
With the collaboration of M. Mattei.
Consultants: Calabrese Engineering S.p.A., structure and plans.

Study for a Prototype Booth
Turin, 1985
Client: Centro Stile Fiat S.p.A.
Architect: Renzo Piano Architect/Paris Atelier.
Design Team: N. Okabe, associated architect; B. Vaudeville.
Consultants: Ove Arup & Partners (P. Rice, T. Barker).

Feasibility Study for Reuse of Lingotto Factories
Turin, 1985
Client: Town of Turin.

Architect: Renzo Piano Architect/Building Workshop, Genoa/associated engineer: Alain Vincent.
Design Team: S. Ishida, associated architect; O. Di Blasi,
K. Dreissigacker, E. Frigerio, F. Marano, M. Mattei.
With the collaboration of G.G. Bianchi, G. Fascioli, M. Visconti.
Consultants: Giuseppe De Rita, economist; Prof. Ing. Roberto Guiducci, sociologist; ECO S.p.A., graphics; P. Castiglioni, lighting; Tenso Forma, tensostructure.
Contractor: Fiat Engineering S.p.A.

The Lingotto Factories: The Congress Center
Turin, 1985
Client: Fiat Auto.
Architect: Renzo Piano Architect/Building Workshop, Genoa/associated engineer: Alain Vincent.
Design Team: S. Ishida, associated architect; O. di Blasi,
K. Dreissigacker, E. Frigerio, F. Marano, M. Mattei.
With the collaboration of G. G. Bianchi, G. Fascioli, M. Visconti.
Consultants: P. Castiglioni, lighting; Tenso Forma, tensostructure.

Reuse of the Old Venetian Arsenal in Khania
Khania, Crete, 1985
Client: UNESCO.
Architect: Renzo Piano Architect/Building Workshop, Genoa/Paris Atelier.
Design Team: N. Okabe, S. Ishida, associated architects;
G. G. Bianchi, T. Hartman, E. Karitakis, N. Prouve.

Mobile Office Walls System
1985
Client: Unifor.
Architect: Renzo Piano Architect/Paris Atelier/associated engineer: Alain Vincent.
Design Team: N. Okabe, associated architect; J. B. Lacoudre.
With the collaboration of N. Prouve.
Consultants: J. Y. Richard, model maker; Peutz E Associes, acoustics; Albion (E. Lenglume), structures.

Competition for the Rehabilitation for the Bicocca Area
Milan, 1985
Client: Industrie Pirelli S.p.A.
Architect: Renzo Piano Architect/Building Workshop, Genoa.
Design Team: S. Ishida, associated architect; O. Di Blasi,
E. Frigerio, D. L. Hart.
With the collaboration of G. G. Bianchi, K. Dreissigacker,
M. Mattei, M. Visconti.
Consultants: A. Vincent, cost control; A. Secchi, town planning study; Ove Arup & Partners, structure and plans; E. Miola, model maker.

Magic Box
Genoa, 1985
Client: Ansaldo S.p.A.
Architect: Renzo Piano Architect/Building Workshop, Genoa.
Design Team: S. Ishida, associated architect; O. Di Blasi.
Consultants: Calabrese Engineering S.p.A., structures.

Enlargement of the Town Office Building
Cagliari, 1985
Client: Town of Cagliari.
Architect: Renzo Piano Architect/Building Workshop, Genoa.
Design Team: S. Ishida, associated architect; M. Carroll, O. Di Blasi, F. Marano.
With the collaboration of F. Santolini, M. Varratta.

Main Office of Credito Industriale Sardo
Cagliari, 1985
Client: Credito Industriale Sardo, Cagliari Competition.
Architect: Renzo Piano Architect/Building Workshop, Genoa.
Design Team: S. Ishida, associated architect; M. Carroll, F. Marano.
With the collaboration of G. G. Bianchi, M. Calosso, O. Di Blasi, D. L. Hart, C. Manfreddo, F. Santolini, M. Varratta.
Consultants: S. Vignale, model maker.

Housing Complex
Paris, 1985
Client: Les Mutuelles du Mans; Regie Immobiliere de la Ville de Paris.
Architect: Renzo Piano Architect/Paris Atelier/associated engineer: Alain Vincent.
Design Team: B. Plattner, associated architect; F. Canal, C. Clarisse, J. Lohse, J. F. Schmit, R. J. Van Santen.
Consultants: Bureau d'Etudes techniques, GEC.

Professional Educational Center
Marne La Vallee, Paris, 1985
Client: French Ministry of Finance and Economy.
Architect: Renzo Piano Architect/Paris Atelier/associated engineer: Alain Vincent.
Design Team: N. Okabe, associated architect; J. F. Schmit, J. B. Lacoudre.
With the collaboration of C. Larisse, J. L. Chassais, F. Lauville, N. Prouve.
Consultants: GEC (A. Benzeno), cost control; C. Simon, documentation; D. Collin, landscaping.

Study for the Conversion of an Industrial Area into an Administrative Offices Center
Gavette, Genoa, 1985
Client: AMGA.
Architect: Renzo Piano Architect/Building Workshop, Genoa.

Design Team: S. Ishida, associated architect; M. Carroll, F. Marano.
With the collaboration of M. Varratta, F. Santolini.

Building for Banca Vallone
Nia Salandra, Lecce, 1985
Client: Le Valli Immobiliare s.r.1.
Architect: Renzo Piano Architect/Building Workshop, Genoa.
Design Team: S. Ishida, associated architect; E. Frigerio, M. Mattei.
With the collaboration of G. Fascioli, F. Marano, M. Visconti.
Consultants: Calabrese Engineering S.p.A., structures, plans, and general contractor; Brizio Montinari, building contractor.

Regional Congress Center
Genoa, 1985
Client: Centro Congressi S.p.A.
Architect: Renzo Piano Architect/Building Workshop, Genoa.
Design Team: S. Ishida, associated architect; D. L. Hart, F. Marano, R. V. Truffelli, G. G. Bianchi.
Consultants: Ansaldo Sistemi Industriali, S.p.A.; Italimpianti S.p.A.; Elsag S.p.A.

Stage for "Quark" Telecast — Survey by P. Angela
Rome, 1985
Client: RAI-Radiotelevisione Italiana.
Architect: Renzo Piano Architect/Building Workshop, Genoa.
Design Team: S. Ishida, associated architect; O. Di Blasi.
With the collaboration of G. Fascioli.

Competition for a Food Market
Genoa, 1985
Client: City of Genoa.
Architect: Renzo Piano Architect/Building Workshop, Genoa.
Design Team: S. Ishida, associated architect; G. G. Bianchi, D. L. Hart, C. Manfreddo, F. Marano.
Consultants: Ansaldo Sistemi Industriali S.p.A., building contractors coordinator.

Research for an Aluminum Facade
1985
Client: Aluminia S.p.A., Italia.
Architect: Renzo Piano Architect/Paris Atelier/associated engineer: Alain Vincent.
Design Team: B. Plattner, associated architect; R. J. Van Santen, B. Vaudeville.
Consultants: D. Laville; J. Y. Richard, model maker; M. Mimram, structures; Peutz & Associes (Y. de Querel), acoustics; Sodeteg (E. Lenglume), thermal insulation.

Feasibility Study for the Lingotto Factories Area
Turin, 1985
Client: Town of Turin.
Architect: Renzo Piano Architect/Building Workshop, Genoa/associated engineer: Alain Vincent.
Design Team: S. Ishida, associated architect; O. Di Blasi,
K. Dreissigacker, E. Frigerio, F. Marano, M. Mattei.
With the collaboration of G. G. Bianchi, G. Fascioli, M. Visconti.
Consultants: Dott. Giuseppe de Rita, economist; Prof. Ing. Roberto Guiducci, sociologist; ECO S.p.A., graphics; P. Castiglioni, lighting; Tenso Forma, tensostructure.
Contractor: Fiat Engineering S.p.A.

Office Tower
Naples, 1985
Client: Congivest; G. di Meglio, M. Mattei, general coordinators.
Architect: Renzo Piano Architect/Building Workshop, Genoa.
Design Team: S. Ishida, associated architect; M. Carroll, D. L. Hart, C. Manfreddo, F. Marano, F. Santolini.

Rehabilitation of the Monticello Area
Savona, 1985
Client: Town of Savona.
Architect: Renzo Piano Architect/Building Workshop.
Design Team: S. Ishida, associated architect; G. G. Bianchi,
D. L. Hart, F. Marano.
Consultants: Studio Ambiente s.r.l., town planning.

Competition for the Rehabilitation of the Hangars at the Bourget Airport
Le Bourget, Paris, 1985
Client: Union Transport Aeriens (UTA).
Architect: Renzo Piano Architect/Paris Atelier/associated engineer: Alain Vincent.
Design Team: N. Okabe, associated architect; J. B. Lacoudre.
With the collaboration of F. Laville, N. Prouve.
Consultants: GEC (F. Petit), cost control.

International Center
Lyons, 1985
Client: City of Lyons; SEM, Cité Internationale de Lyons.
Architect: Renzo Piano Architect/Paris Atelier/associated engineer: Alain Vincent.
Design Team: A. Vincent, engineer; N. Okabe, associated architect;
T. Hartman, J. B. Lacoudre, J. Lelay, P. Vincent.
Consultants: Ove Arup & Partners (P. Rice, T. Barker), structures and services; GEC Ingenierie, structures and services; Peutz, acoustics; M. Corajoud, landscape architect; O. Doizy, model maker; G. C. Francoise, scenography.

Office Building Rehabilitation
Genoa-Fegino, 1985–1986
Client: Ansaldo S.p.A.
Architect: Renzo Piano Architect/Building Workshop, Genoa/in joint venture with CESEN.
Design Team: S. Ishida, associated architect; G. Grandi,
R. V. Truffelli.
With the collaboration of G. Fascioli, C. Manfreddo, M. Visconti.
Consultants: Ansaldo Divisione Impianti S.p.A., structures and coordination; Aerimpianti S.p.A., engineers; Coopsette s.c.r.1, main contractor.

Main Office for the Light Metals Experimental Institute
Novara, 1985–1987
Client: Aluminia.
Architect: Renzo Piano Architect/Paris Atelier/associated engineer: Alain Vincent.
Design Team: B. Plattner, associated architect; A. Benzeno, J. Lelay, R. Self, B. Vaudeville, R. J. Van Santen.
Consultants: M. Mimram, structure; Sogetec, services; Italstudio, facade; Omega, local engineering partners; M. Desvigne, landscape architect.
Contractor: Alucasa, building contractors; Cattaneo.

Development of the Municipal Laboratories
Paris, 1985–1987
Client: City of Paris.
Architect: Renzo Piano Architect/Paris Atelier/associated engineer: Alain Vincent.
Design Team: B. Plattner, associated architect; J. F. Schmit.
With the collaboration of J. L. Chassais, C. Clarisse,
J. B. Lacoudre.
Consultants: A. Benzeno, cost control; Bureau d'Etudes techniques (F. Petit), GEC; Dumez, general contractor.

An Administrative Office Center
Rome, 1986
Client: Italscai S.p.A.
Architect: Renzo Piano Architect/Building Workshop, Genoa.
Design Team: S. Ishida, associated architect; G. G. Bianchi,
G. Grandi, R. V. Truffelli.

La Valletta City Gate
La Valletta, Malta, 1986
Client: Malta Government.
Architect: Renzo Piano Architect/Paris Atelier/associated engineer: Alain Vincent.
Design Team: B. Plattner, associated architect; P. Callegia,
A. Chaaya, D. Felice, Kzammit Endrich.
Consultants: M. Mimram.

Reuse of the Rampart and Gate of the Town
La Valletta, Malta, 1986
Client: Malta Government-UNESCO.
Architect: Renzo Piano Architect/Building Workshop, Genoa.
Design Team: S. Ishida, associated architect; D. L. Hart.
Consultants: S. Busuttil, M. Zerafa, K. Buhagia, coordinators.

Sport Hall
Ravenna, 1986
Client: City of Ravenna.
Architect: Renzo Piano Architect/Building Workshop, Genoa/associated engineer: Alain Vincent.
Design Team: S. Ishida, M. Cucinella, O. Di Blasi, associated architects; F. Marano.
With the collaboration of F. Moussavi, S. Smith, M. Visconti.
Consultants: Ove Arup & Partners (P. Rice, R. Hough), structure and engineering; M. Milan-S. Favero Engineers.

Crystal Tables System
Milan, 1986
Client: Fontana Arte.
Architect: Renzo Piano Architect/Building Workshop, Genoa.
Design Team: S. Ishida, associated architect; O. Di Blasi.

Main Office of Credito Industriale Sardo
1986
Client: Credito Industriale Sardo.
Architect: Renzo Piano Architect/Building Workshop, Genoa/associated engineer: Alain Vincent.
Design Team: S. Ishida, associated architect; M. Carroll, F. Marano, R. V. Truffelli.
With the collaboration of E. Baglietto, D. Campo, R. Costa, F. Santolini.
Consultants: Mageco s.r.l. (L. & D. Mascia), structure; Pecorini (Cagliari), G. Gatti, geologic study; Manens Intertecnica s.r.l., engineering; STED s.r.l., cost control.
Contractor: Esar s.r.l.

UNESCO-Building Workshop Joint Research Program on Natural Structures
Vesima, Genoa, 1986
Client: UNESCO.
Architect: Renzo Piano Architect/Building Workshop, Genoa/associated engineer: Alain Vincent.
Design Team: S. Ishida, associated architect; M. Carroll, O. Di Blasi, M. Lusetti, F. Marano, R. V. Truffelli, M. Varratta, M. Desvignes, landscape architect.
Consultants: C. Di Bartolo (CRSN), bionic research.

Rehabilitation of the Moat of the Ancient Town
Rhodes, Greece, 1986
Client: UNESCO.
Architect: Renzo Piano Architect/Building Workshop, Genoa/associated engineer: Alain Vincent.
Design Team: S. Ishida, associated architect; G. G. Bianchi.
Consultants: Arch. S. Sotirakis, Town of Rhodes; Arch. D. De Lucia, historical documentation; E. Sailler, photographic documentation.

Rehabilitation of the Palladio Basilica and Town Hall
Vicenza, 1986
Client: City of Vicenza.
Architect: Renzo Piano Architect/Building Workshop, Genoa/associated engineer: Alain Vincent.
Design Team: S. Ishida, associated architect; G. Grandi, project architect; D. Di Blasi, G. G. Bianchi.
Consultants: Ove Arup & Partners, M. Milan, S. Favero, structures and services; Sivi Illuminazione, lighting; Arup Acoustic (D. Sudgen), acoustics; S. Baldelli, A. Grasso, cost analysis; G. Sacchi, model maker.

The IBM Travelling Pavilion "Lady Bird"
1986
Client: IBM Europe.
Architect: Renzo Piano Architect/Building Workshop, Genoa/associated engineer: Alain Vincent.
Design Team: S. Ishida, associated architect; K. Dreissigacker, M. Visconti.
Consultants: Ove Arup & Partners.

Competition for the Jules Verne Leisure Park
Amiens, France, 1986
Client: City of Amiens.
Architect: Renzo Piano Architect/Paris Atelier/associated engineer: Alain Vincent.
Design Team: N. Okabe, associated architect; B. Hubert, M. Vaith, R. J. Van Santen, B. Vaudeville.
Consultants: D. Vaudeville, model maker; M. Corajoud, C. Dalnoki; M. Desvigne, landscape architect; M. Mimram, structure.

Development of a Tourist Resort
Trieste, 1987
Client: Finsepol.
Architect: Renzo Piano Architect/Paris Atelier/associated engineer: Alain Vincent.
Design Team: B. Plattner, associated architect; E. Agazzi, A. Chaaya, L. Couton, F. Joubert, R. Self, P. Vincent; M. Desvignes, landscape architect.
Consultants: Ove Arup & Partners (P. Rice, T. Barker), GEC Ingenierie, Studio Ambiente, Marc Consult, TPE (M. Milan, S. Favero), structure and services; CINEMA, film.

Study for an Infrastructural System for Urbino

Urbino, 1987
Client: Town of Urbino.
Architect: Renzo Piano Architect/Building Workshop, Genoa/associated engineer: Alain Vincent.
Design Team: S. Ishida, associated architect; G. G. Bianchi.
With the collaboration of S. Smith.

New Center for Amiu

Genoa, 1987
Client: AMIU, Genoa.
Architect: Renzo Piano Architect/Building Workshop, Genoa/associated engineer: Alain Vincent.
Design Team: S. Ishida, associated architect; G. Grandi, E. Baglietto.
Consultants: Tradeco s.r.1. (Prof. Ing. G. Chiesa), engineering; S. Baldelli, cost control.

Garden Shelter

Marne la Vallee, France, 1987
Client: Departement du Val de Marne.
Architect: Renzo Piano Architect/Paris Atelier/associated engineer: Alain Vincent.
Design Team: N. Prouve, R. J. Van Santen, P. Vincent.
Consultants: O. Doizy, model maker.

Bari Football Stadium

Bari, 1987
Client: City of Bari.
Architect: Renzo Piano Architect/Building Workshop, Genoa/associated engineer: Alain Vincent.
Design Team: S. Ishida, associated architect; O. Di Blasi, project architect; F. Marano, L. Pellini; M. Desvignes, landscape architect.
With the collaboration of M. Allevi, M. Carroll, G. G. Bianchi, D. Compo, M. Cucinella, R. Costa, D. Defilla, F. Doria, E. Frigerio, G. Fascioli, M. Mallamaci, C. Manfreddo, M. Pietrasanta, R. V. Truffelli, V. Tolu.
Consultants: D. Cavagna, E. Miola, G. Sacchi, model makers; Ove Arup & Partners (P. Rice, T. Carfrae, R. Kinch, A. Leczner), Mageco s.r.1. (L. Mascia, D. Mascia), structures; Manens Intertecnica (R. De Stefanis, D. Boni, P. Turri), engineers; S. Baldelli, A. Grassi, M. Montanari, cost control.

Extension of the IRCAM

Paris, 1987
Client: Ministry of Cultural Affairs, Centre Georges Pompidou.
Architect: Renzo Piano Architect/Paris Atelier/associated engineer: Alain Vincent.
Design team: N. Okabe, associated architect; P. Vincent.
With the collaboration of J. Lelay, A. O'Carroll, L. L.Chassais.
Consultants: Axe Ib, GEC Ingenierie, structure and services; A.I.F Services, C.E.P., control; Gemo, site management; O. Doizy, model.

California Contemporary Art Museum

Newport, California, 1987
Client: Newport Harbor Art Museum.
Architect: Renzo Piano Architect/Building Workshop, Genoa; associated engineer: Alain Vincent.
Design Team: S. Ishida, associated architect; M. Carroll, project architect; N. Freedman, M. Desvigne, landscape architect; Blurock Partnership, Newport, assoc. arch.
Consultants: Ove Arup & Partners (P. Rice, T. Barker), structures and services.

Polyfunctional Complex in the Petriccio Area

Urbino, 1987
Client: Costruzioni Edili Bertozzini S.p.A.
Architect: Renzo Piano Architect/Building Workshop, Genoa/associated engineer: Alain Vincent.
Design Team: S. Ishida, associated architect; G. G. Bianchi.

The Lingotto Factories: An Exhibition Hall

Turin, 1987
Client: Fiat Auto.
Architect: Renzo Piano Architect/Building Workshop, Genoa/associated engineer: Alain Vincent.
Design Team: S. Ishida, associated architect; M. Carroll, M. Cucinella, E. Frigerio, Project architects; R. Costa, P. Maggiora, F. Marano.
Consultants: Iguzzini, S.p.A., lighting; Eco S.p.A., graphic.

European Synchrotron Radiation Facility

Grenoble, 1987
Client: E.S.R.F.
Architect: Renzo Piano Architect/Paris Atelier/associated engineer: Alain Vincent.
Design Team: N. Okabe, associated architect; A. O'Carroll, J. L. Chassais, J. Lelay, P. Merz, C. Morandi, P. Vincent.
Consultants: B.E.T. Novatome, Interatom-R.F.A, Ussi; J. Y. Richard, model maker; Ove Arup & Partners (P. Rice), structure; Ove Arup & Partners (T. Barker), environment control; Ansaldo, lighting; Initec, fire prevention; M. Corajoud, landscape architect; Seri Renault, planning.

Commercial Center of Bercy-Charenton

Bercy, France, 1987
Client: G.R.C.
Architect: Renzo Piano Architect/Paris Atelier/Building Workshop, associated engineer: Alain Vincent.
Design Team: N. Okabe, associated architect; J. F. Blassel, M. Bojovic, D. Illoul, A. O'Carroll, N. Westphal.
With the collaboration of K. McBryde, M. Henry, R. Rolland, M. Salerno, P. Senne.

Consultants: B.E.T., O.T.R.A., J. L. Sarf, Ove Arup & Partners (P. Rice, A. Lenczner), Veritas, controls; Y. Chaplain, O. Doizy, model makers; M. Desvigne, landscape architect.

Sports Center
Trani, 1987
Client: Town of Trani.
Architect: Renzo Piano Architect/Building Workshop, Genoa/associated engineer: Alain Vincent.
Design Team: S. Ishida, associated architect; R. V. Truffelli, project architect; D. Campo, R. Costa, E. Frigerio, C. Manfreddo, F. Marano.
Consultants: S. Baldelli, A. Grasso, M. Montanari, cost control.

Rehabilitation of the Ancient Sassi Quarter
Matera, 1987
Client: Chamber of Commerce.
Architect: Renzo Piano Architect/Building Workshop, Genoa/associated engineer: Alain Vincent.
Design Team: S. Ishida, associated architect; G. G. Bianchi, project architect; D. Campo, F. Marano.
Consultants: Ove Arup & Partners (P. Rice, T. Barker).

IBM
Pompeii, 1987–1988
Client: IBM.
Architect: Renzo Piano Architect/Building Workshop, Genoa/associated engineer: Alain Vincent.
Design Team: S. Ishida, associated architect; G. G. Bianchi.
With the collaboration of S. Smith.

Cruise Vessel
Trieste, 1988
Client: P & O.
Architect: Renzo Piano Architect/Building Workshop, Genoa, Building Workshop, Paris; associated engineer: Alain Vincent.
Design Team: S. Ishida, N. Okabe, associated architects; K. McBryde, M. Carroll, R. Costa, M. Cuccinella, R. J. Van Santen, R. Self, S. Smith, O. Touraine.
With the collaboration of G. G. Bianchi, N. Freedman, G. Grandi, D. L. Hart, P. Maggiora, C. Manfreddo, F. Santolini.
Consultants: D. Cavagna, model maker.

Kansai International Airport Competition
Osaka, 1988
Architect: Renzo Piano Architect/Building Workshop/Paris
Associate Architect: Noriaki Okabe
Architectural team: O. Touraine, K. McBryde, L. Koenig, G. Torre, R. Keiser, S. Planchez, R. Brennan, R. Rolland, A. Chaaya, L. Couton, J. Blassel, N. Westphal.
With the collaboration of M. Salerno, M. Henry,

J. Lelay, P. Henneguier, C. Ardilley, A. O'Carroll G. Breton, P. Senne, A. Temenides, F. Hughes, T. Jaklin
Engineers: Ove Arup and Partners; P. Rice, structural engineer; T. Baker, services engineer.
Engineering Team: Structural; A. Hughes, R. Donnan, Services; A. Sedgwick, M. Raman.
Acoustics: R. Yau
Landscape: M. Desvigne
Model Makers: J. Fiore, O. Doizy, G. Bontemps
Documentation: F. Bertolero
Photography: M. Denance

The Projects

Centre Georges Pompidou
Paris, 1971–1977

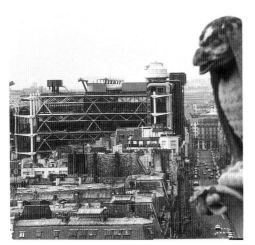

Fig. 2. View of the building from tower of Notre-Dame
Fig. 3. Aerial view

The Centre is in the middle of historic Paris, at the edge of the densely populated Marais quarter, within one kilometer of Notre Dame and the Louvre.

When the competition was announced, the only available open space of convenient size in central Paris was the Plateau Beaubourg.

The neighboring Les Halles, one of the largest wholesale markets in the world, a dynamic center of popular activities extending well beyond the boundaries of the present pavilion, was being demolished. It was to be replaced above ground level by a commercial center exploiting the existing major public transport interchange running underground.

The general approach to the Beaubourg project was to create "a live center of information, entertainment, and culture" to be housed in a building that was both a flexible container and a dynamic machine, highly serviced and made of prefabricated pieces, with the aim of attracting the widest possible public by overcoming the conventional cultural and institutional limits.

More than half of the square was left as an open space suitable for a wide variety of public events. Long, sheltered streets were arranged so that shops could open onto the pedestrian area.

On the west side of the building the square opens on a sheltered amphitheatre sloping toward the facade. The facade itself has been thought of as an activity container: a three-dimensional structural framework where people can walk and enjoy the view.

The client had specified a number of special cultural activities. The aim was to broaden the scheme without forgetting specific requirements: creating a center for both tourists and local people; avoiding creating a center divided into individual tight departments; and creating a dynamic meeting place where the various activities could merge in flexible, well-serviced spaces. The attitude was that the greater the involvement of the public, the greater the success.

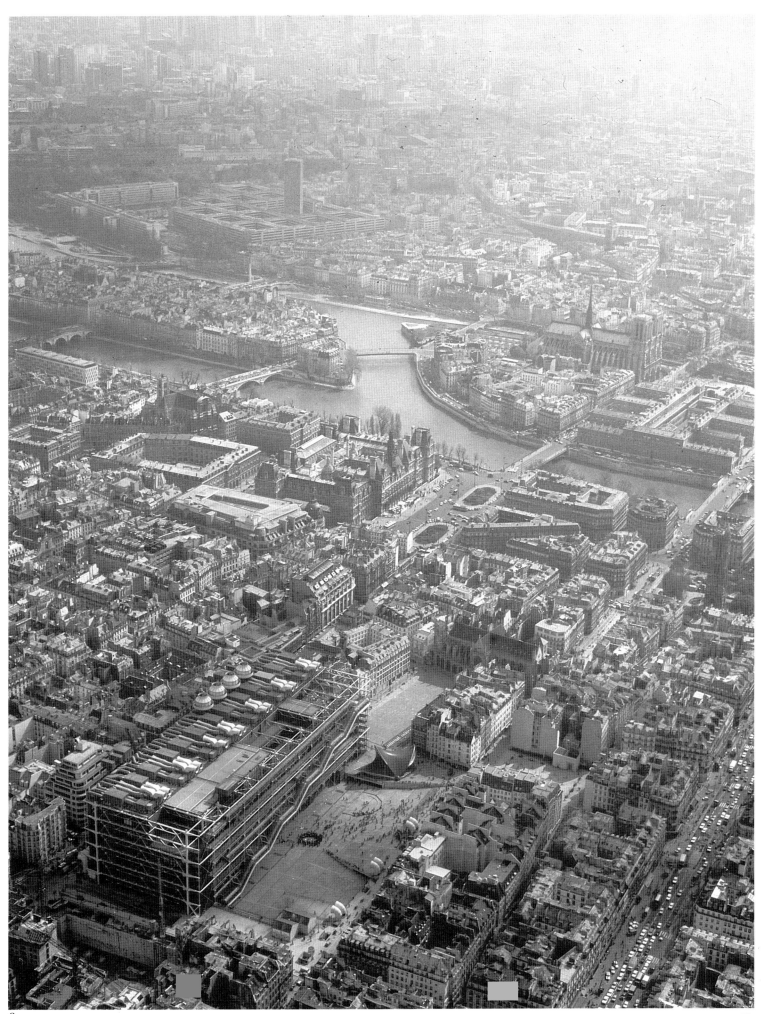

3

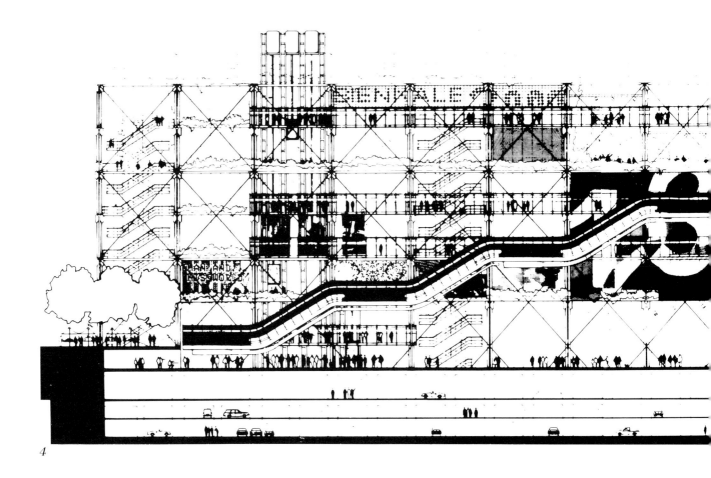

4

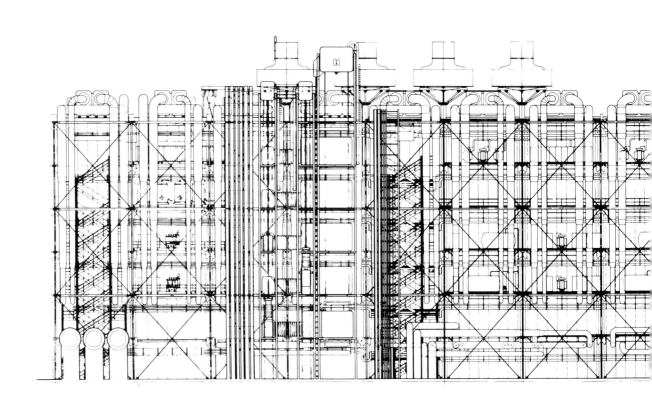

5

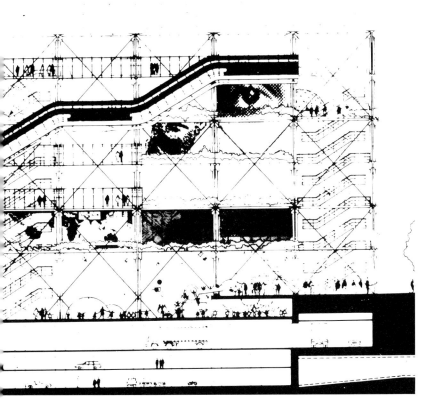

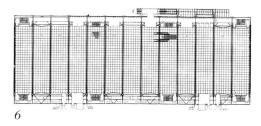

6

Fig. 4. Façade drawing
Fig. 5. Elevation on Rue du Renard
Fig. 6. Floor plan

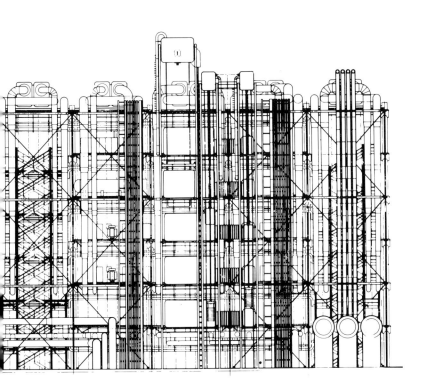

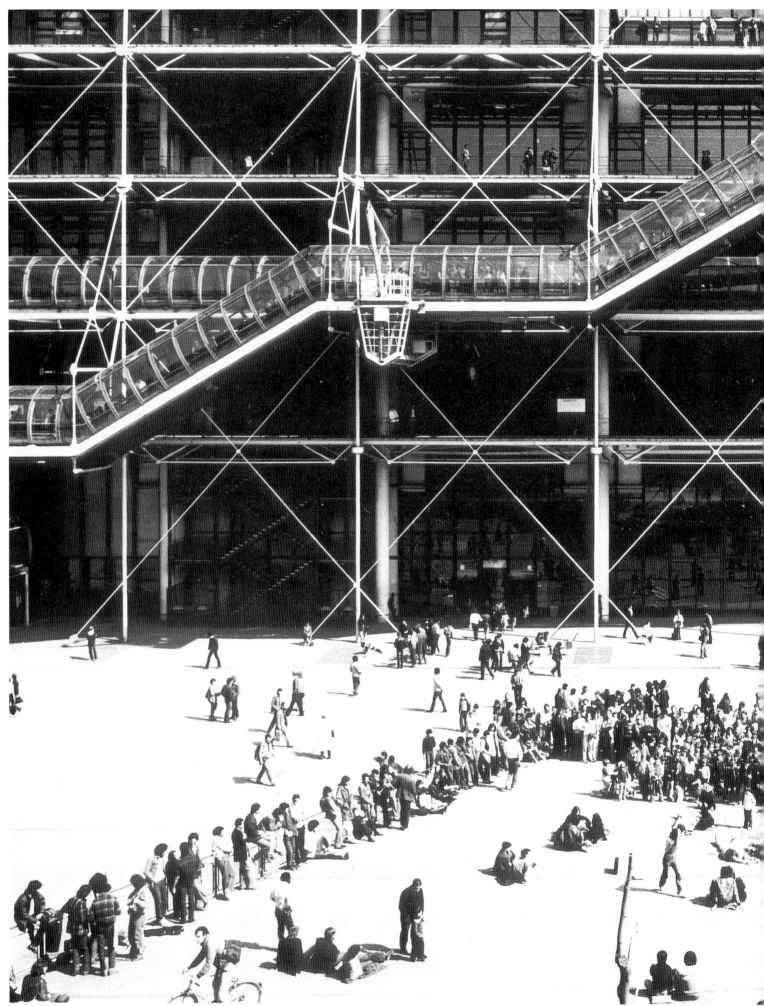

Fig. 7. Side facing the plaza

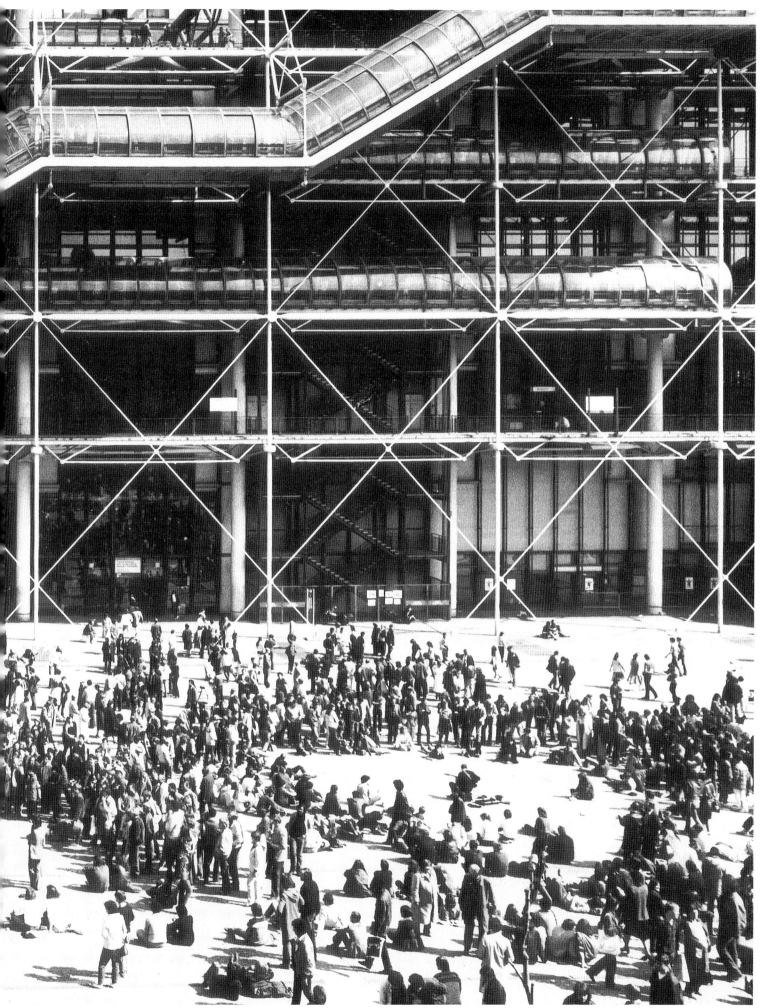

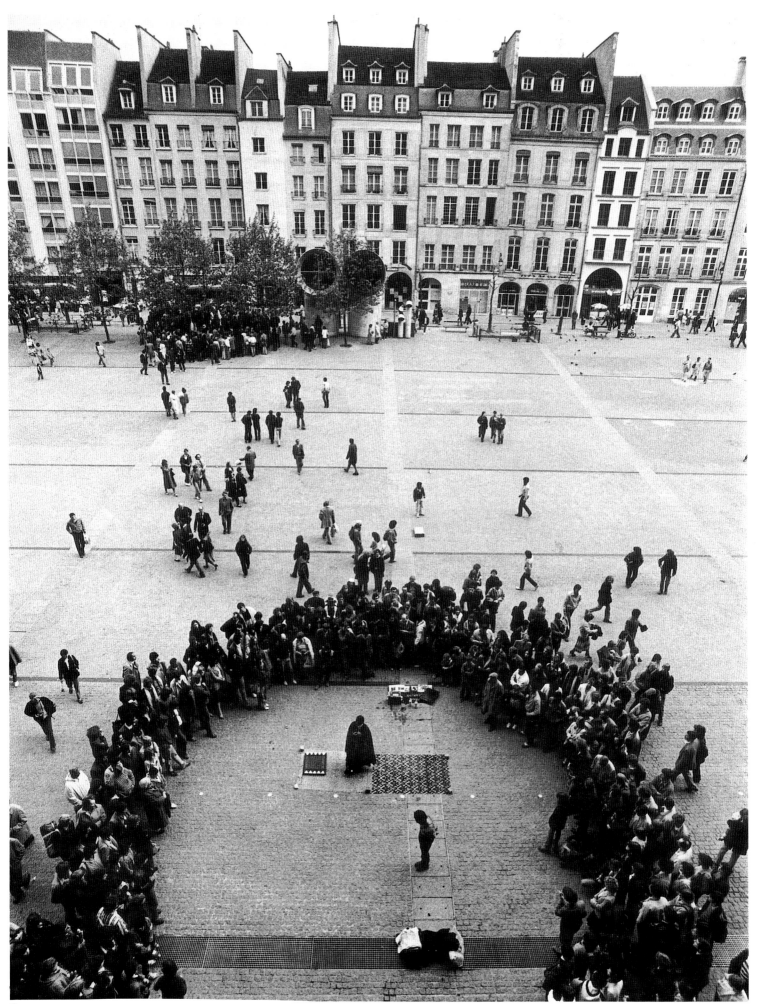

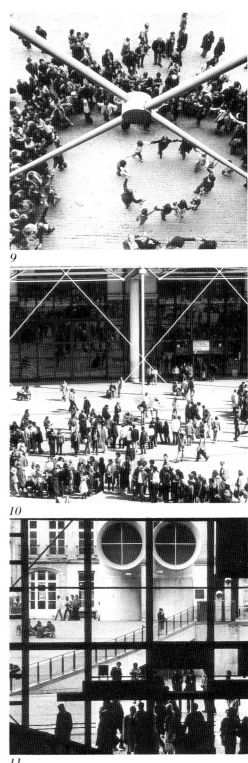

9

10

11
Fig. 8, 9, 10, 11. People using the plaza and center

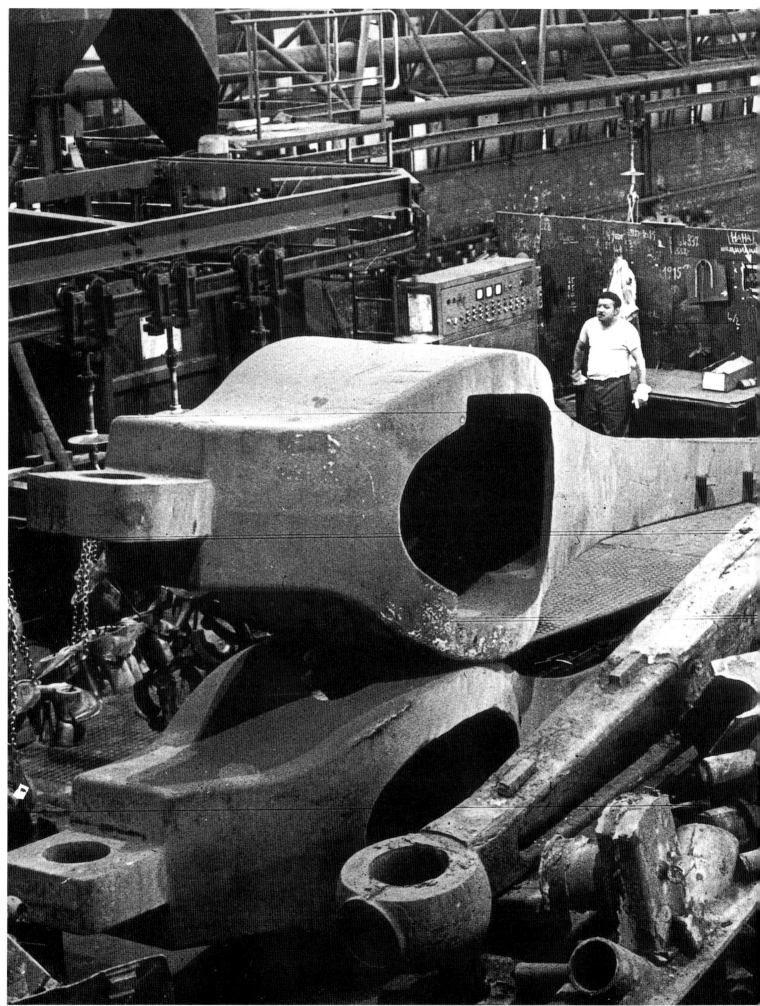

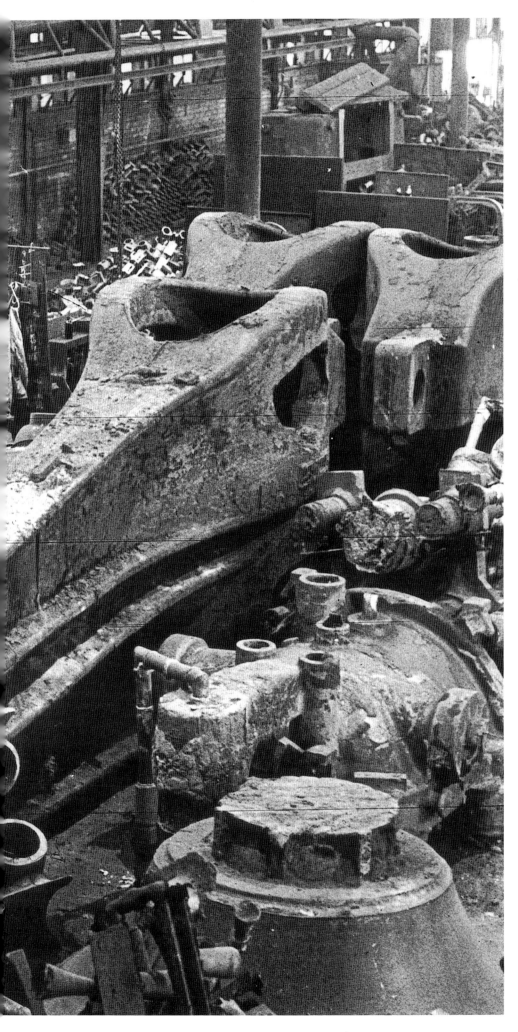

Fig. 12. Heads of the Gerber beams immediately after casting

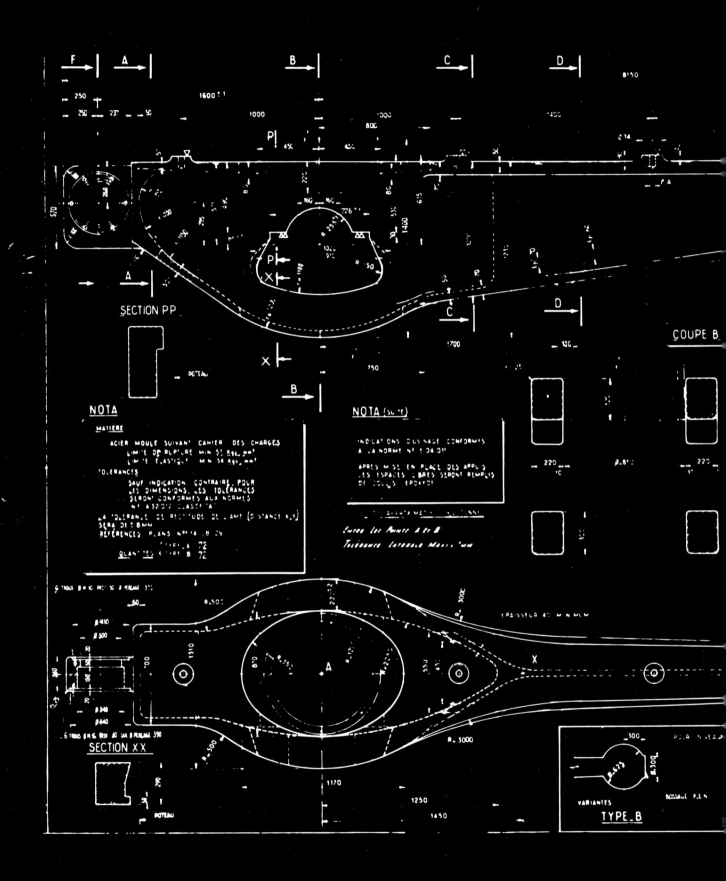

SECTION PP

NOTA

MATIÈRE

ACIER MOULÉ SUIVANT CAHIER DES CHARGES
LIMITE DE RUPTURE MIN 51 Kg/mm²
LIMITE ÉLASTIQUE MIN 36 Kg/mm²

TOLÉRANCES

SAUF INDICATION CONTRAIRE POUR
LES DIMENSIONS LES TOLÉRANCES
SERONT CONFORMES AUX NORMES
NF A32012 CLASSE "A"

LA TOLÉRANCE DE RECTITUDE DE L'AME (DISTANCE A.B)
SERA DE 3MM
RÉFÉRENCES PLANS NOTA B.25

COUPE B

NOTA (SUITE)

INDICATIONS D'USINAGE CONFORMES
A LA NORME NF E 04.01

APRES MISE EN PLACE DES APPUIS
LES ESPACES LIBRES SERONT REMPLIS
DE COLLE EPOXYDE

SECTION XX

VARIANTES
TYPE.B

13

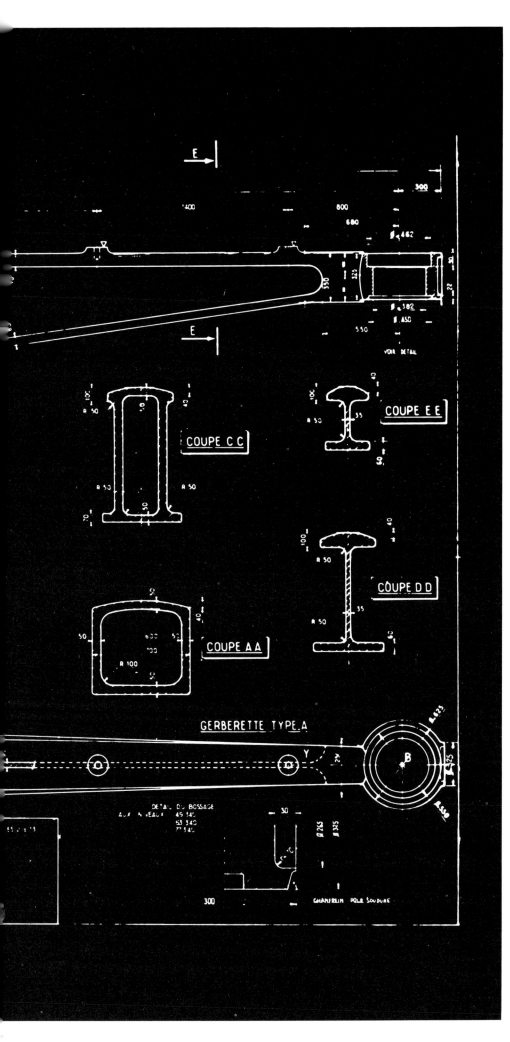

COUPE E E

COUPE C C

COUPE D D

COUPE A A

GERBERETTE TYPE.A

14

Fig. 13, 14. Engineering design of the "Gerberette": a single casting of 11 tons of steel

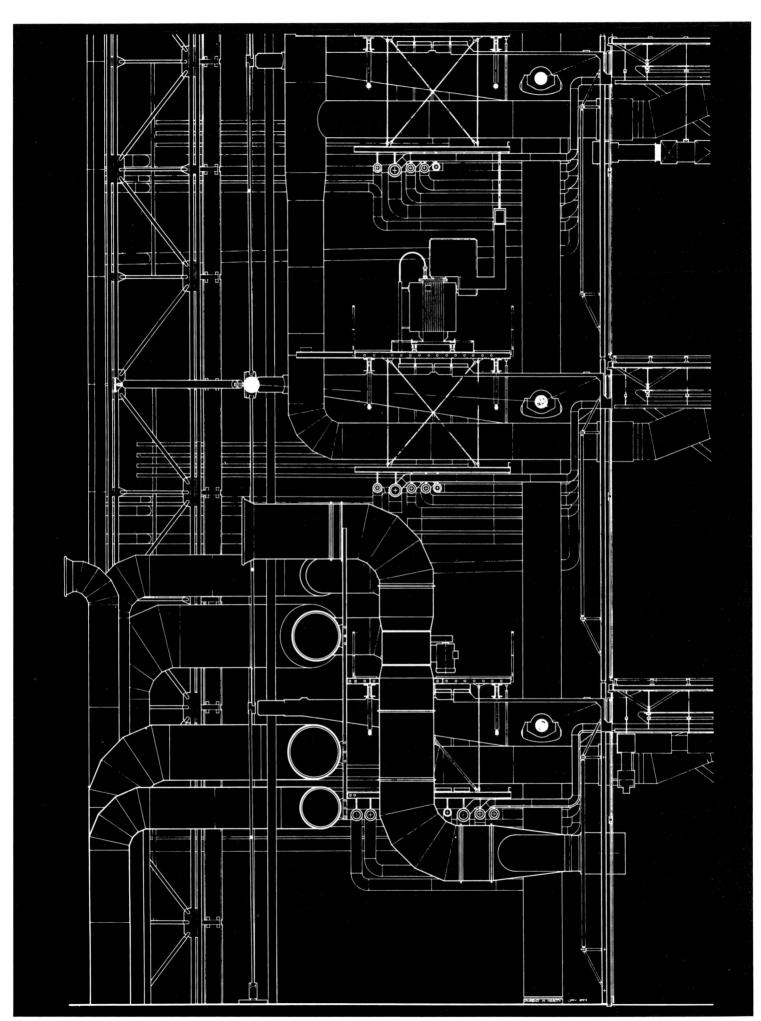

Fig. 15. Section through ventilation and air-conditioning system at ground floor

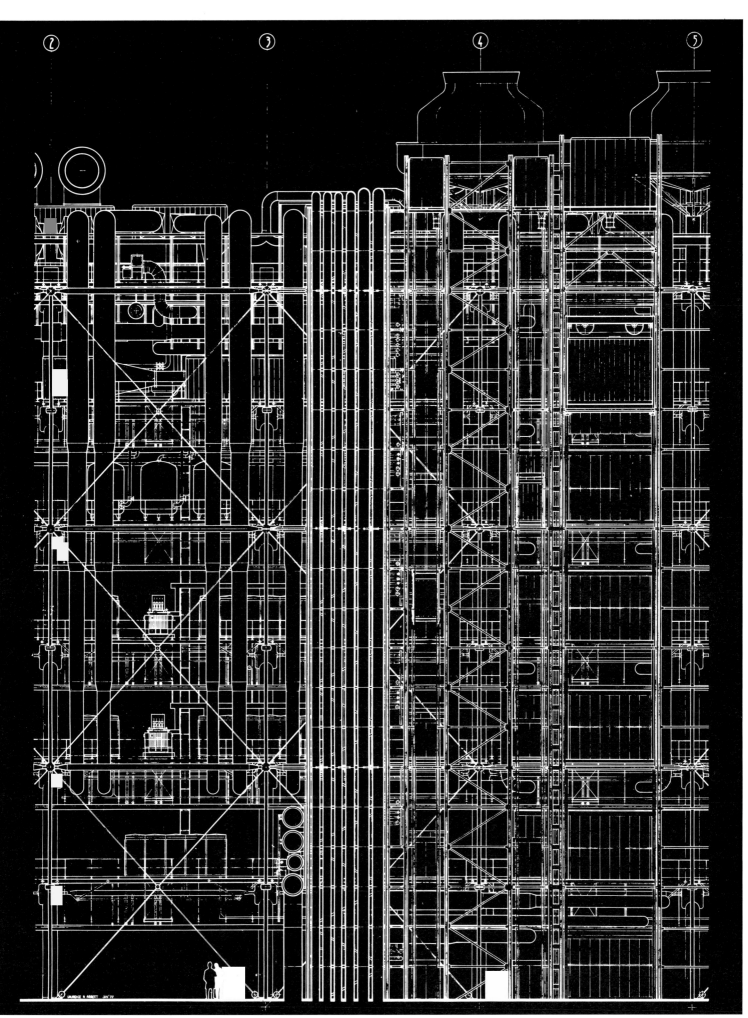

Fig. 16. Partial elevation of services façade

33

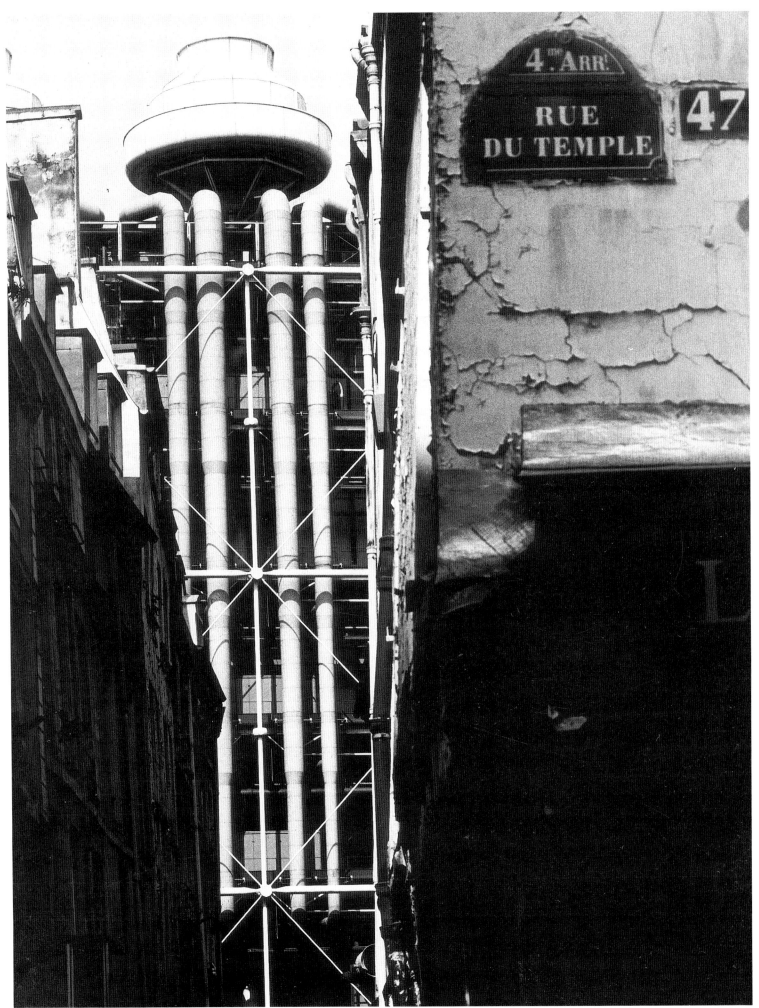

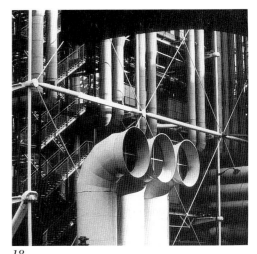

18

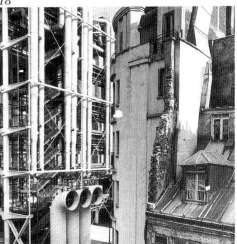

19

Fig. 17. Close-up view of services façade
Fig. 18, 19. View of the center from the old
Marais quarter

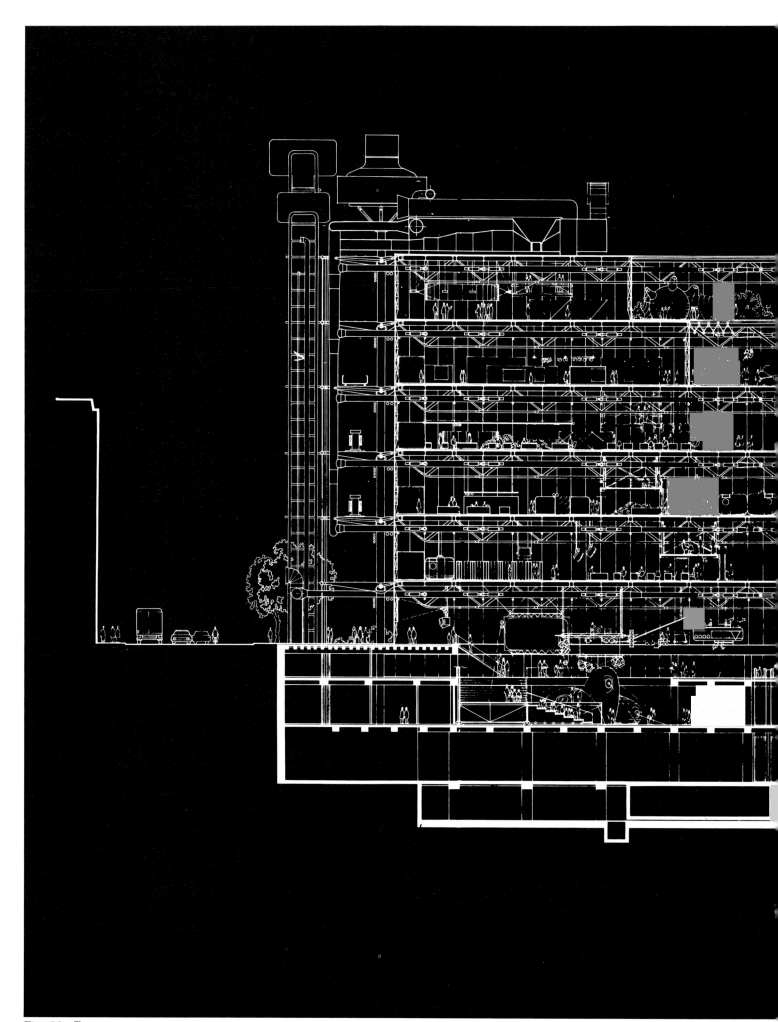

Fig. 20. Transverse section

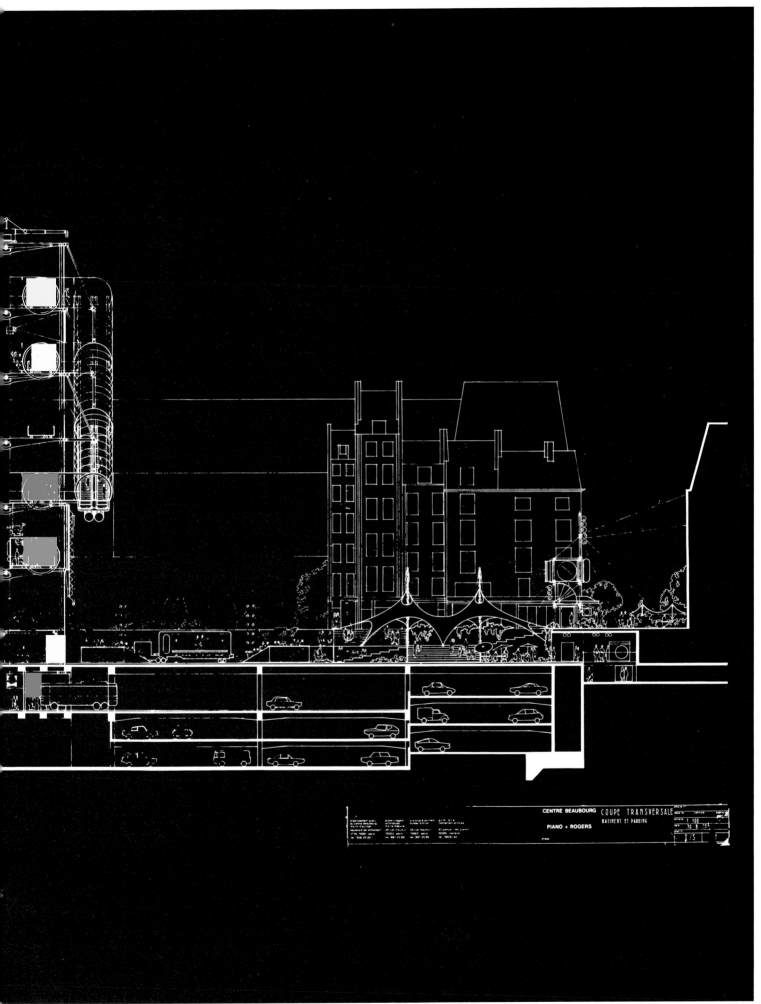

CENTRE BEAUBOURG COUPE TRANSVERSALE
BATIMENT ET PARKING

PIANO + ROGERS

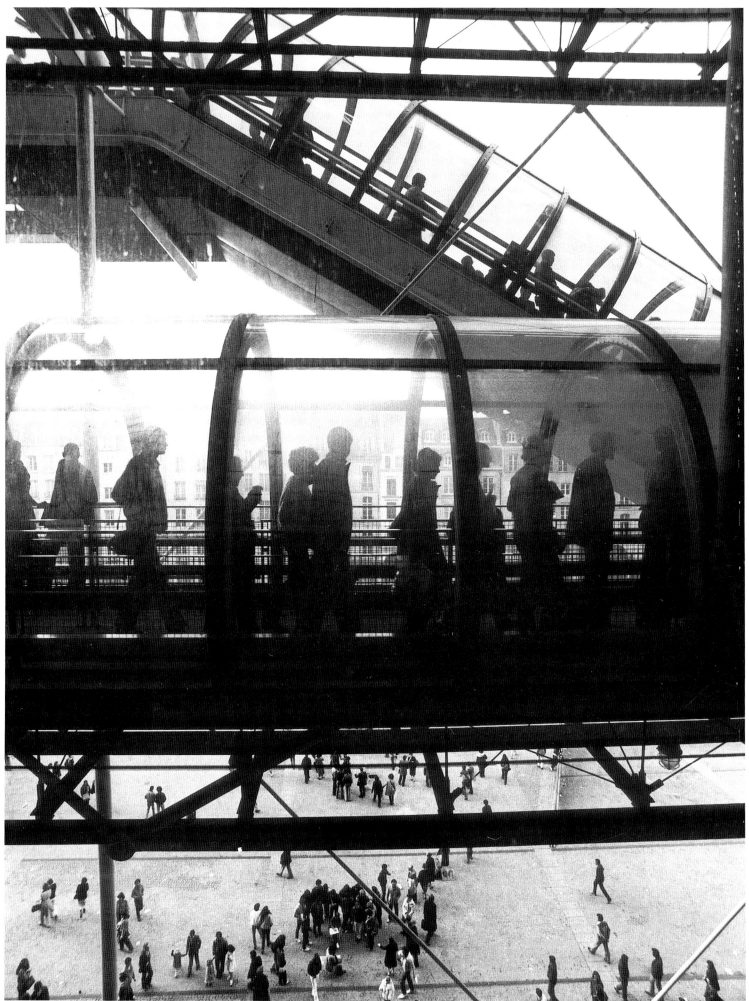

22

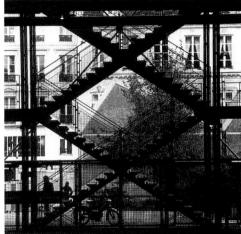

23

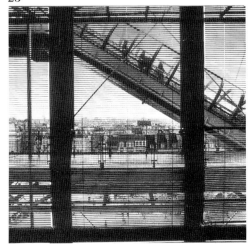

24

Fig. 21. Catwalk and escalator
Fig. 22. People pausing on the catwalk
Fig. 23. Stairs outside the center
Fig. 24. View to outside

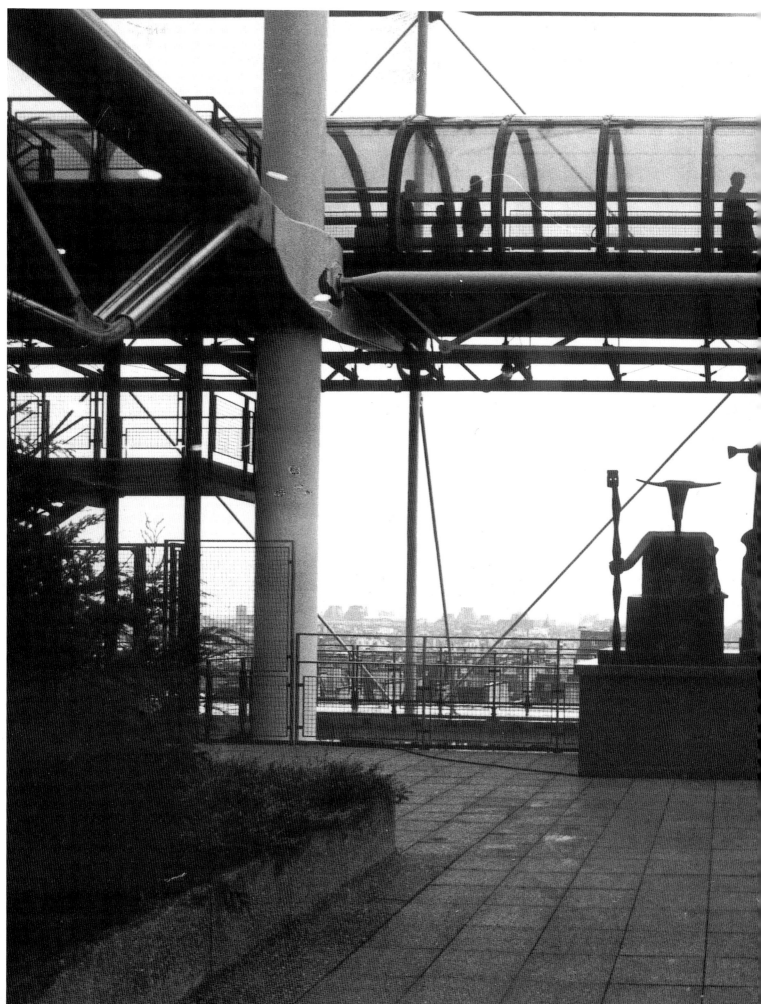

Fig. 25. One of the terraces, facing West

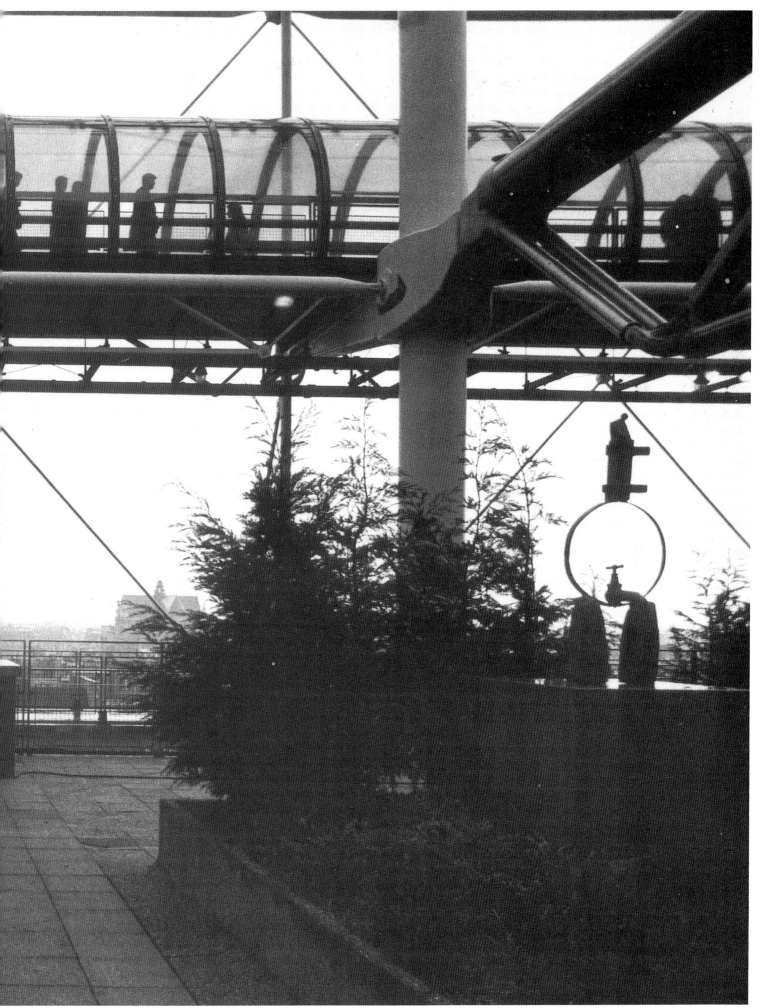

IRCAM: Institute for Research and Coordination in Acoustics and Music
Paris, 1973–1977

The aim of IRCAM is to extend the boundaries of musical and acoustic research through interdisciplinary techniques. Research will be carried out by scientists and musicians in psychoacoustics, electronic computer science, artificial intelligence, neurophysiology, psychology, linguistics, sociology, etc., so that such interdisciplinary research may act as an incentive for musical inventions.

IRCAM has four main departments: instruments, voice, electroacoustics, computers, and coordination.

The building, approximately 100,000 square feet, consists of a primary concrete shell sunk 66 feet into the ground to ensure the maximum acoustic insulation; it is carefully zoned so as to divide general activities. All general activity in the building is semi-exposed to the view so that any form and functional activities inside the building are immediately under the eyes of visitors. The public may participate in the results of the research process performed in the Projection Space, the largest studio in the building.

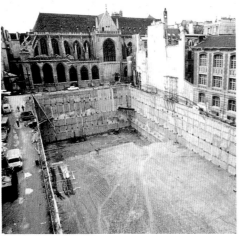

26

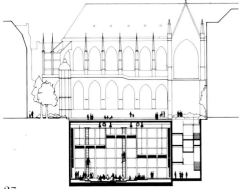

27

Fig. 26. Starting work at the IRCAM yard
Fig. 27. Section showing location of the IRCAM
Fig. 28. The plaza above IRCAM, with sculpture by Jean Tinguely and Niki de Saint Phalle

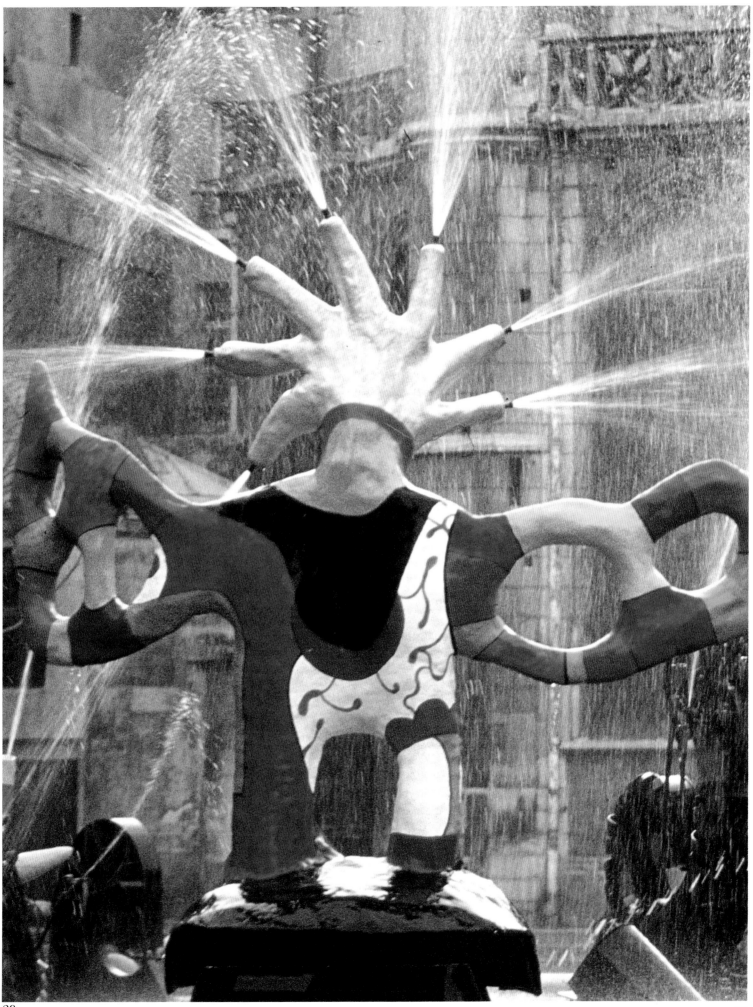

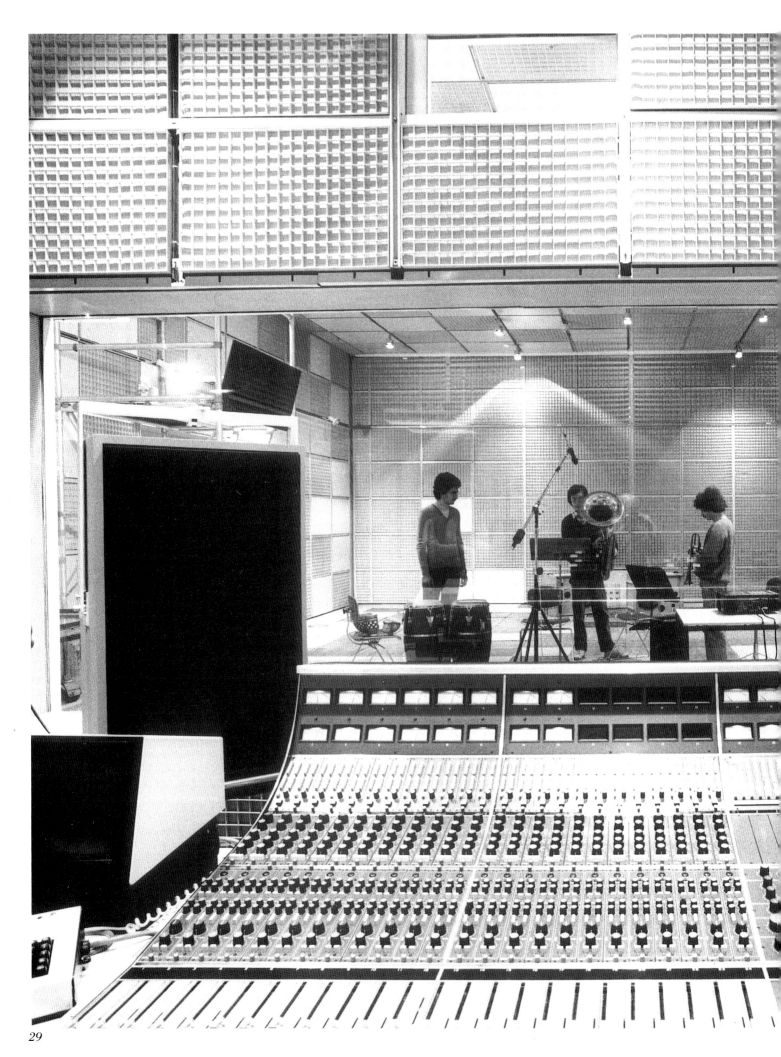

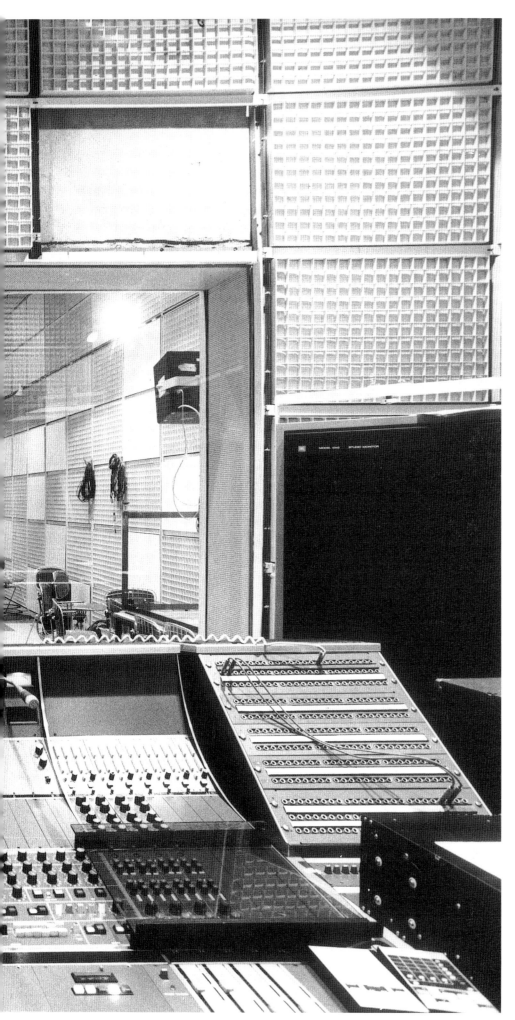

30

Fig. 29. The recording chamber
Fig. 30. Floor plan

45

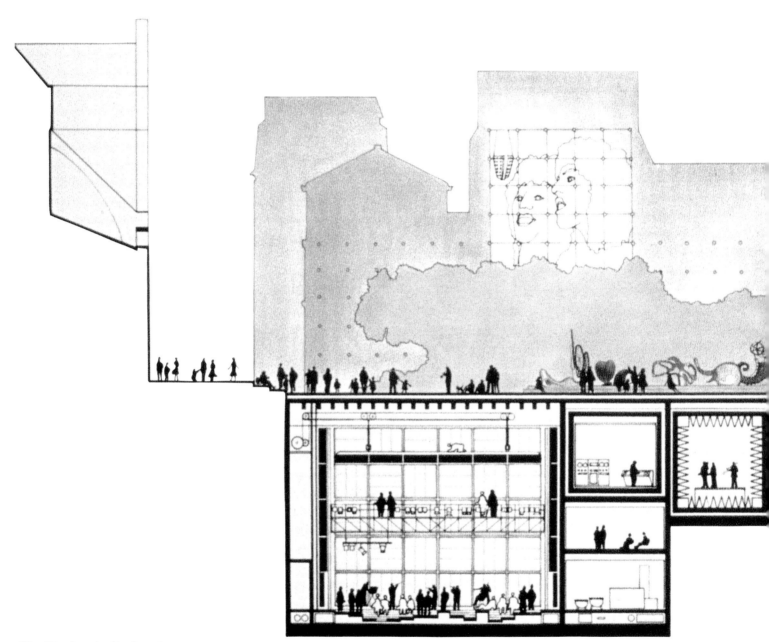

Fig. 31. Longitudinal section

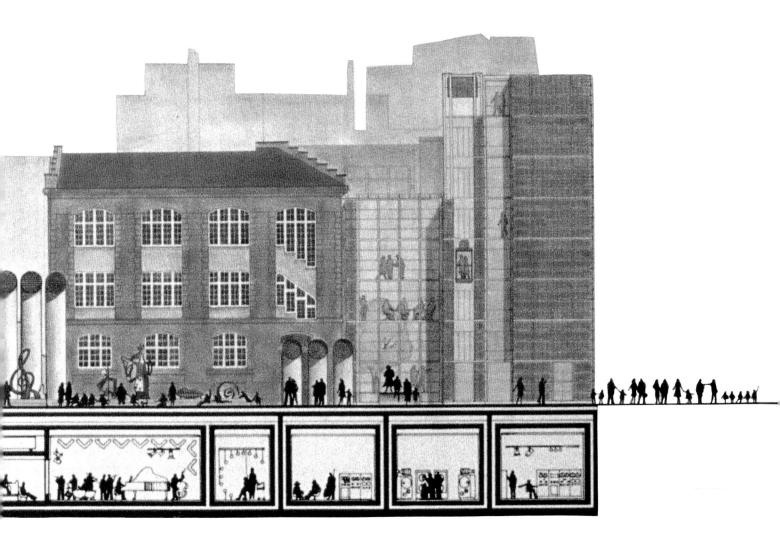

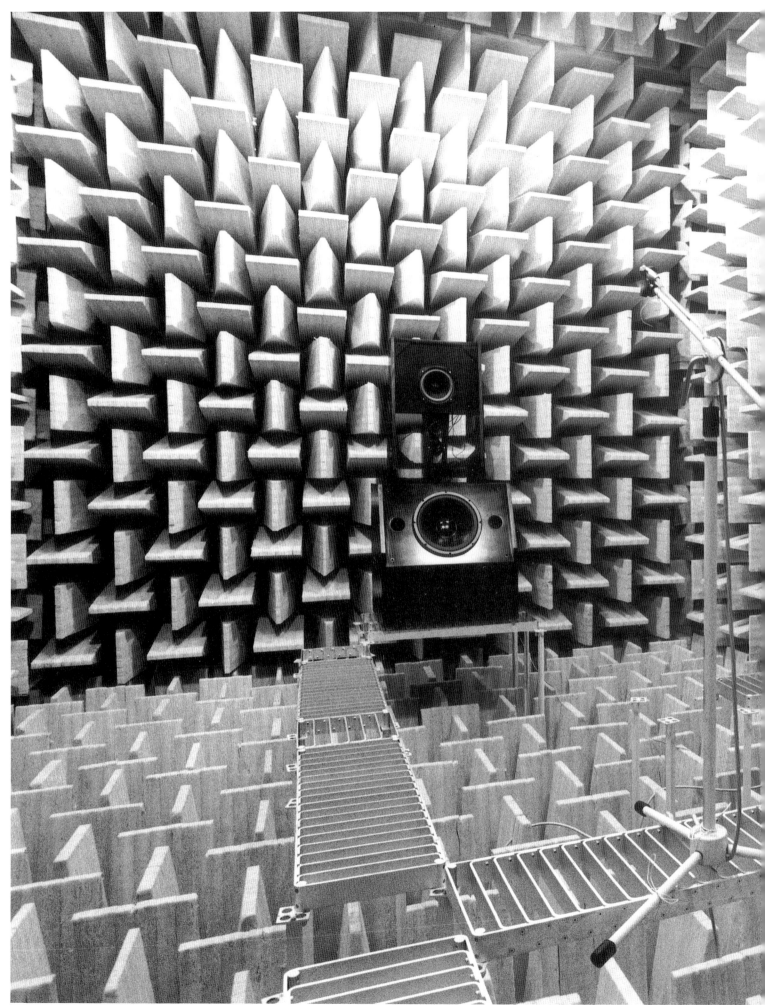

Fig. 32. The music research chamber

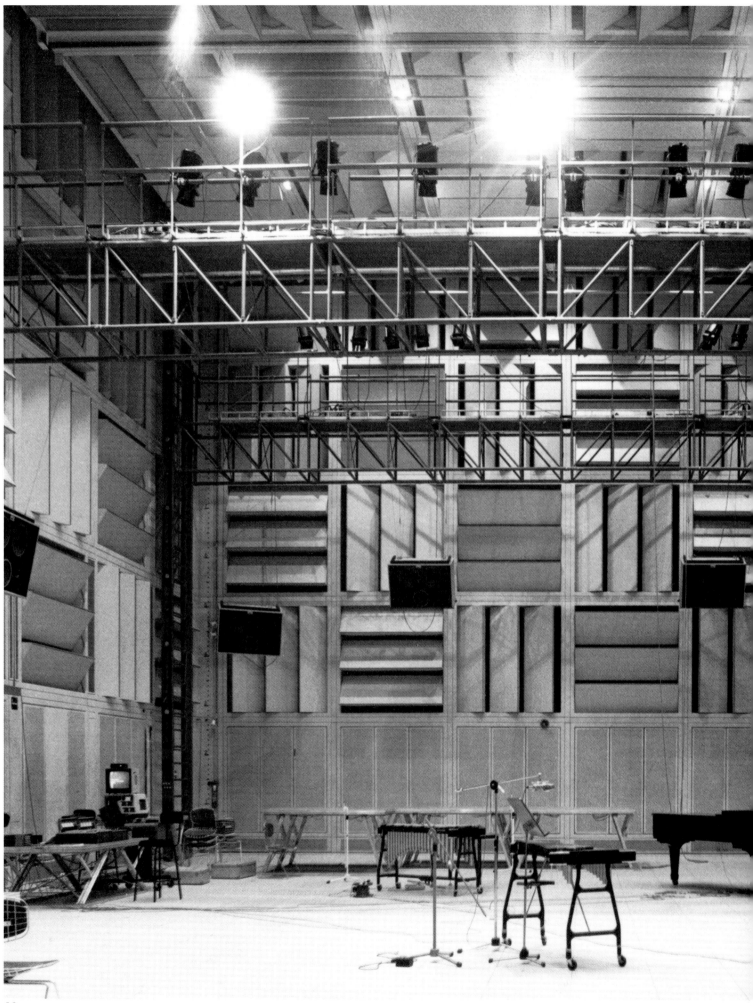

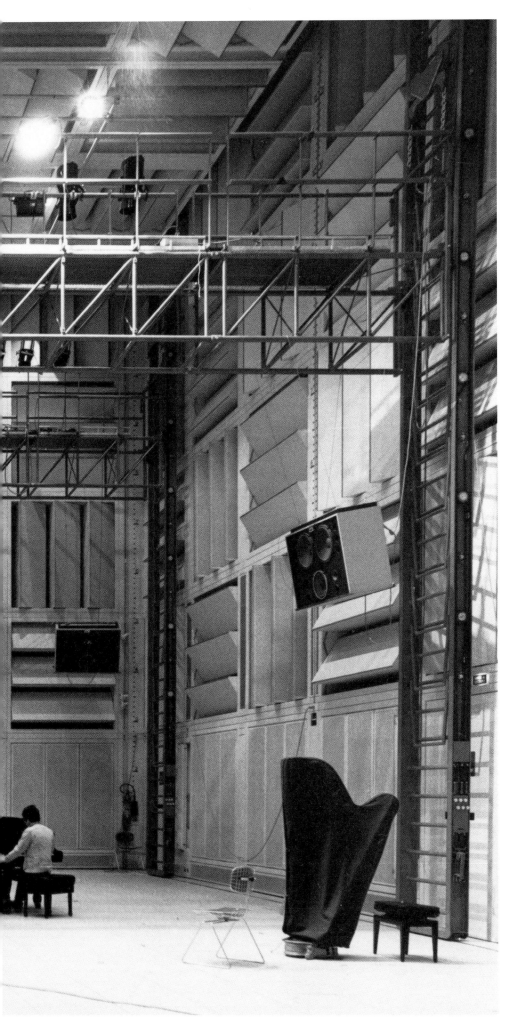

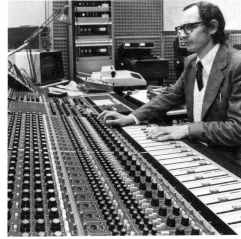

34

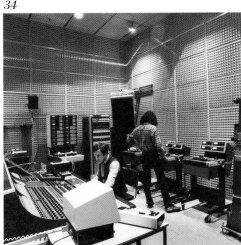

35

Fig. 33. The acoustic projection chamber
Fig. 34. The synthesizer
Fig. 35. The recording chamber

Projects of Urban Reconstruction in Historic Centers of Italy
1979

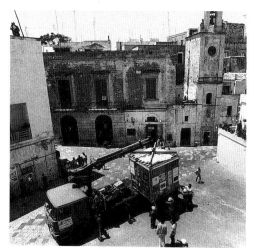

36

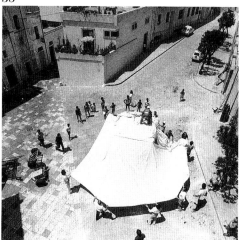

37

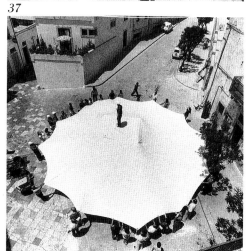

38

For the preservation and restoration of historically evolved town centers, Renzo Piano together with his associates have developed a mobile "laboratory" that can be set up wherever the problem is to salvage from decay old town centers that have grown organically over the centuries.

The mobile laboratory, which was developed with the support of UNESCO, is housed in a double container that can be transported on an ordinary truck. At the points of application, after unloading, the two halves of the container are assembled together to form the core of the "laboratory," resulting in a block square in plan. The side walls can be opened up and folded out to form four sectors of variable dimensions connected with the central block. A tent roof stretching over the top protects the whole installation from both bad weather and excessive sunlight.

Renewing an Old Neighborhood
Otranto, 1979

In June 1979 the mobile laboratory was set up experimentally for the first time in the center of Otranto, the most easterly town in southern Italy. The old historic center with some 500 inhabitants is still bustling with life, full of shops and workshops. The houses are not too high and not too close to each other, which made it easier to design for this town center a residential neighborhood meeting modern hygienic requirements, as it was sufficient to bring slight structural alterations to the buildings. This would, however, be more difficult to obtain in the newer outlying districts.

The aim of the experiment in Otranto, using this mobile laboratory, its technical equipment and technicians, was to show the local people how they themselves with the help of new technologies and new materials could "gently" renovate and preserve their neighborhood at low cost. The main point was to make them understand that they could do this living in their houses during the construction, thus avoiding a loss of contact with their surroundings. It is the only promising form of "urban reorganization" that allows old town centers to remain alive.

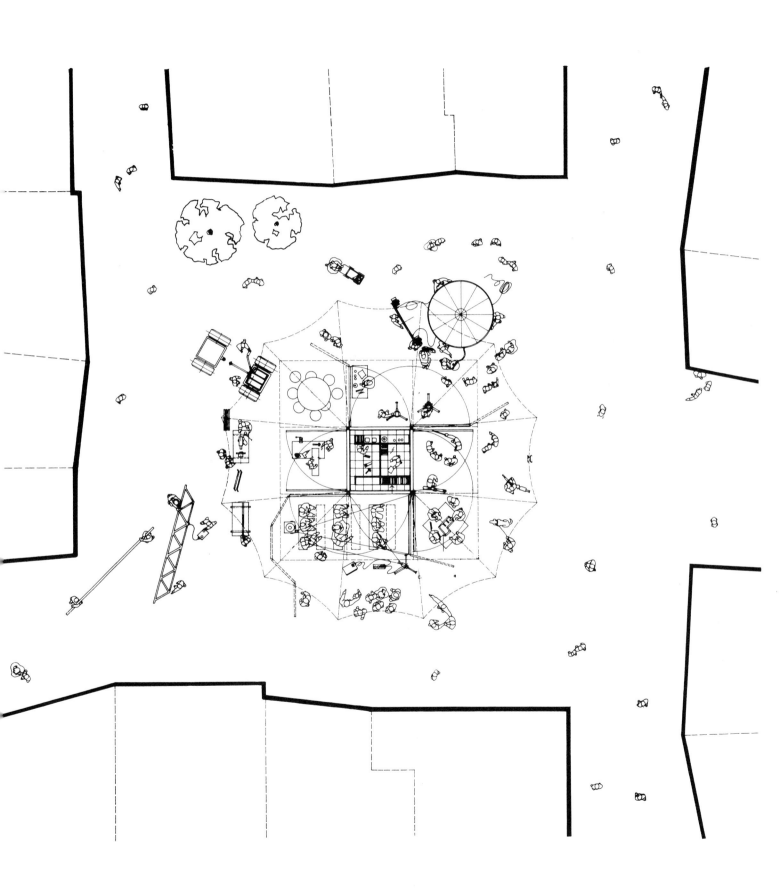

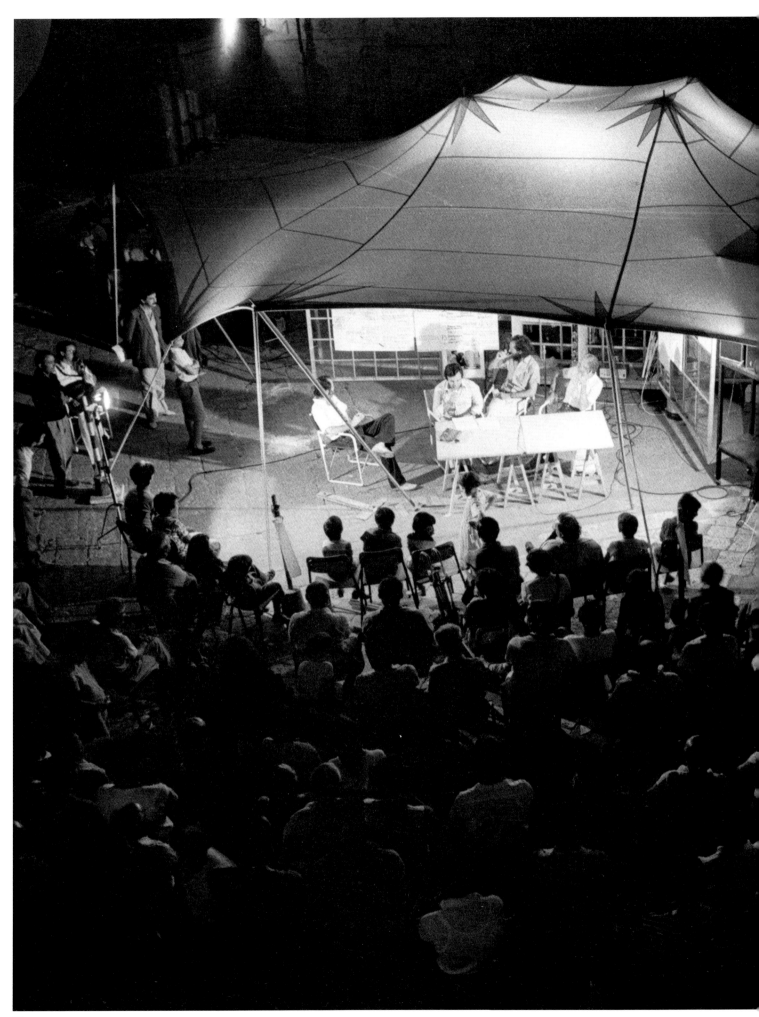

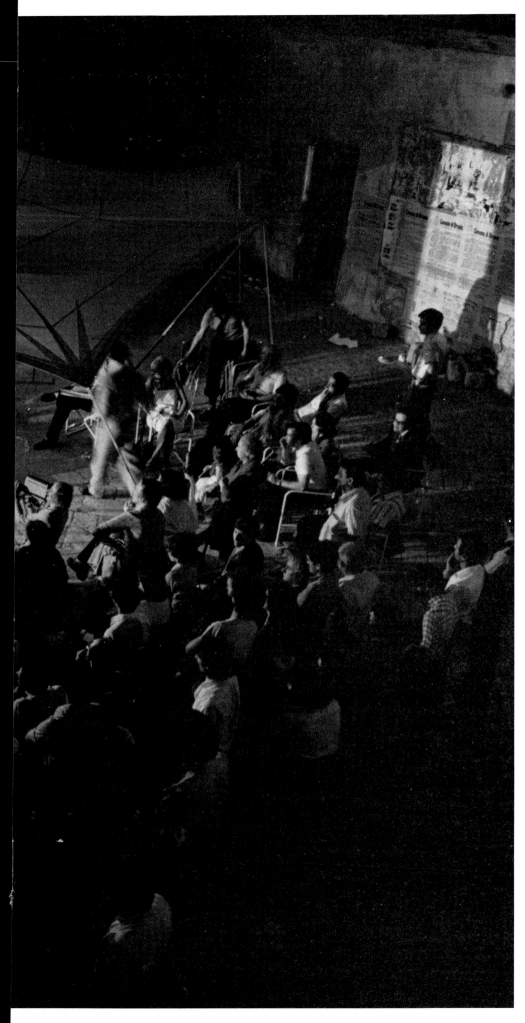

Fig. 40. Night view

Fig. 41, 42, 43, 44. Typical Otranto stone samples

41

42

43

45

46

47

Fig. 45. The laboratory
Fig. 46, 47, 49. Interior and exterior of
houses being restored
Fig. 48. Laboratory, elevation

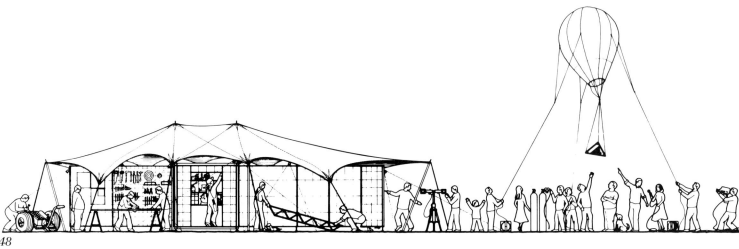

48

Design for Restructuring Burano

Venice, 1980

50

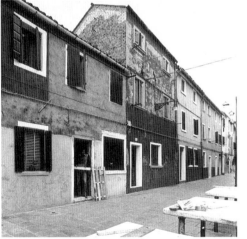

51

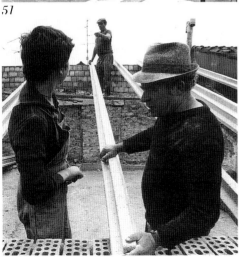

52

Venice began to take shape at the beginning of middle ages on a number of small islands in the shallow waters of a lagoon as people crossed from the mainland to escape barbaric hordes. Although the core of the original settlement has been lost within the larger city of today, its scale has been maintained. An example of the early type of town can still be seen on nearby Burano, where many-colored houses are still lived in by fishermen.

The city of Venice put at our disposal part of an unused monastery. A Neighborhood Workshop could thus be set up to coordinate the planning of the preservation and renovation work required, to be carried out with the cooperation of inhabitants, local craftsmen, and anyone with skills appropriate for the project.

As with the workshop in Otranto, groups were set up in charge of carrying out planning, construction, analysis, and the collection of data, all jobs with the same object in mind: to select suitable materials for plastering and to try to solve such problems as dampness, ventilation, heating, insulation, and sanitation, and problems related to flooding at high tide.

An example of what was· actually achieved is seen in the method adopted to overcome the problem of traditional plastering, in which the wall "sweats" out the moisture as a result of the way the lime in the plaster soaks it up. We selecterd a new, self-absorbent plaster, but had to make sure that not only plasterers and craftsmen understood the reasons for it, but also the inhabitants. The workshop thus became a link between memories and skills of past and modern technology.

*Fig. 50, 51, 52. Views of Burano island
showing the phases of work
Fig. 53. Plan of the island showing the
phases of work
Fig. 54. View of Burano*

53

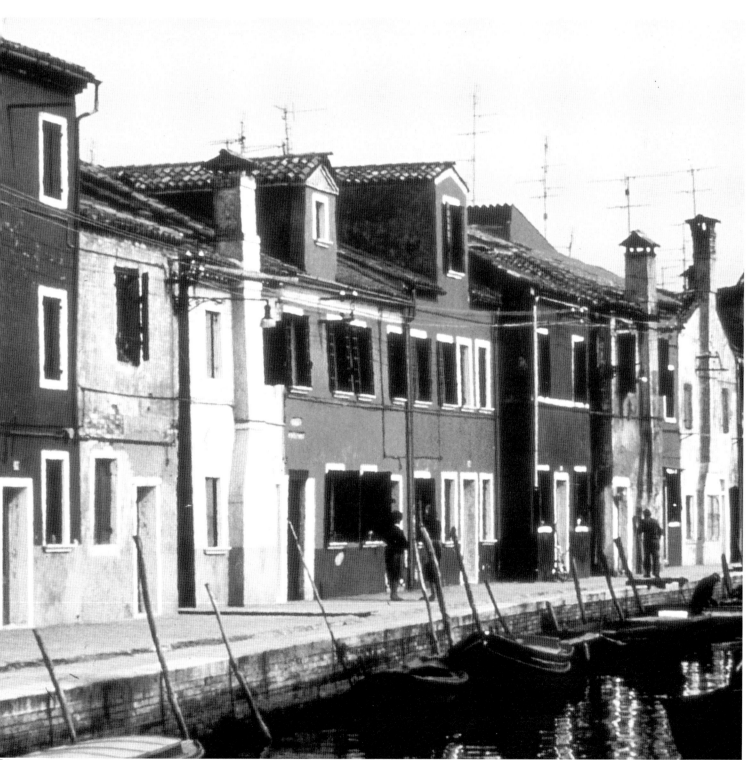

54

Renewing the Old Del Molo Quarter

Genoa, 1981

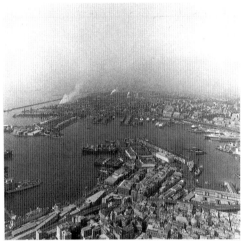

Fig. 55. Aerial view of the Molo quarter
Fig. 56. Section
Fig. 57. Model showing recovery operations

The old Del Molo quarter dates back to the Middle Ages and covers an area of 2.2 hectares, with a density of 637 inhabitants per hectare.

The renewal project is in two stages: renovation, carried out with the active collaboration of local population, and the superimposition of new structures aimed at giving new life to the quarter. As far as the renovation is concerned, the project is related to the Neighborhood Workshop operating in Otranto (p. 52). The workshop includes equipment and tools, instruction manuals and a team of specialists to help inhabitants actively and directly participate in the work. The houses are restored with people still living in them, by consolidating the wall structures, filling in the cracks, remaking roofs and plaster, eliminating dampness from the walls, and installing sanitary equipment.

The main point is to "start a gear that had been clogged for ages": to create a continuous and permanent building yard amidst the complex sequence of contaminations and superimpositions that have characterized the town from the middle ages to the industrial revolution, when the center began its decline with the separation between crafts work and urban life. The architecture of memory can thus be recovered by the proper mastering of scientific instruments that improve knowledge of people's requirements, and by giving proper value to crafts jobs.

All the structures designed to bring new life to the quarter, such as schools and social facilities, are located in top of the buildings: this is to solve lighting problems (special scientific techniques are used to capture light and reflect it down into the narrow streets), and at the same time to provide views of the town and port. The project also includes suspended gardens and vertical circulation outside of buildings in the form of bridges and gangways of transparent tubes with reflecting surfaces to capture light. Shops, restaurants and other activities will be at ground level so that life in the street can continue as before. Other meeting and circulation areas will be placed at intermediate levels. Three new elevators will serve the whole quarter, so that existing staircases will not need to be changed. Consequently, ventilation shafts inside buildings will not need to be closed, which would result in less air and light.

This project is part of a wider program of the Genoa municipality that considers six areas in the historical center for pilot rehabilitation.

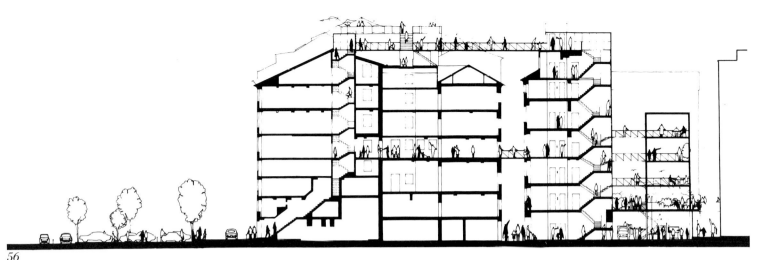

56

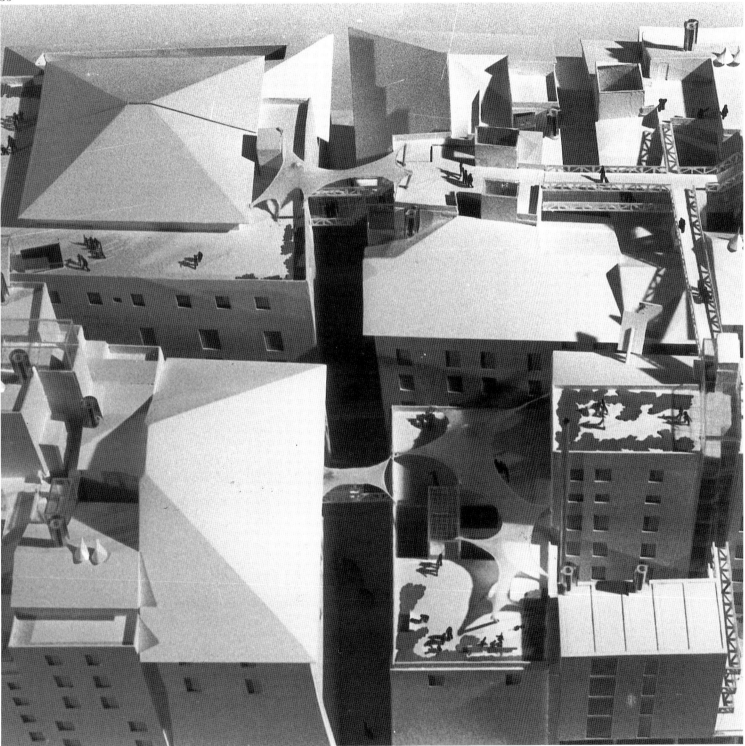

57

Rehabilitation Project for the Ancient Sassi Quarter

Matera, 1987

Located 300 Km south of Naples, Matera is said to be one of the world's oldest cities. Its origins date back to the New Stone Age, and it continued to grow until the end of last century. The oldest part of the town, called Sassi, consists of caves hewed out of tuff (volcanic ash hardened into a solid mass) over the centuries. These were first used as dwellings, stables and stores, and then gradually simply as storage yards for building materials while erecting the new houses above the caves. The caves were inhabited until 1950, when the Sassi quarter was declared unsuitable for normal housing purposes and the inhabitants were moved to the new towns built nearby.

The importance of the ancient town has recently been reconsidered, and a preservation movement was founded with the purpose of determining how this quarter could be recovered and reconditioned. In 1977 an international design competition was held, based on a program specially worked out for the preservation and development of the towns in the Matera area, promoted by city authorities and the Design Evaluation Committee. On the basis of the previous experience with the Neighborhood Workshop for Burano and Otranto, the involvement in this redevelopment project started with the setting up of a workshop charged to analyze the state of the existing buildings in the Sassi. The workshop should be seen as a service facility for people doing the surveys, with the purpose of becoming a center for retraining specialized craftsmen and shop keepers. It should remain a center for research on materials, where any problem could be studied regarding research, analysis and preservation of the underground quarter itself.

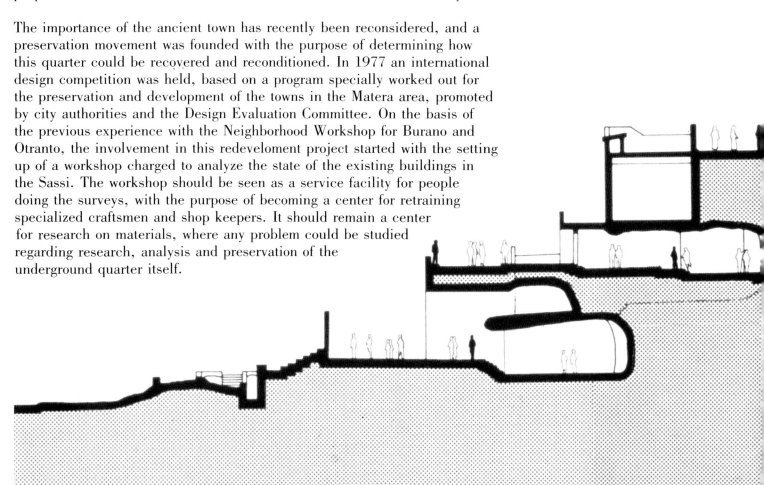

Fig. 58. Section showing the subterranean
area of the Sassi quarter
Fig. 59. Plan
Fig. 60. General view of the Sassi quarter

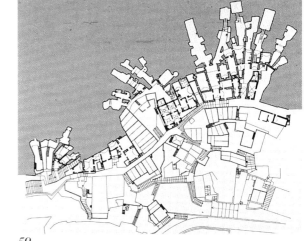

59

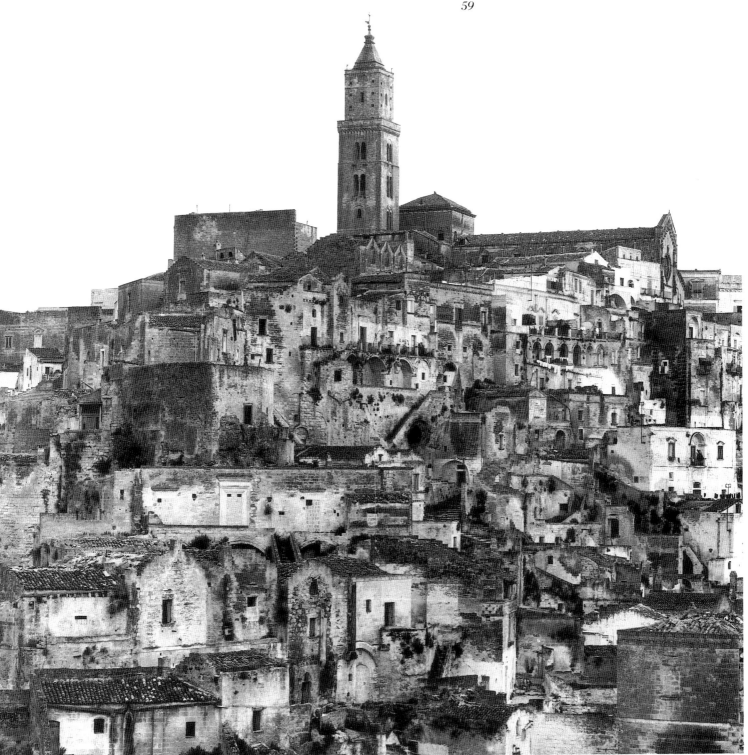

60

Il Rigo Quarter
Corciano, Perugia, 1978–1982

The project at Corciano near Perugia for medium-density public housing was derived from a continuous investigation into industrialized construction systems for homes in an ongoing phase of evolution.

It involved people's participation in the design process through "neighborhood workshops" where inhabitants were asked to give their opinions about the inside arrangement of the apartments in question.

The basic element of the prototype house, developed to meet the requirements of a bid tender, consists of a three-dimensional U-shaped structure made of reinforced concrete. People were asked to try to arrange the interior of the boxlike enclosure by using lightweight beams and panel floorings. The living room could in fact be increased from approx. 530 sq. ft. up to 1290 sq. ft. by simply moving window surfaces and intermediate floor panels.

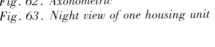

Fig. 61. Section
Fig. 62. Axonometric
Fig. 63. Night view of one housing unit

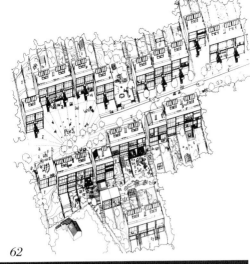

62

63

IBM Travelling Exhibition
1982–1986

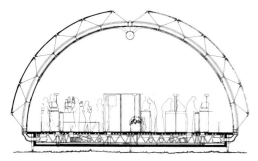

Fig. 64. Section
Fig. 65. The pavilion assembled, and its trailer, in Milan

The IBM travelling pavilion was expressly designed for an exhibition touching twenty European towns between 1982 and 1986.
IBM Europe wanted a pavilion for the exhibition of computer technology that could be easily disassembled, readily trucked to a new site, and quickly reerected.

The pavilion designed by Renzo Piano was formed by 4 modular elements each of 3 pyramids, molded together and factory assembled in pairs, ready to be mounted on-site.

Juxtaposed 34 times, the arch-piece creates a covered transparent space, a tunnel with diamond-like bosses, 157 ft. wide and 23 ft. high. The service and the mechanical systems were installed between the raised floor of the tunnel and the ground.

In this project the concept of nature was of utmost importance: Renzo Piano thought of a travelling exhibition on informatics as one to be easily set up everywhere in existing parks using as pavilion a translucent structure that could readily be disassembled and transported like a circus from town to town.

Such a see-through building would give visitors the feeling of being close to nature in spite of being surrounded by all the latest computer equipment. The main point was that though this century began by using technologies often antagonostic toward nature, it nevertheless seems to have concluded by discovering a new technology (informatics) that is essentially an ally of nature, especially with regard to all that concerns energy and pollution.

The travelling IBM pavilion is composed of elements that exploit the newest technologies not only technically but esthetically: polycarbonate is in fact the best performing plastic material at the moment, with its most conspicuous characteristic being its excellent transparency, essential in this case for giving the feeling of contact with nature.

Plywood—which is a perfect material for the likes of Renzo Piano, who favors high-accuracy components lending themselves to "the patient play of craft"—has been joined here to light and resistant aluminum frames.

These three elements meet the requirements of a geometrical structure in which joints are made by using gluing systems reminiscent of those found in nature: another example of how tradition can be reinterpreted through method.

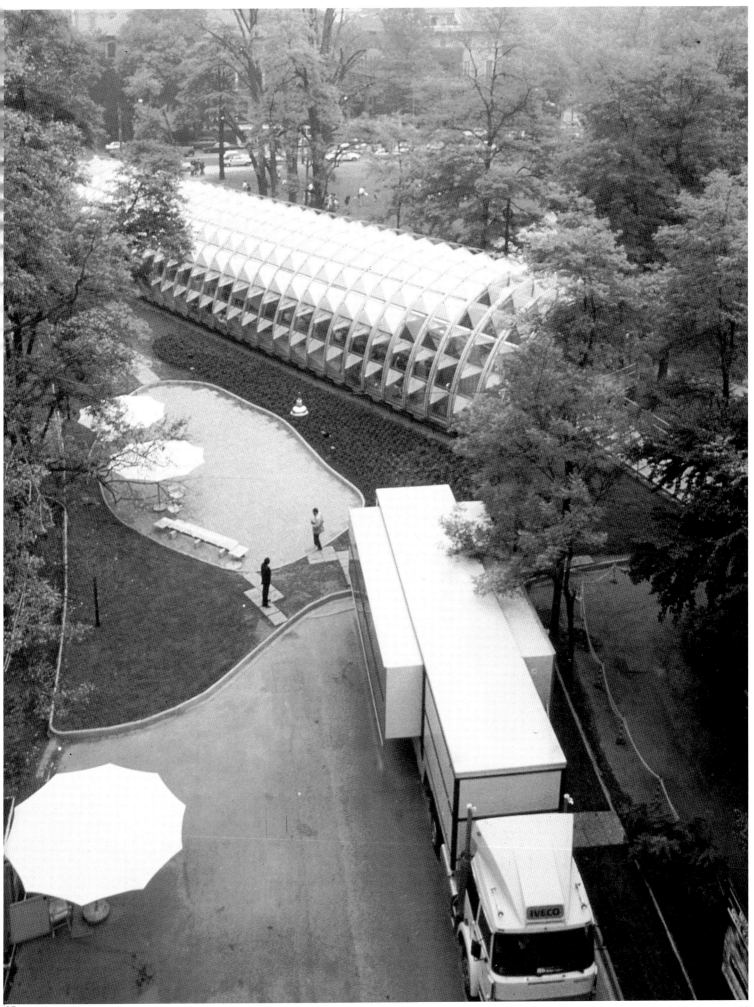

Fig. 66. Longitudinal section
Fig. 67. Details of connection between
ladder and pyramid
Fig. 68. Details of connection between
wooden staff and top of pyramid
Fig. 69. Partial section

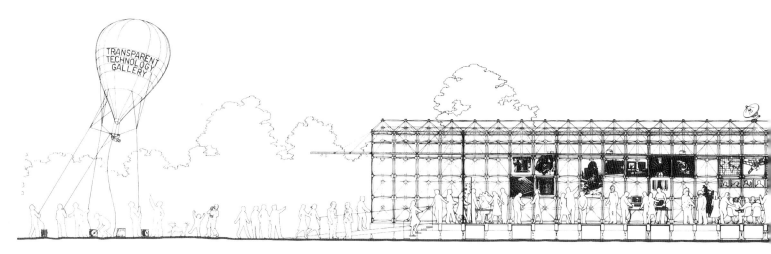

66

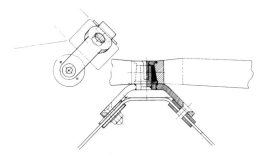

67

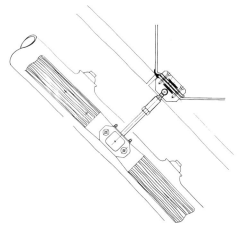

68

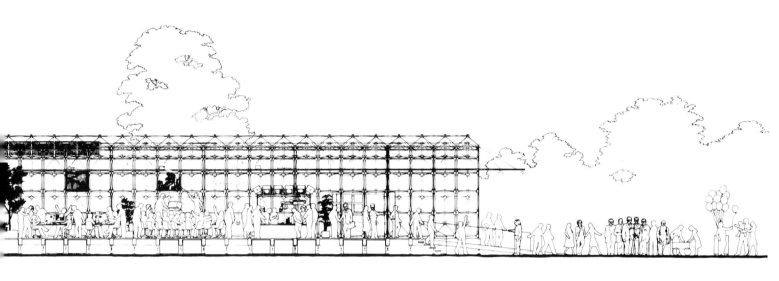

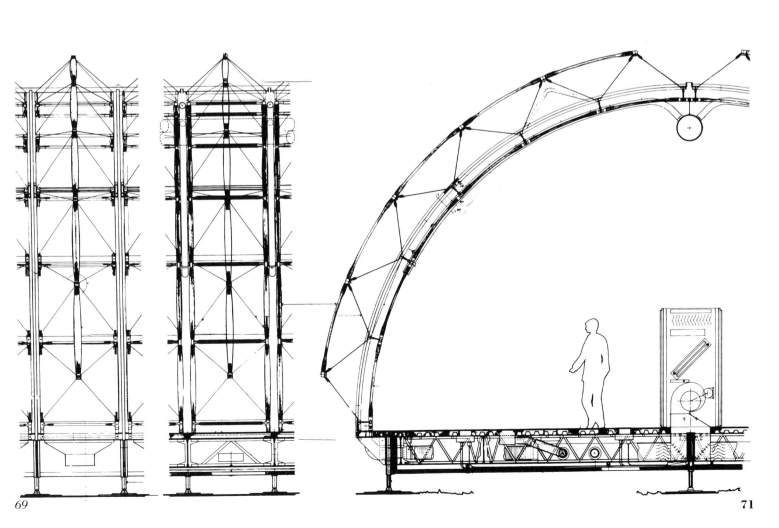

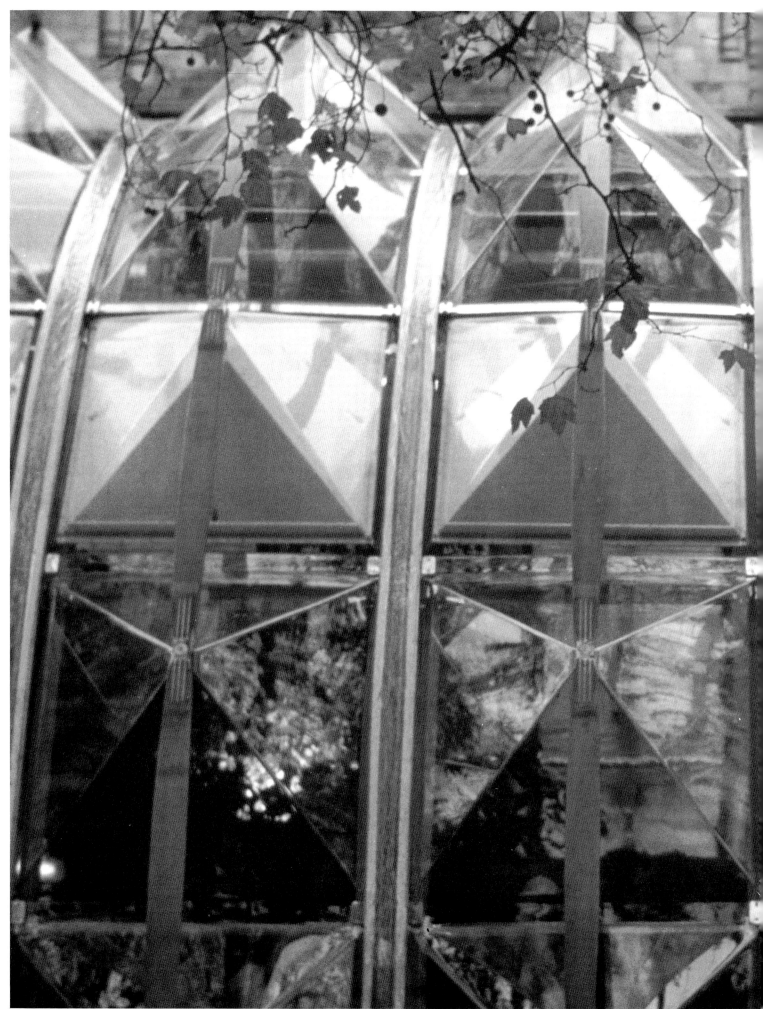

Fig. 70. Side view

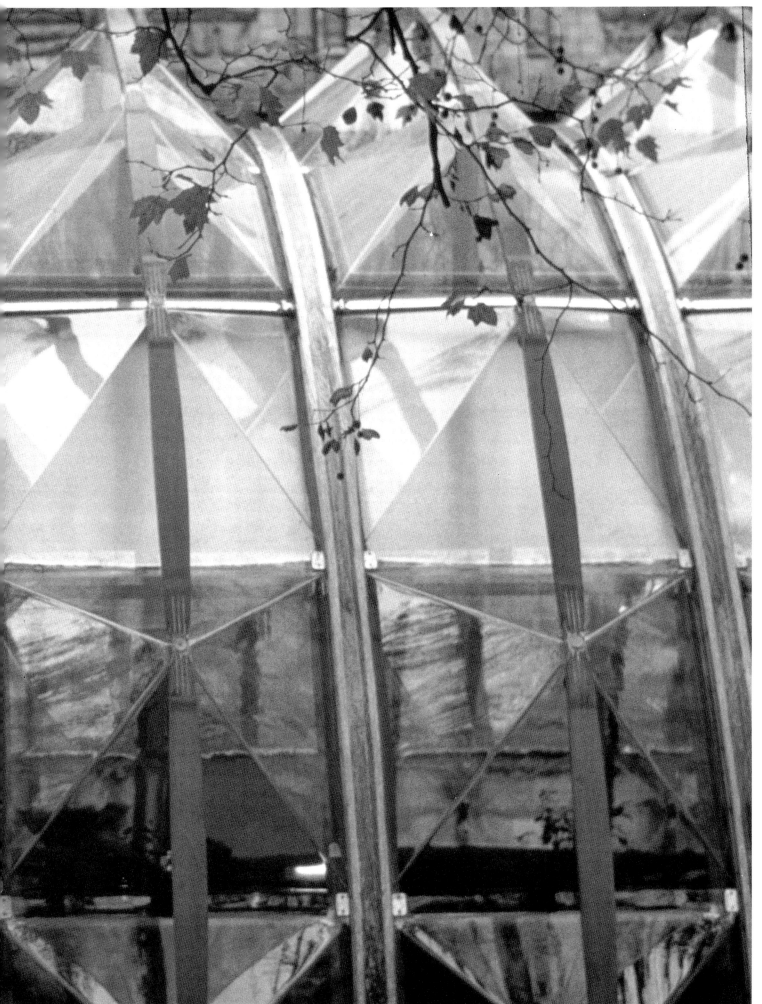

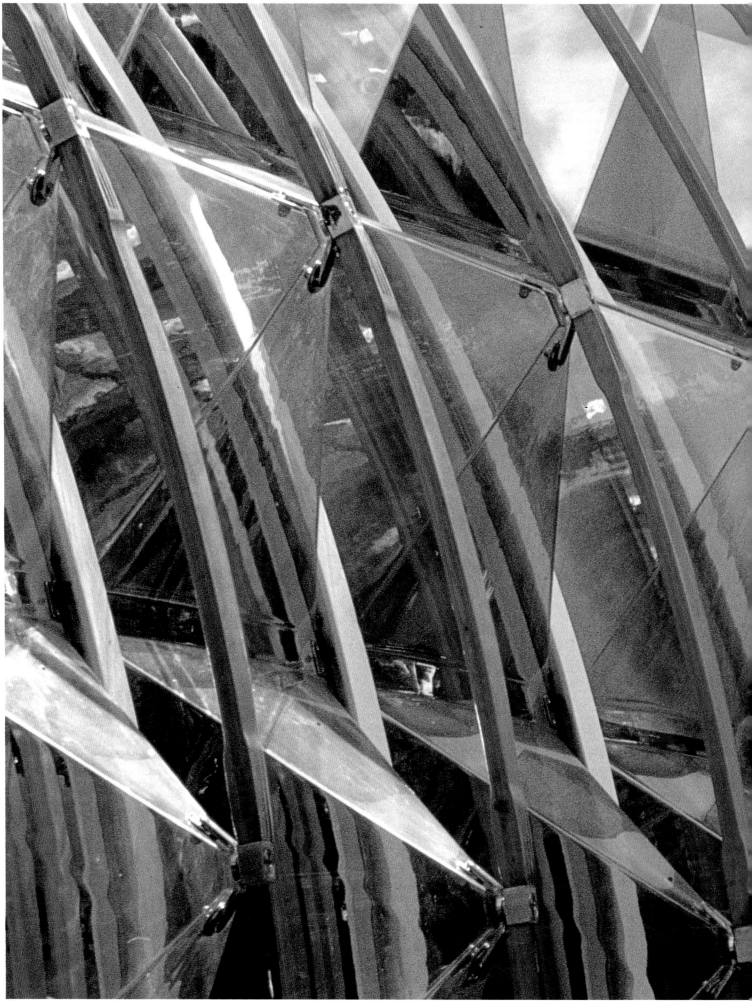

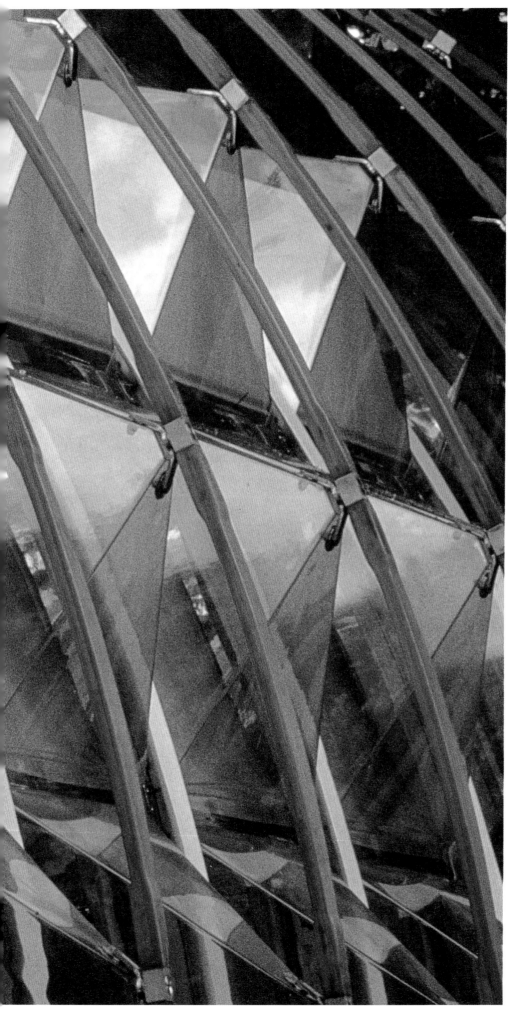

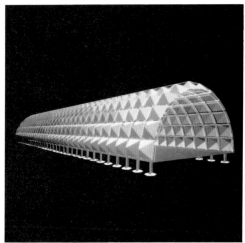

72

Fig. 71. Detail view of the polycarbonate elements
Fig. 72. Computer perspective

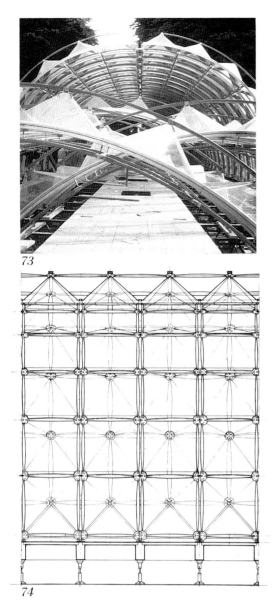

73

74

Fig. 73. Erection phase
Fig. 74. Elevation, detail
Fig. 75. The pavilion in York, England

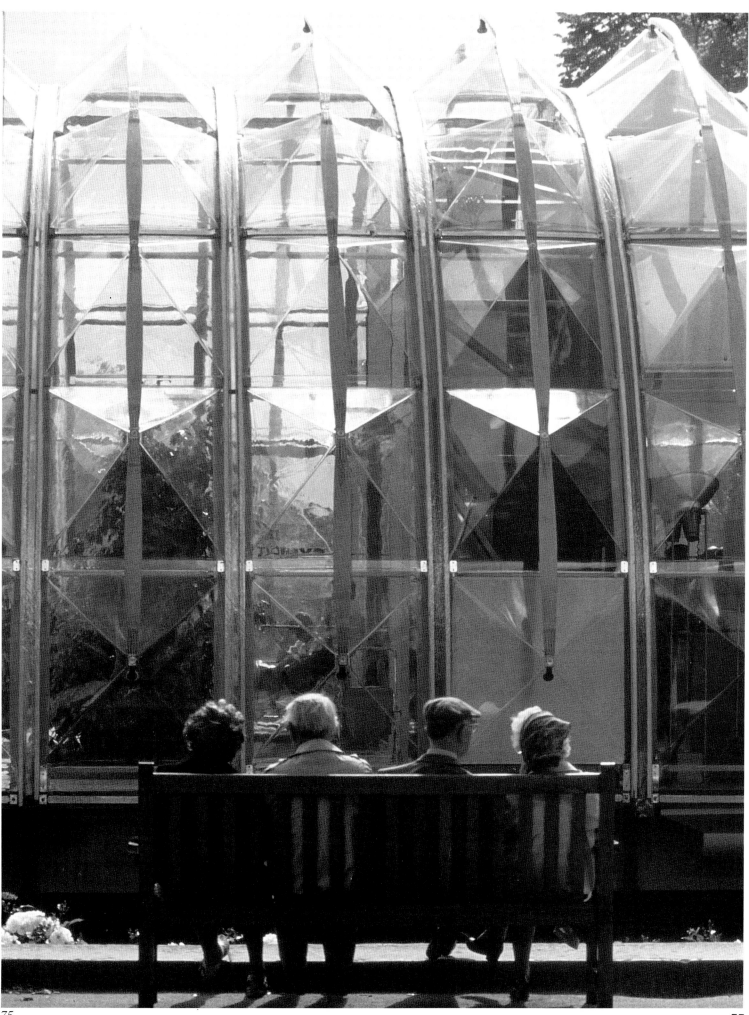

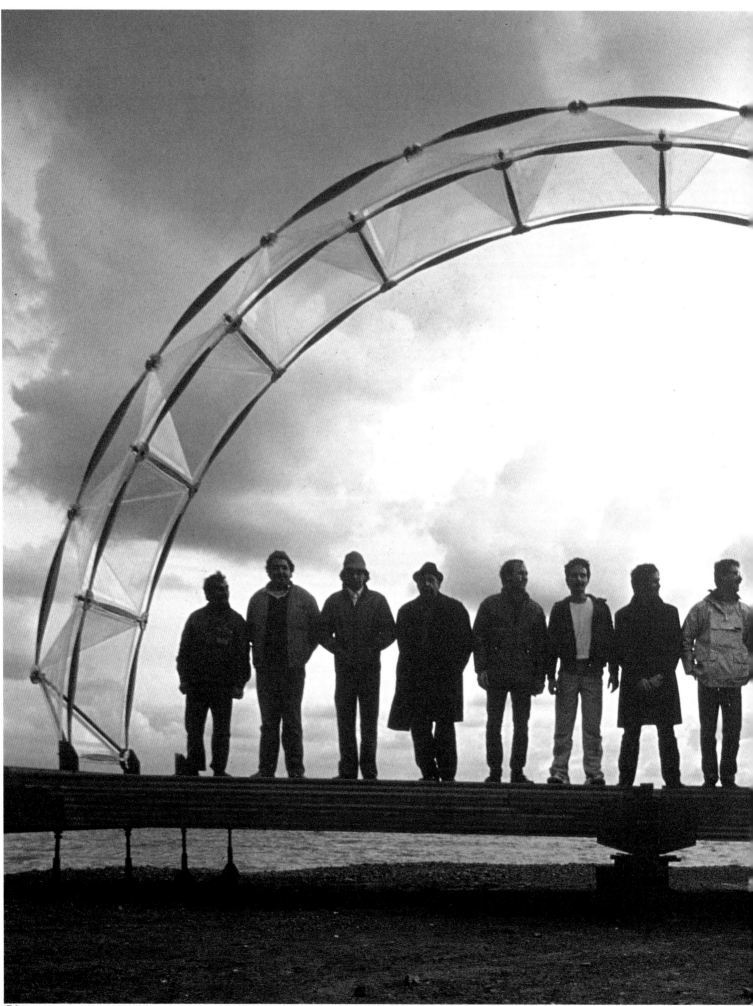

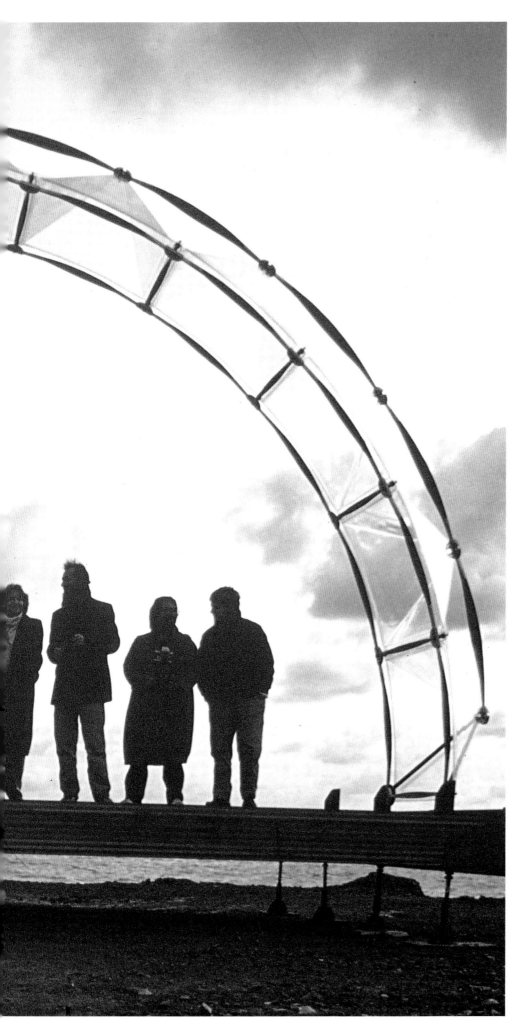

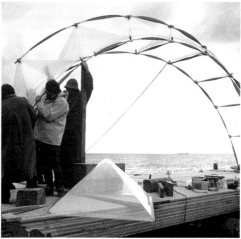

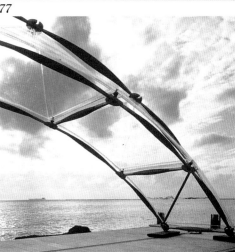

Fig. 76. Prototype erected on the beach in Genoa
Fig. 77, 78. Different stages during prototype assembly

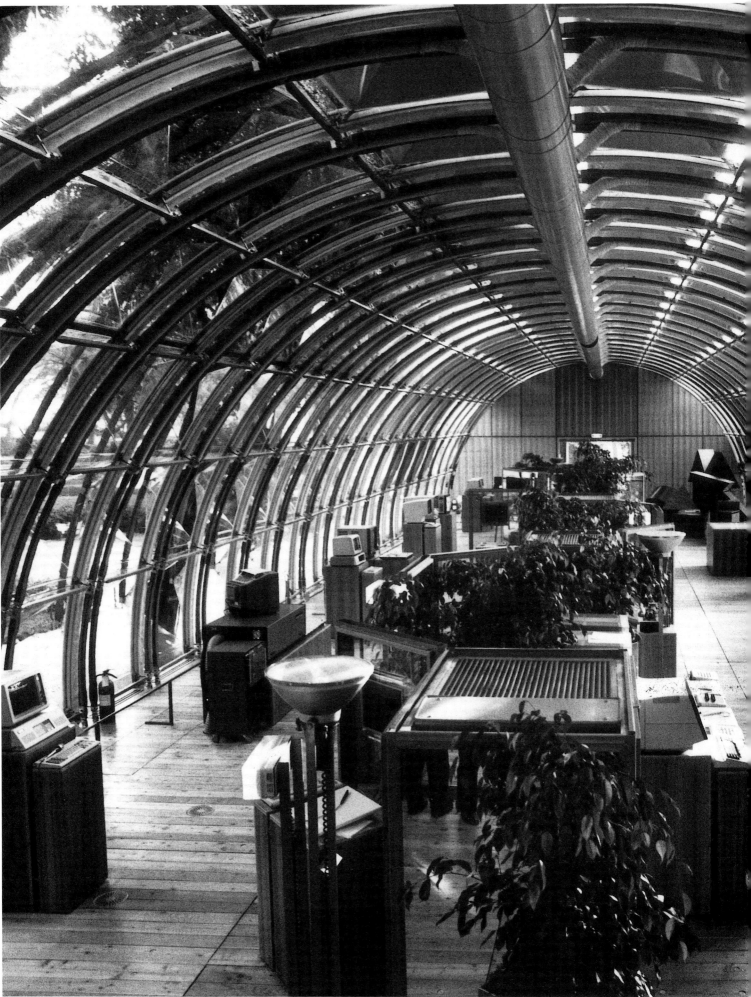

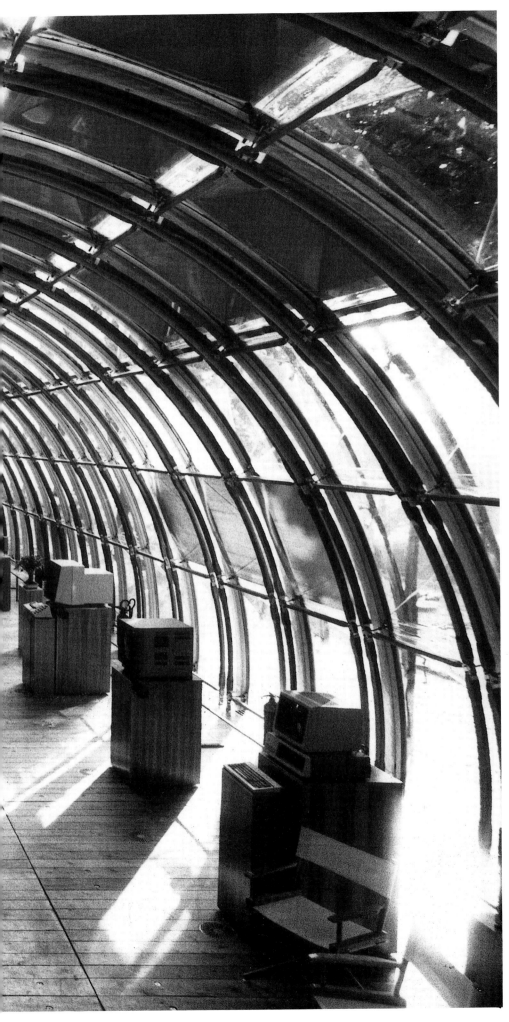

80

Fig. 79, 80. Interior views

Fig. 81. The pavilion in Paris

Fig. 82. The pavilion in Amsterdam

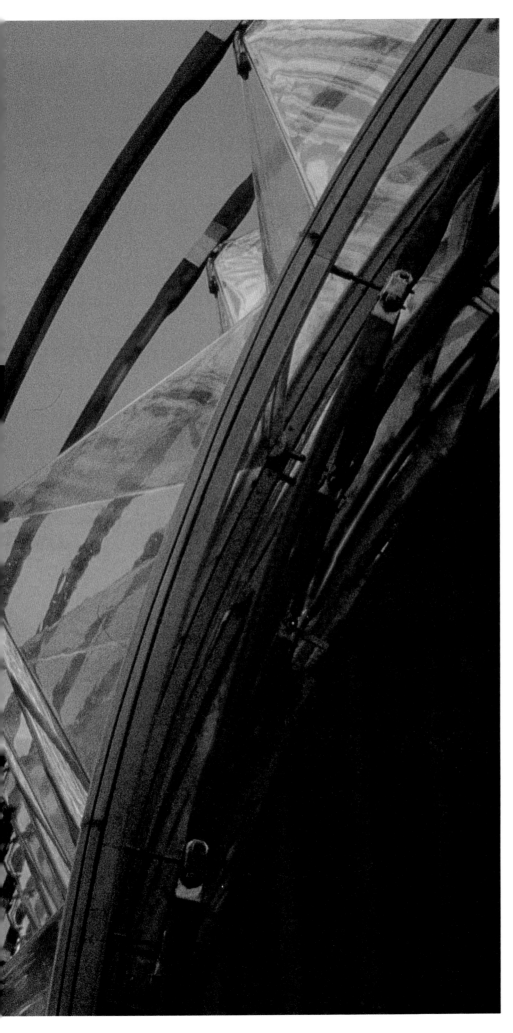

84

Fig. 83. The pavilion in London
Fig. 84. The pavilion in York

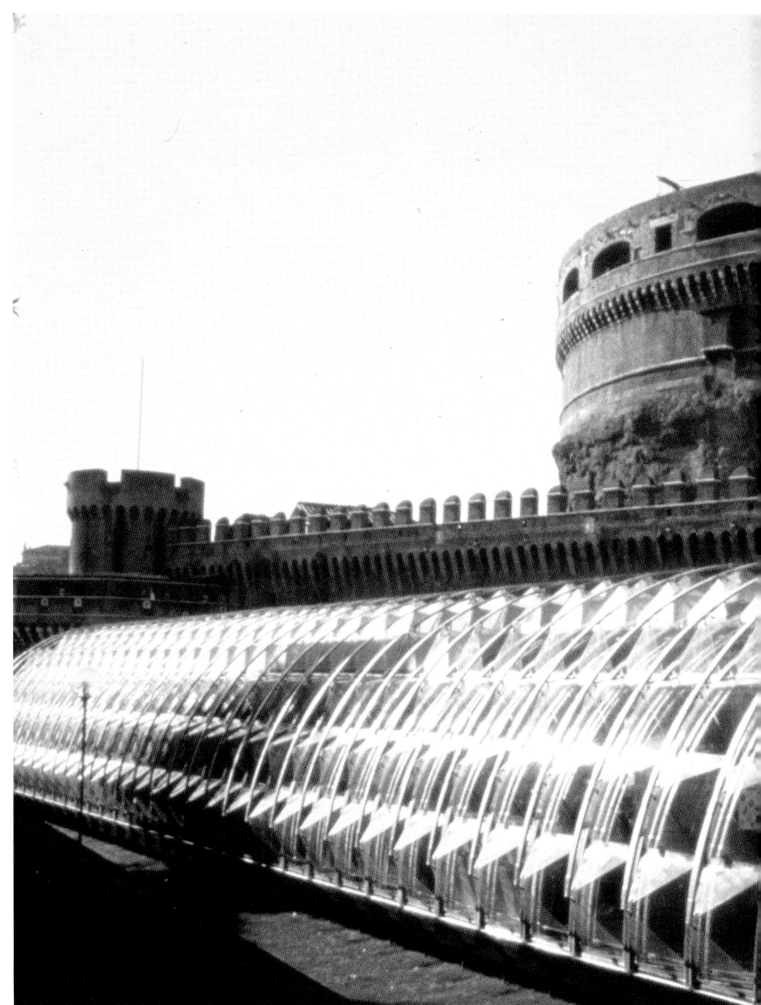

Fig. 85. The pavilion in Rome

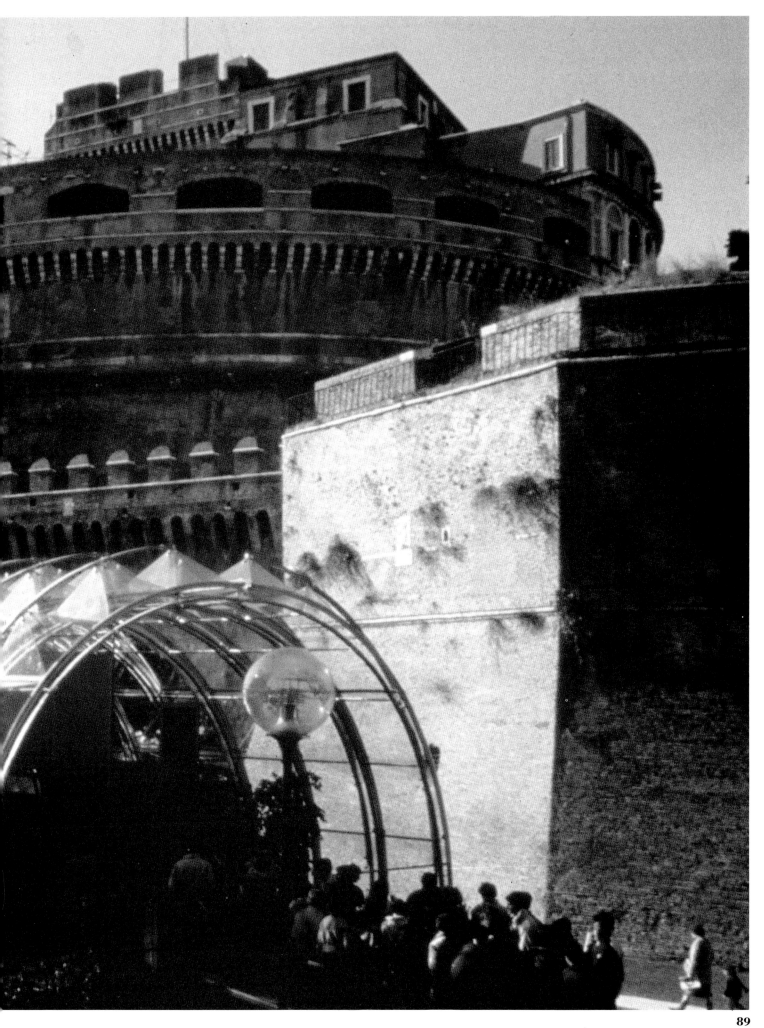

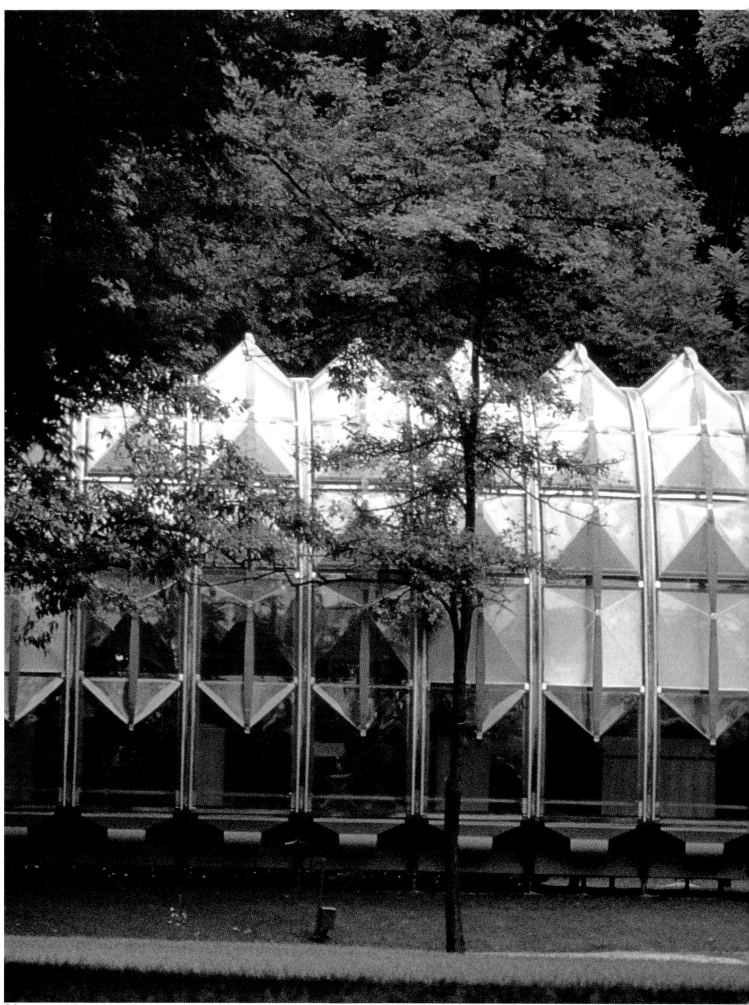

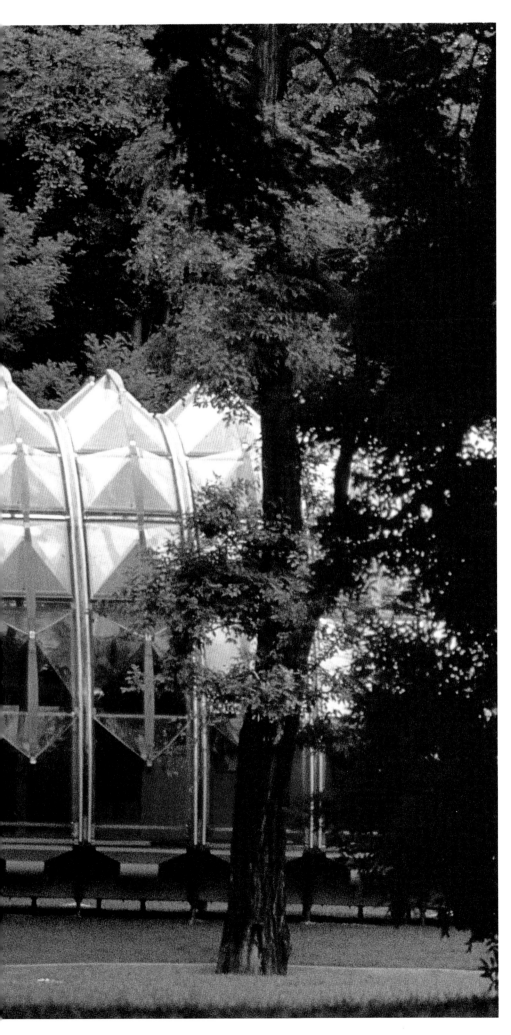

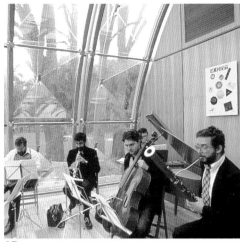

87

Fig. 86. The pavilion in Milan
Fig. 87. A chamber orchestra playing inside pavilion

Rehabilitation of the Schlumberger Factories

Montrouge, Paris, 1981–1984

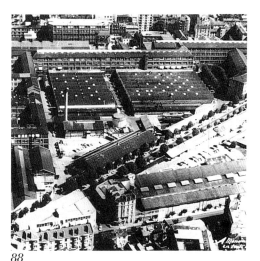

88

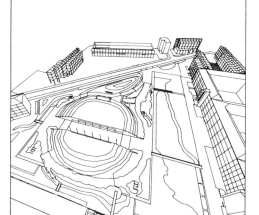

89

Fig. 88. Aerial view of preexisting site
Fig. 89. Aerial perspective after rehabilitation
Fig. 90. Detailed view of renovation

The Schlumberger factory has gone through a complete transformation over the last twenty years, changing from a concentration on heavy engineering production systems to a multinational manufacturing enterprise for the production of precision equipment for electric detection systems in oil fields. The area of industrial production in which the company is engaged has thus switched from the electromechanical to the electronics field. As a result of this change there was a need for facilities that could accommodate 2,000 people operating in areas such as administration and research.

Because the price of land in greater Paris had soared, a decision was made to renovate in the most effective way possible the existing group of sixteen five-story. buildings, which consist of concrete structural frames with brickwork infill extending in regular arrangement across the large site. To do this a plan was needed that would bring up to date both the function of the buildings and their environment.

This project included three major objectives: (1) maintain the formal memory of the factory that had for such a long time been the mainstay of production; (2) rearrange the interior planning of each building by modifying some of its parts, thus bring the building more in line with present requirements; (3) arrange a garden in the center of the site in an attempt to improve the environment and at the same time the functional aspect of the site in general. The one-story factory building at the center of the site was dismantled and replaced by a garden that opened this wide area (approx. 215,000 sq. ft.) to public use.

Underneath the central area a parking place was obtained for 1,000 cars. Atop this the Forum shares space with various companies owned by the Schlumberger group. The Forum is concealed behind the contoured landscape and tent cover. It houses a restaurant, a bar, a bank, a travel agency, sport facilities, an auditorium, a projection room, a conference room, and the offices of the administrative headquarters.

As there were relatively few trees in the landscaped area, planting was carried out in order to remind people of the changing of seasons, and newly created ponds were stocked with ducks.

A kit system, called "Catalogue," has been adopted for items such as steel staircases, elevators, bridges, tent structures, façades, facing panels, and street furniture. The approach is to try to tie together the new constructions with the existing structures, as well as natural elements to man-made ones. The details of each of these kits were designed in accordance with a number of restraints in order to avoid a clash with the existing architecture.

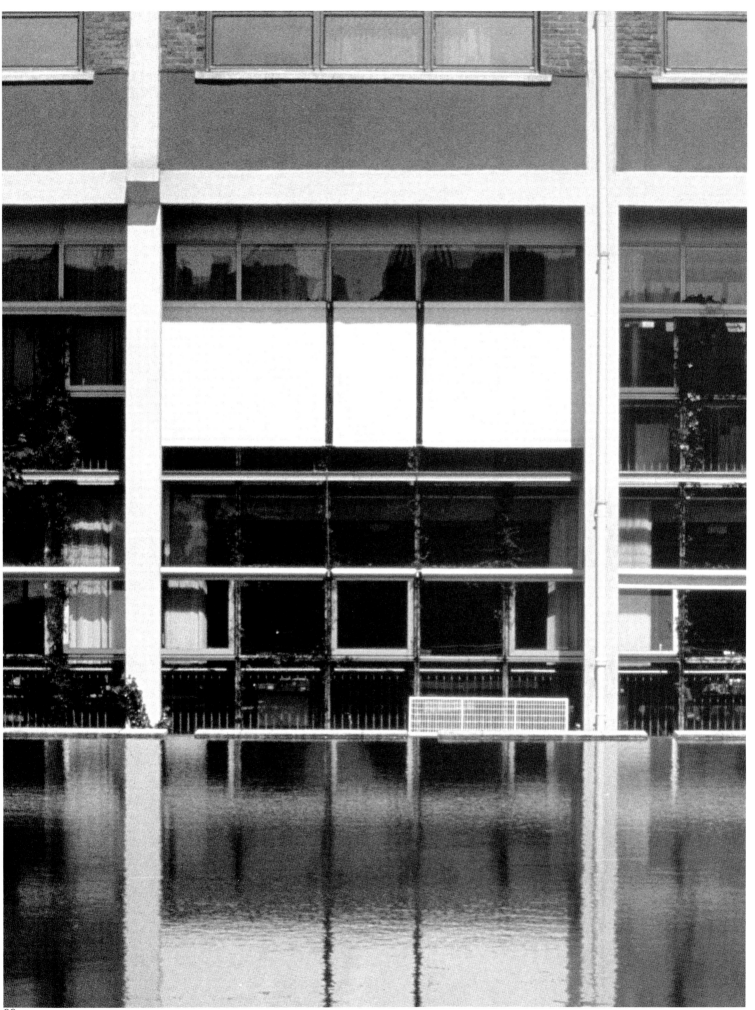

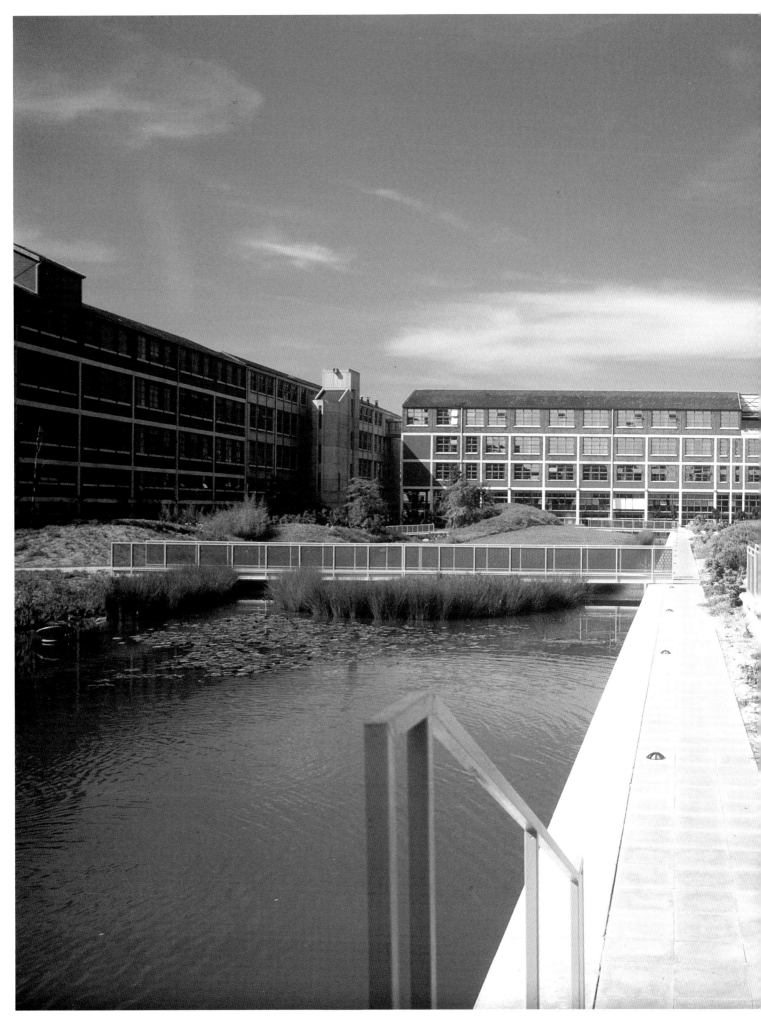

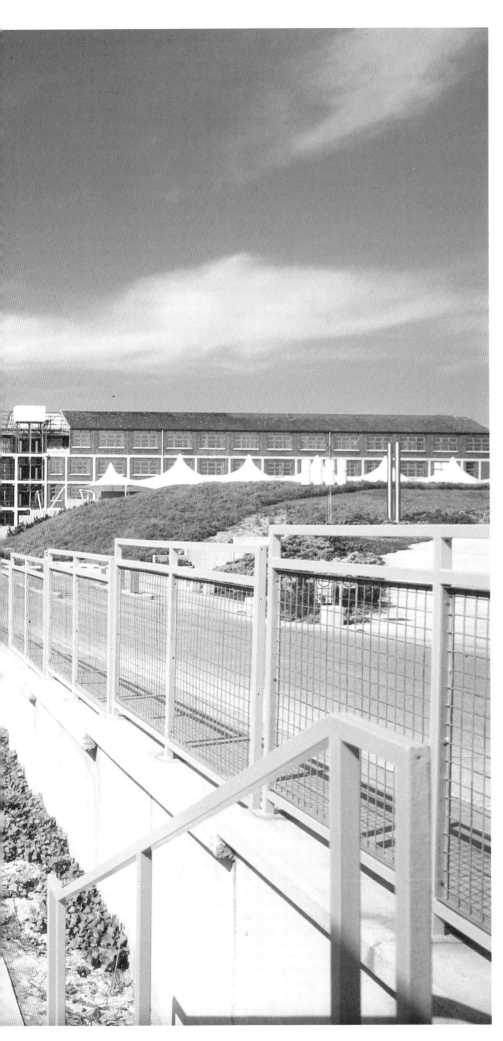

Fig. 91. Front view

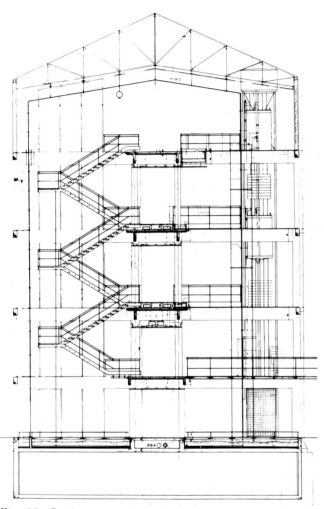

Fig. 92. Section
Fig. 93. Side view

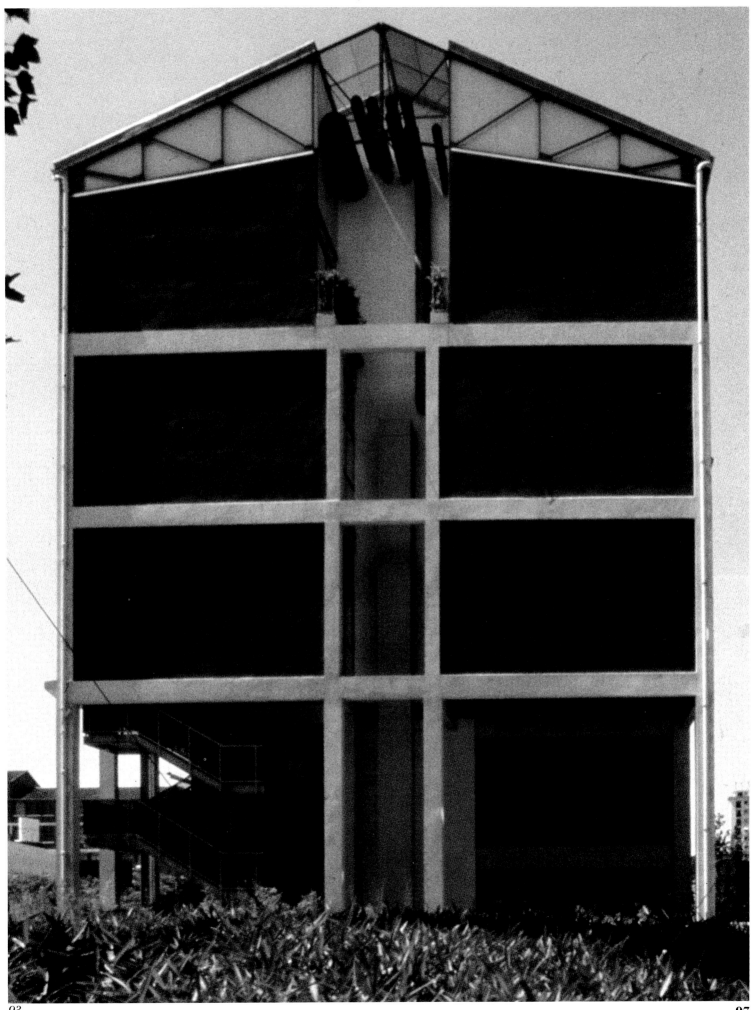

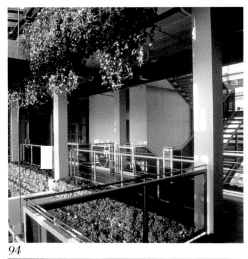

94

95

96

Fig. 94, 95, 96, 97. Interior views

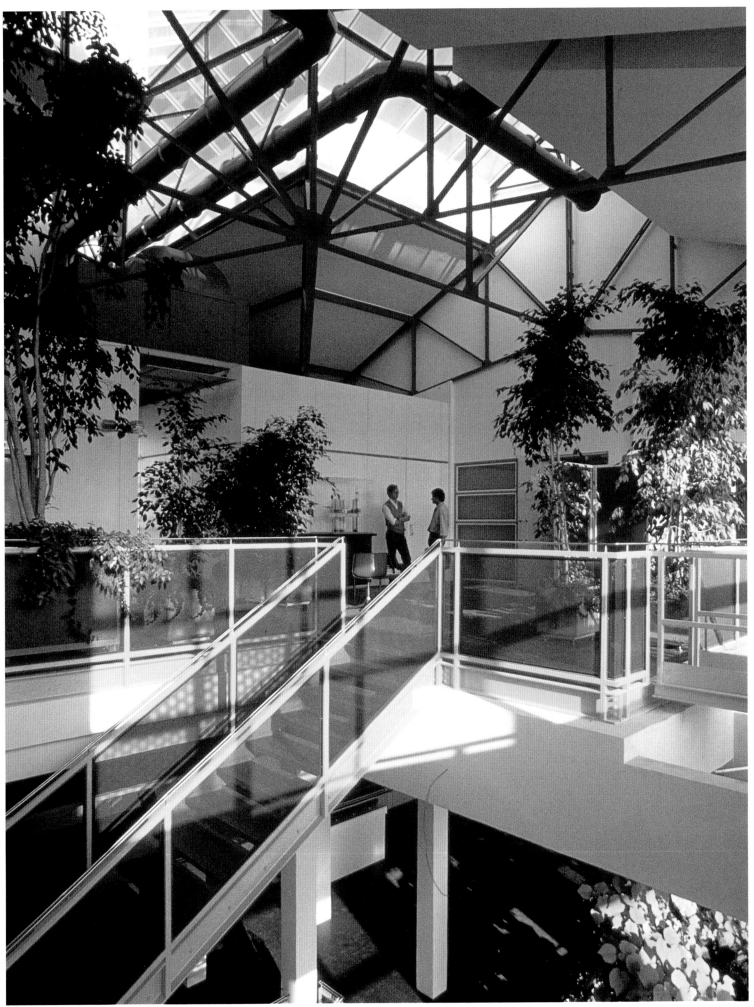

Fig. 98. The building and gardens

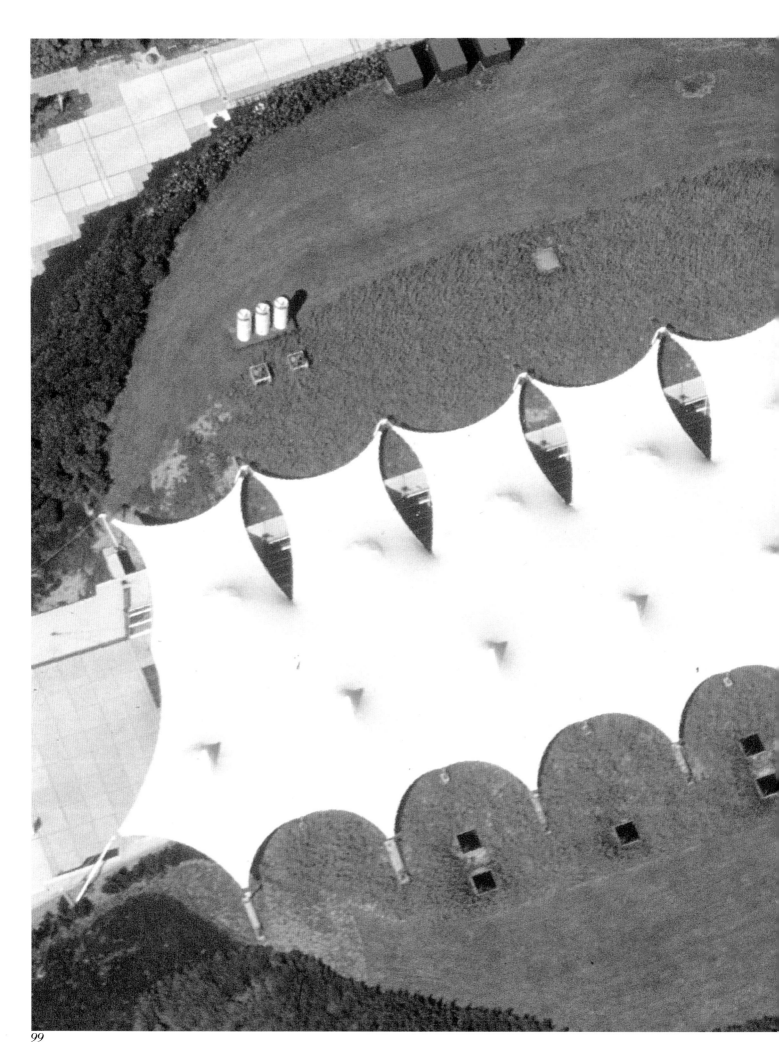

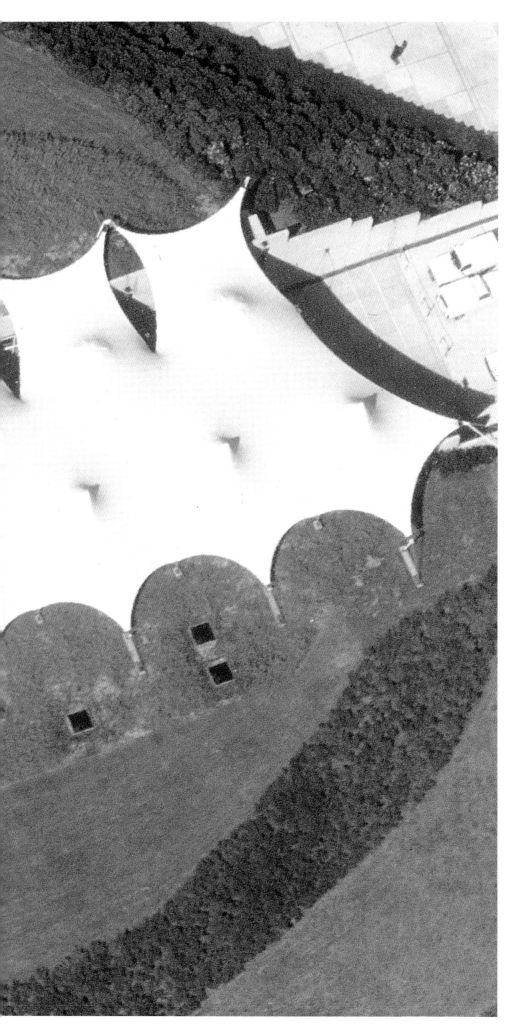

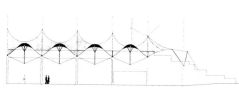

Fig. 99. The tensostructure from above
Fig. 100. Tensostructure, section

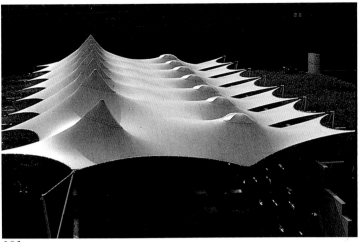

101

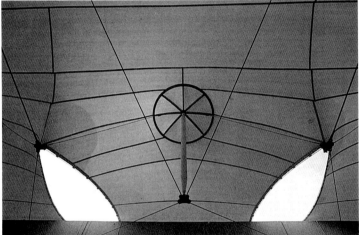

102

Fig. 101. The tensostructure

Fig. 102, 103. Tensostructure, details

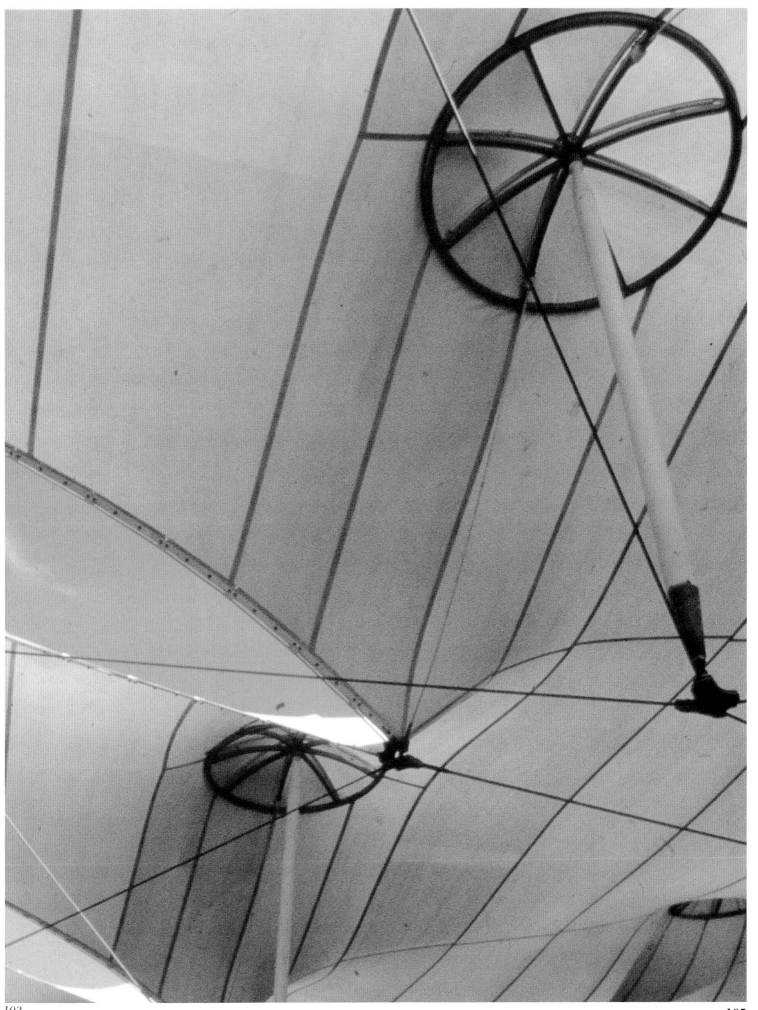

Fig. 104. Schlumberger park

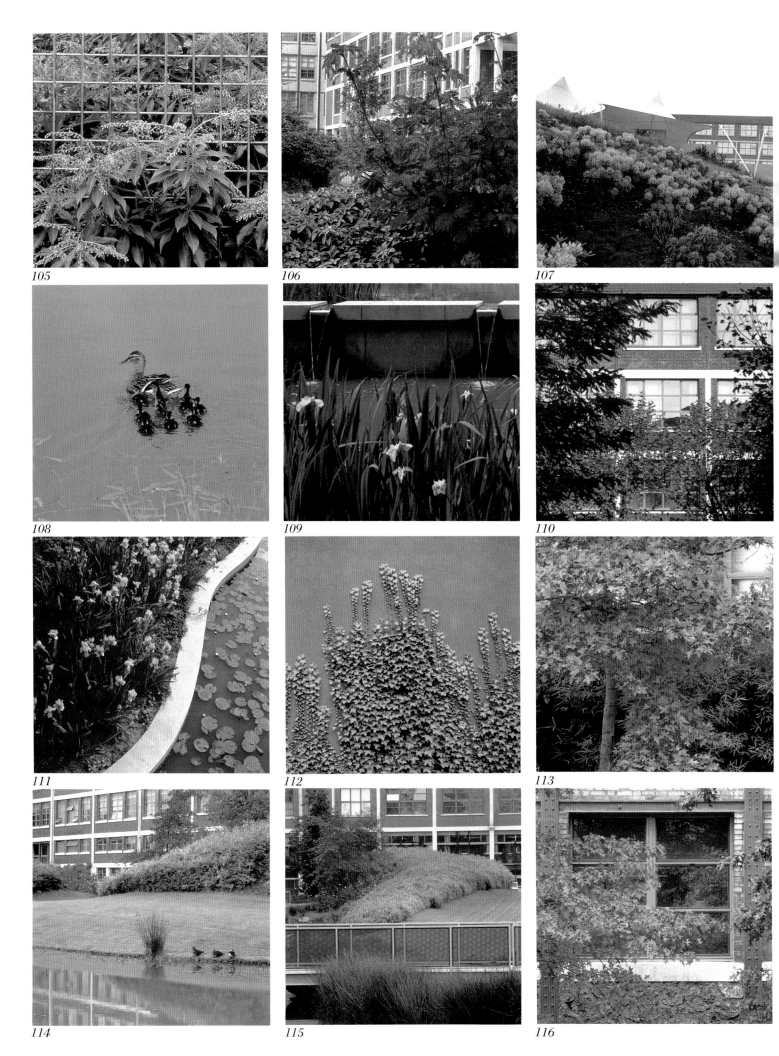

105

106

107

108

109

110

111

112

113

114

115

116

Fig. 105—116. Schlumberger park
Fig. 117—120. Drawings showing change
of seasons in the park

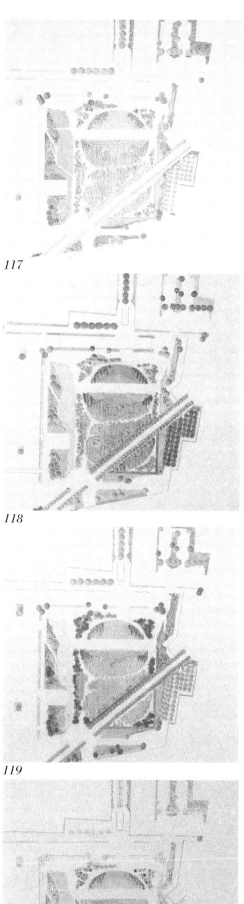

117

118

119

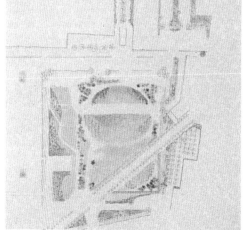

120

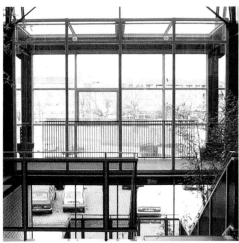

Fig. 121. Views of external approach
Fig. 122. Interior

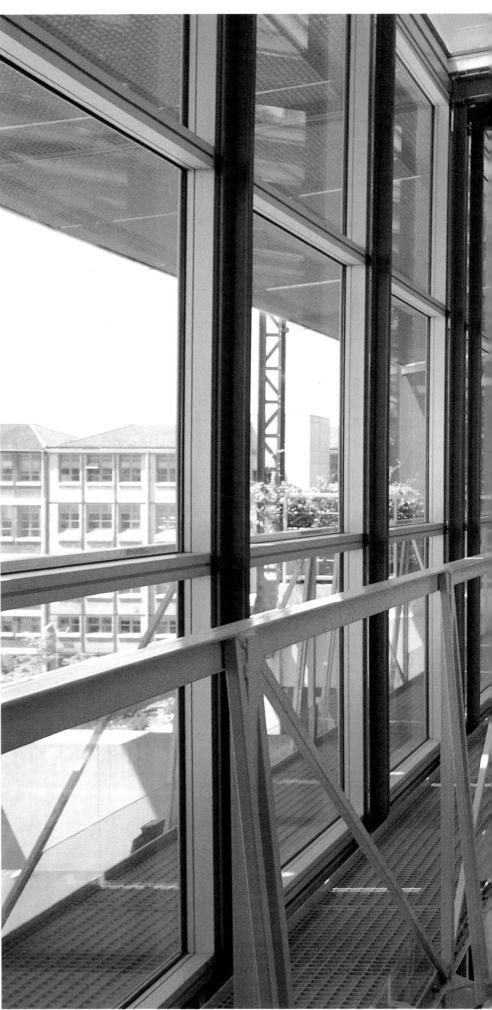

122

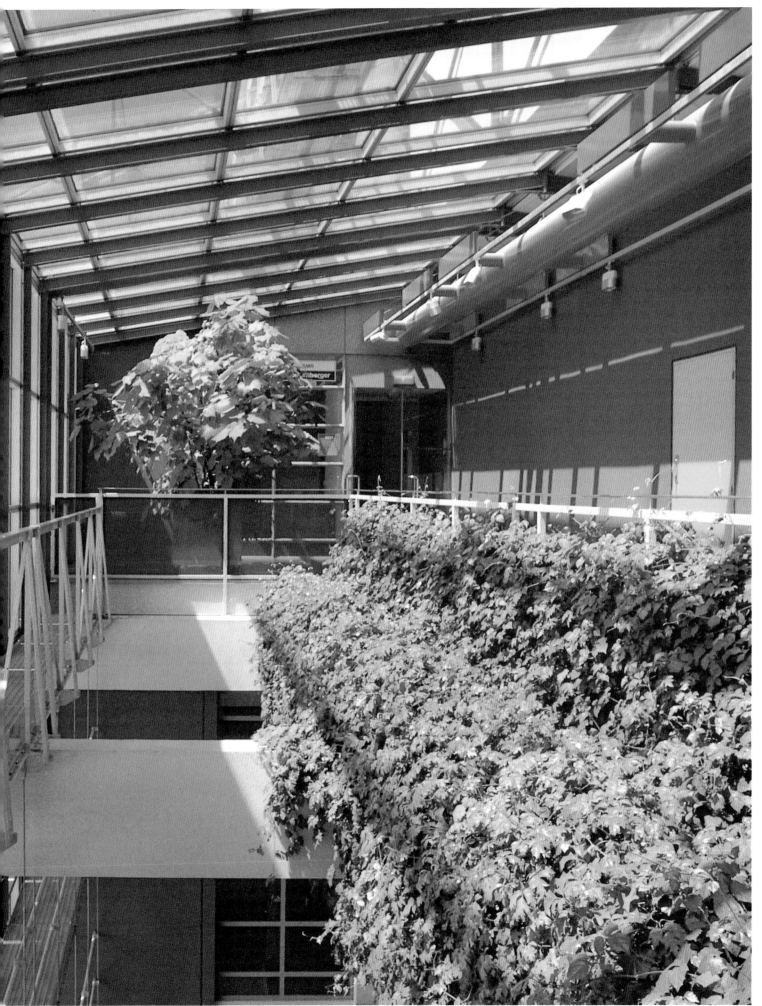

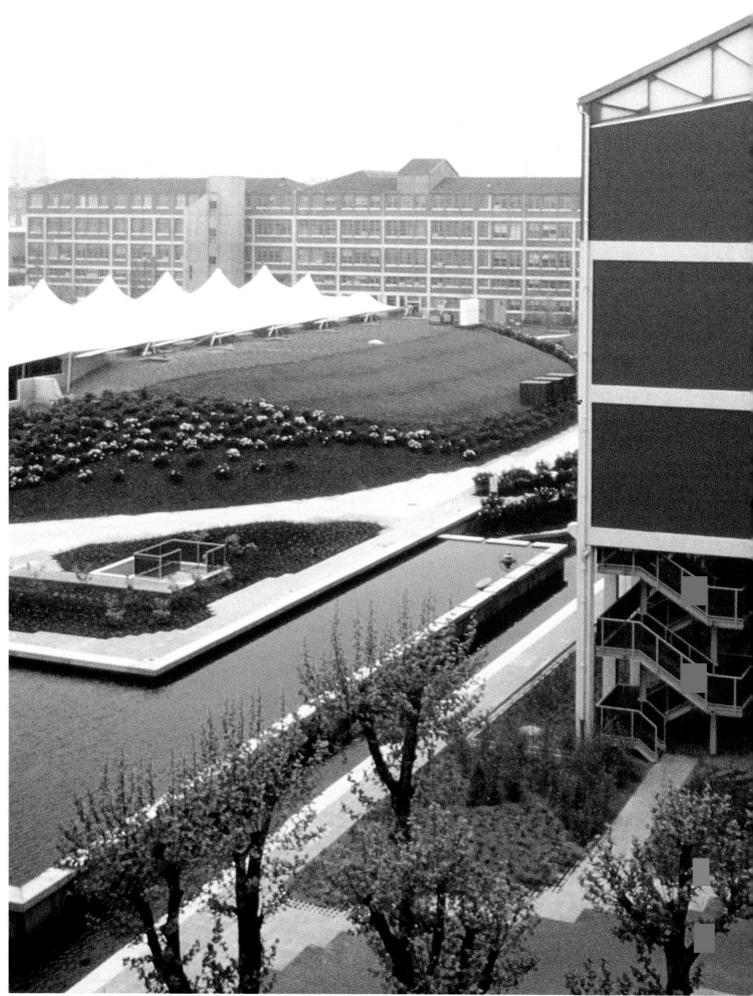

Fig. 123. Side view

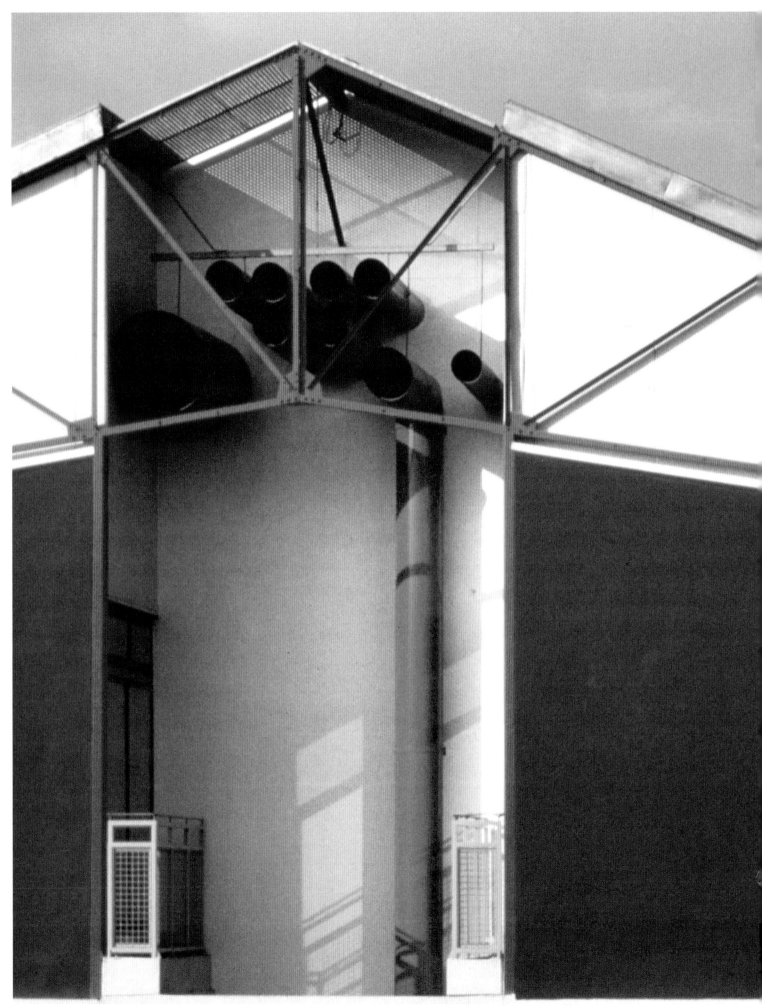

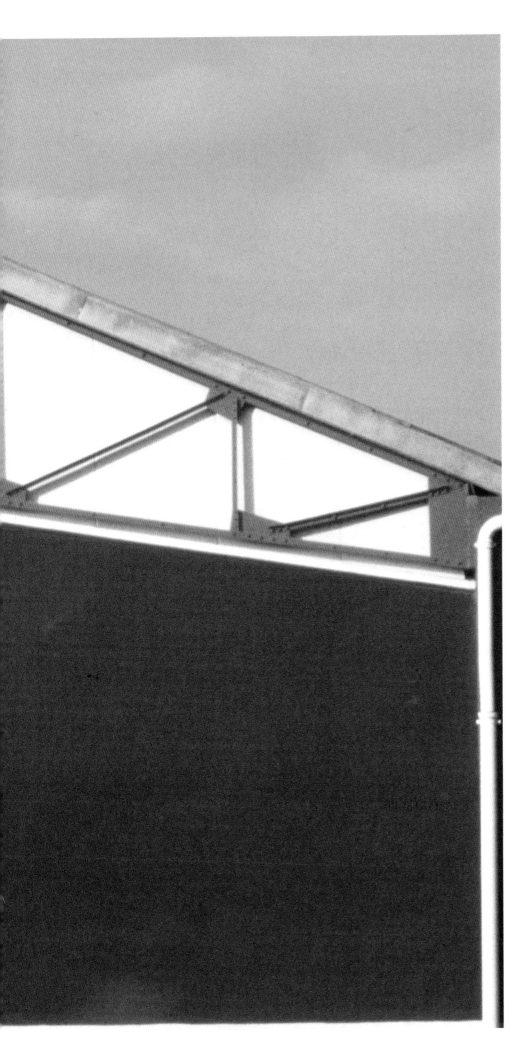

Fig. 124. Roof detail

125

126
Fig. 125, 126. Exterior details
Fig. 127. Interior circulation

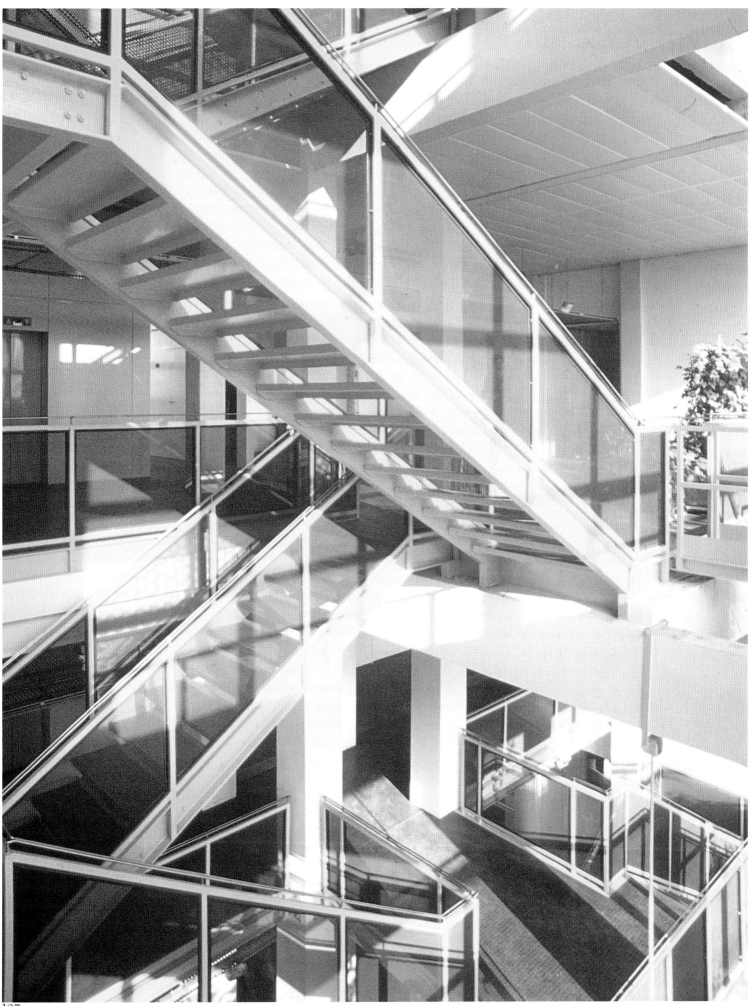

127

Fig. 128. The building and the park

The Menil Collection Museum
Houston, 1981–1986

Fig. 129. Site plan
Fig. 130. Detail of museum showing ferrocement "leaves"

In 1981 Dominique de Menil entrusted Renzo Piano with the design of a new museum in Houston for the Menil Collection, one of the most important collections of surrealist and primitive African art in the world. The museum opened in April 1987.

Here the aim of the design was to create a space facilitating a direct and relaxed relationship between visitors and exhibited objects by creating a nonmonumental, familiar environment open to contact with nature.

The building is sited in a green 19th-century residential area in Houston where, together with the other already existing buildings, it forms a sort of "Village Museum." The main building harmonizes with the other smaller houses because of its low outline and the "balloon frame" treated timber of the outside walls.

The solution of having natural lighting in the exhibition rooms gives the building its architectural character: a one-inch thick ferrocement "leaf" supported by a ductile iron structure is repeated 300 times across the top of the building, acting as a filter to solar heat and light. The profile of this element ensures that the works of art displayed are not directly struck by sunlight and creates an ever-changing environment that reflects the natural conditions outside.

An accurate study of solar angularity conditions—the filtering of ultraviolet rays, multiple refraction, etc.—was carried out with an appropriate "solar machine."

The lighting is indirect and natural, maintaining the outer variations within the building.

In addition to these studies, experiments were made with several structural materials that resulted in the "leaf" device for modulating both artificial and natural light.

These "leaves," cast in 1-inch-thick ferrocement and especially shaped, regulate the light admitted into each exhibition bay through a glass platform.
Continued on page 128

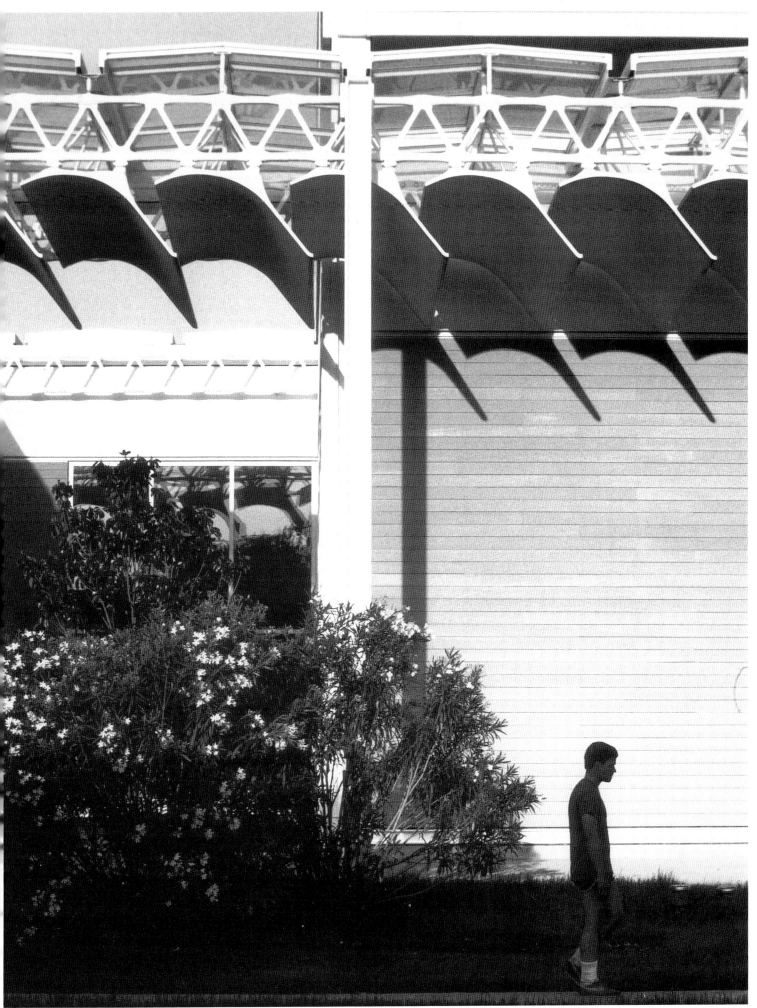

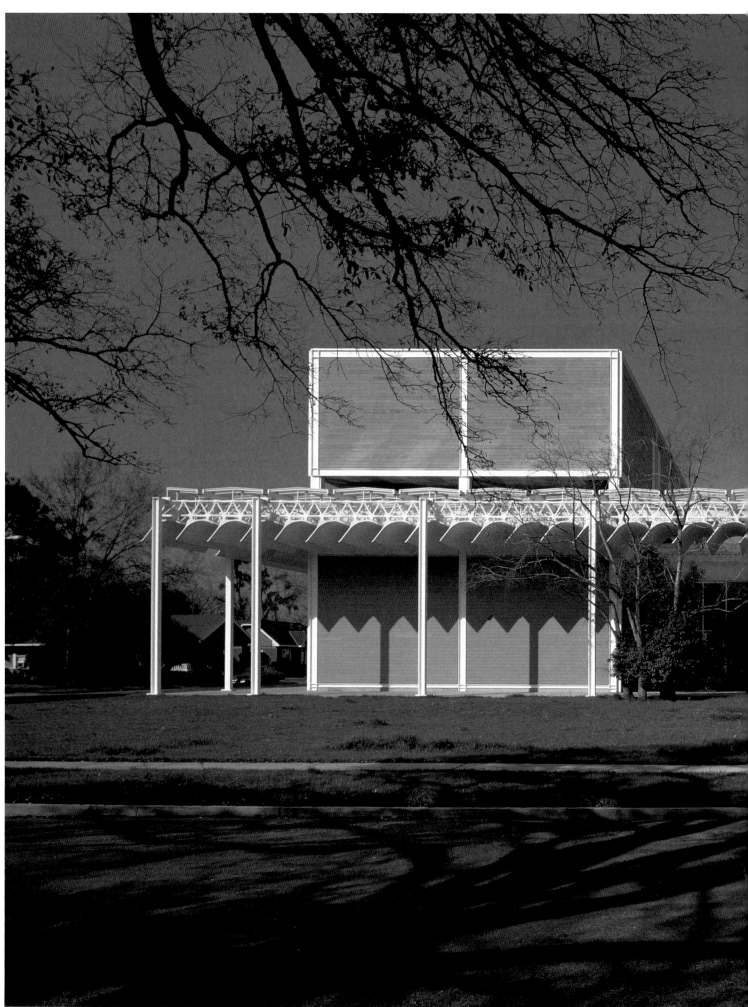

Fig. 131. View of entry façade

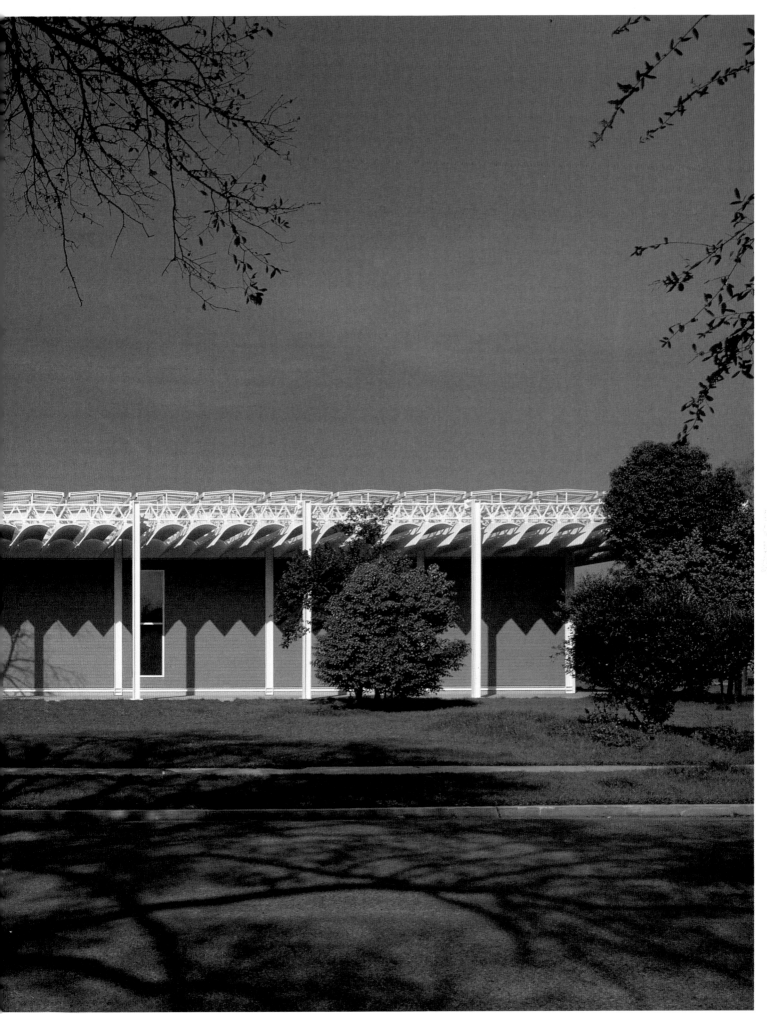

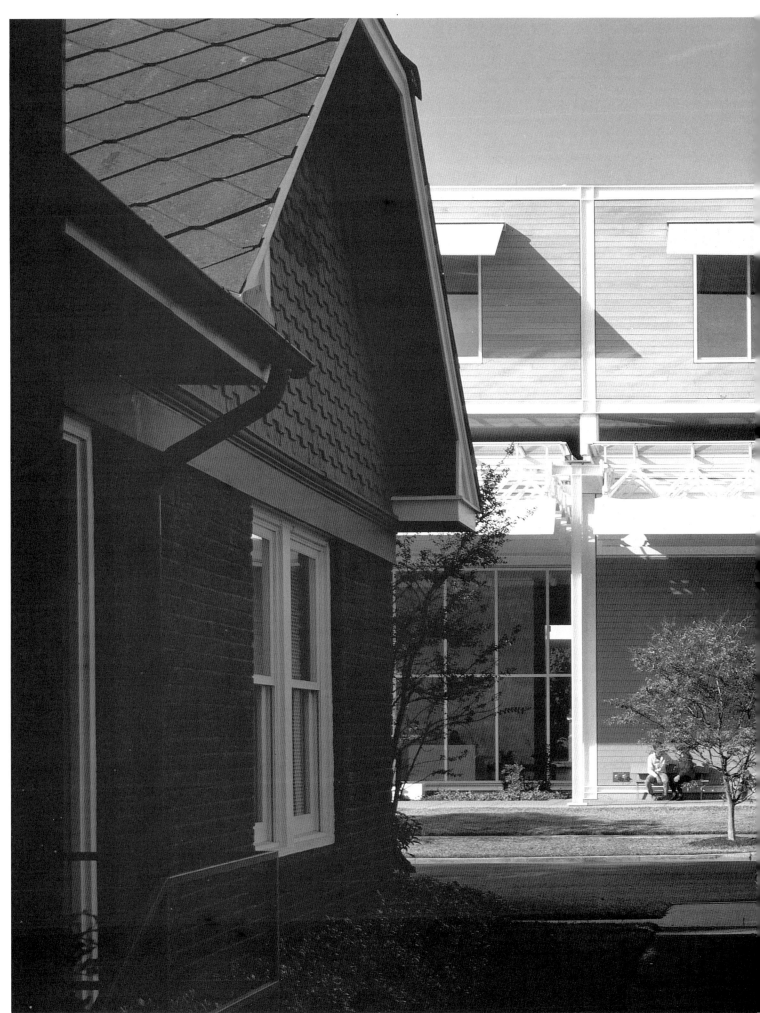

Fig. 132. *The museum seen from the neighboring houses*

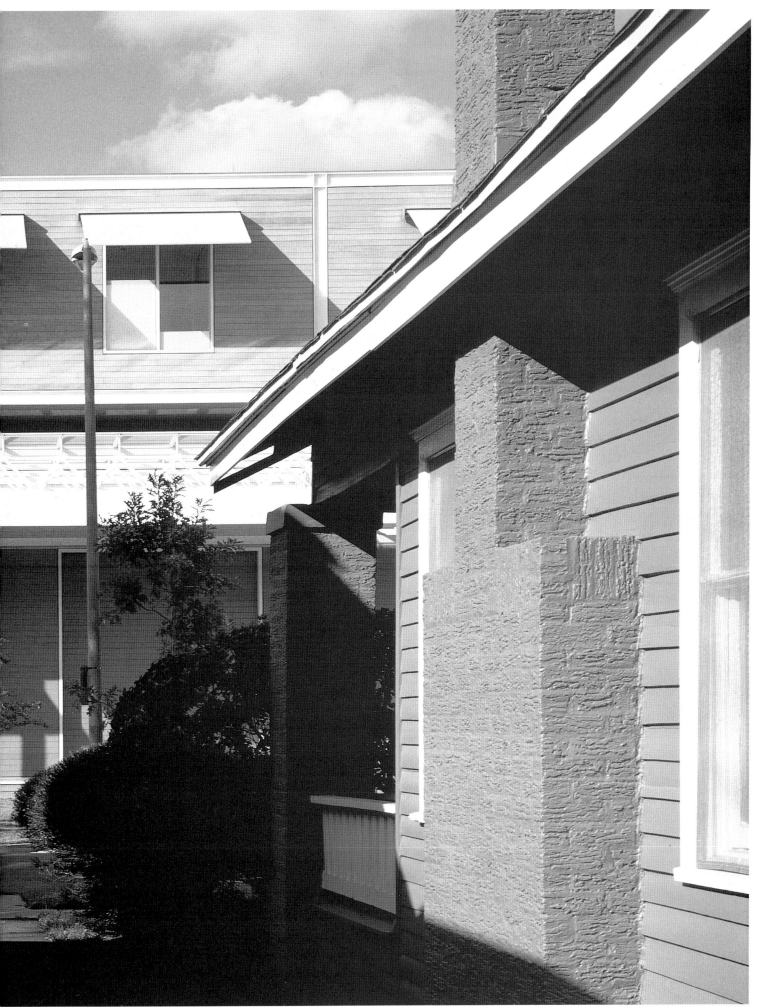

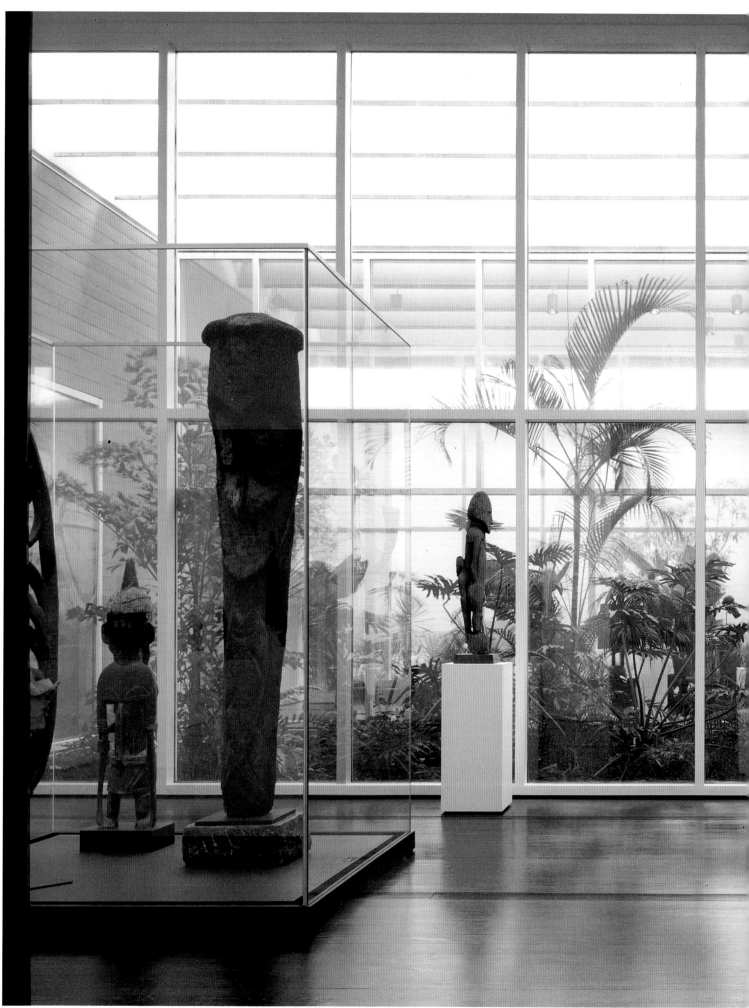

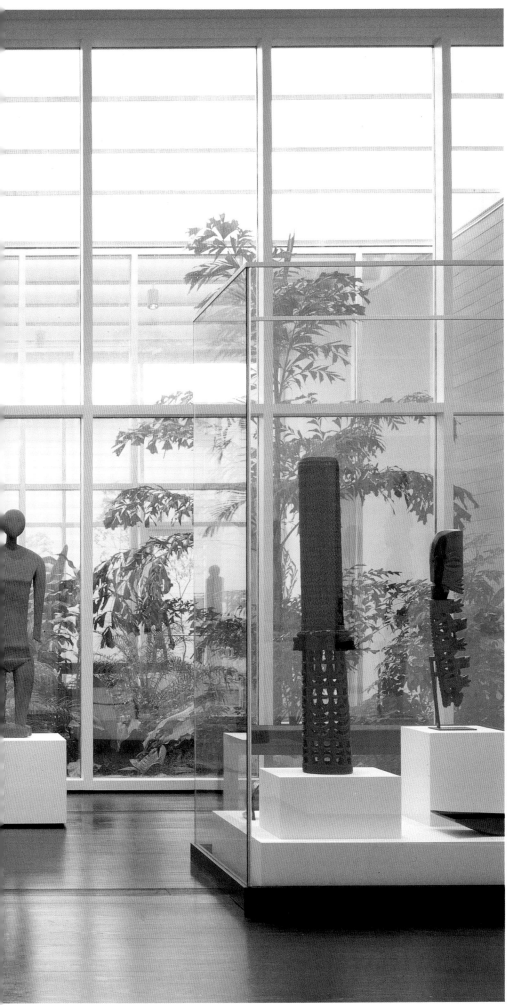

Fig. 133. One of the tropical gardens

The basic idea in this museum is to arrange the actual exhibition rooms on the ground floor, and leave the storage rooms (Treasure House) well separated upstairs. The objects are never exhibited all together. Only 200 to 300 at a time are brought down to the ground floor to be exhibited and are rotated quite often.

This scheme is scientifically very important as it allows the works of art to be maintained in the best environmental conditions possible for preservation (humidity, temperature, light, etc.) according to the specific type of material concerned (wood and stone sculpture, tapestries, canvas work, etc.). In this way the few works exhibited can be enjoyed by visitors in the best conditions without suffering damage.

The Treasure House is not isolated from the museum. It can be visited. Guided visits are recommended because of the special requirements with regard to humidity, temperature, etc.

The logic of the building is related to nature: the platform protrudes from the building façade because it makes sense to have pedestrian paths sheltered from sun and rain. The tropical gardens have been arranged in such a way that plants and trees may grow through the building, showing the importance of a true relationship between the building and the surrounding nature.

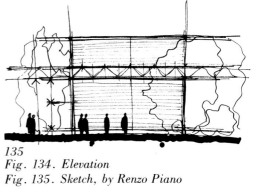

135

Fig. 134. Elevation
Fig. 135. Sketch, by Renzo Piano

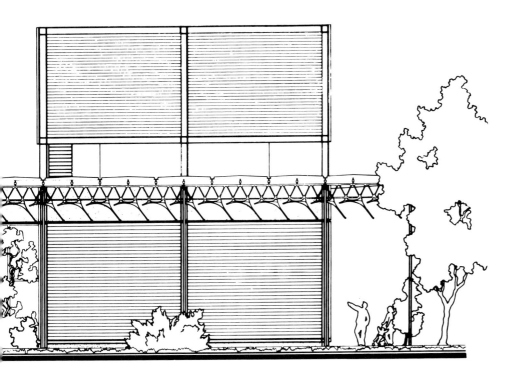

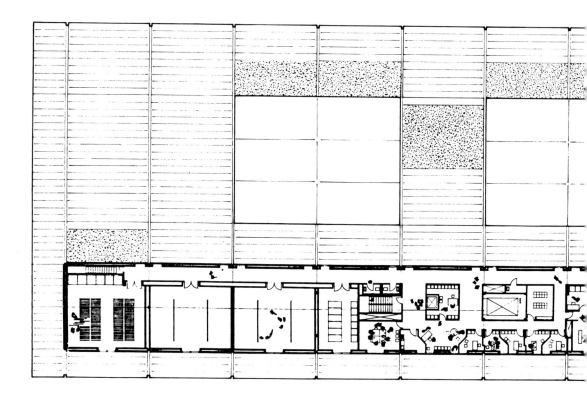

136

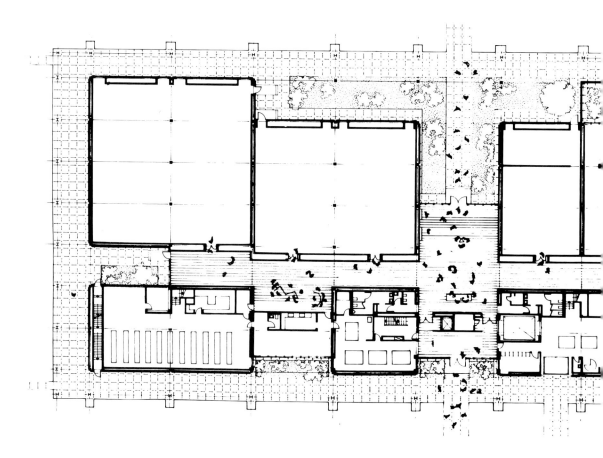

137

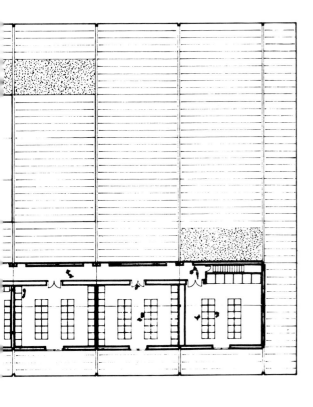

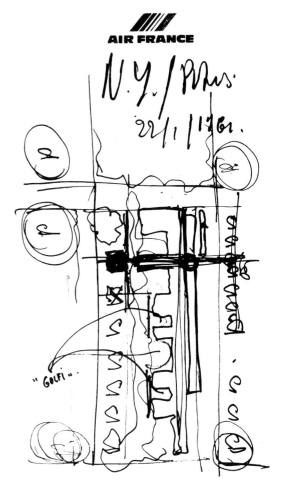

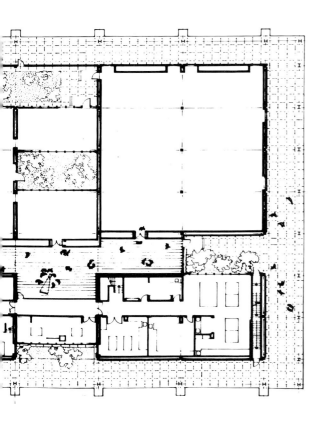

138
Fig. 136. Treasure House, plan
Fig. 137. Floor plan
Fig. 138. Sketch, by Renzo Piano

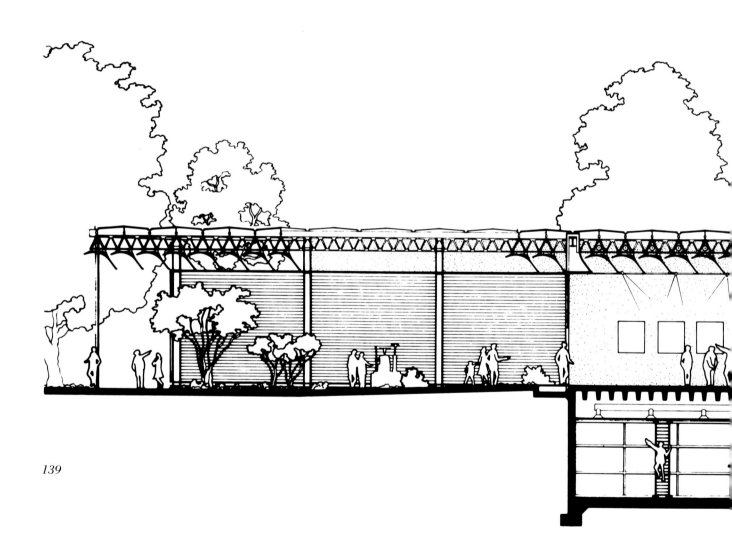

139

140
Fig. 139. Longitudinal section
Fig. 140. Partial section

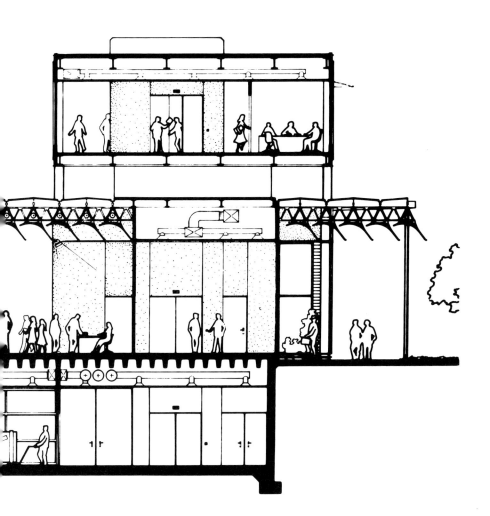

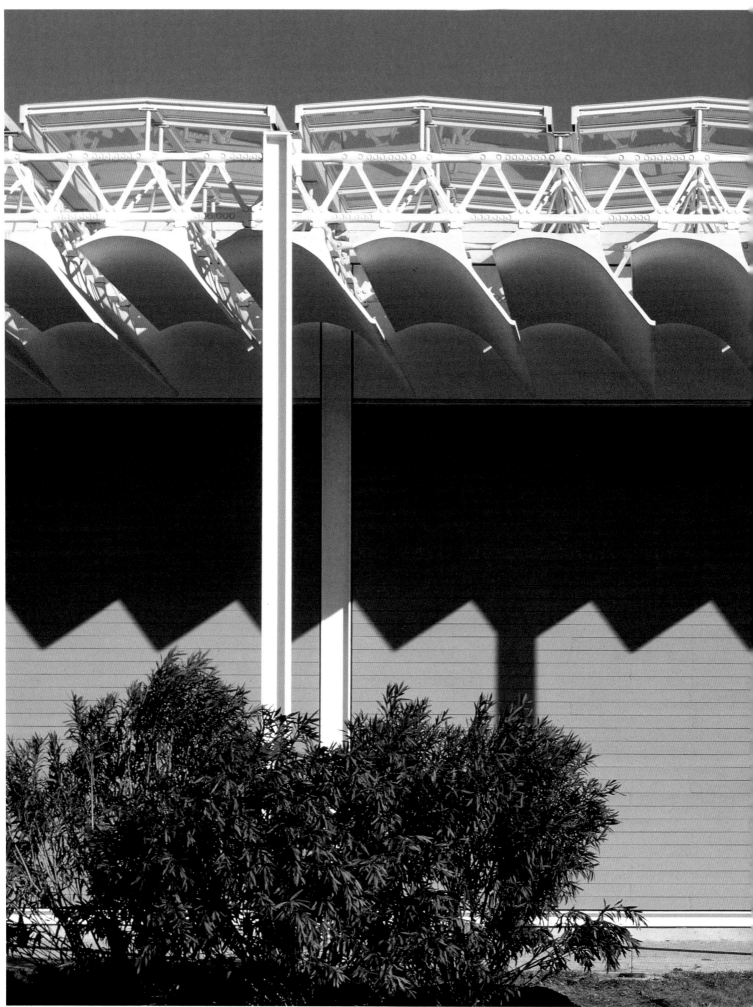

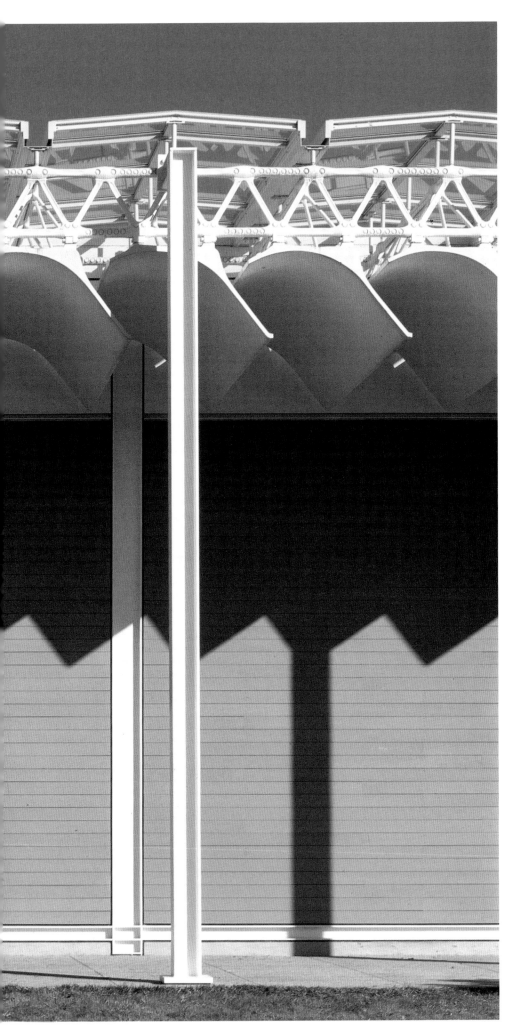

142

Fig. 141. Exterior walkway shaded by "leaves"

Fig. 142. Exterior façade detail

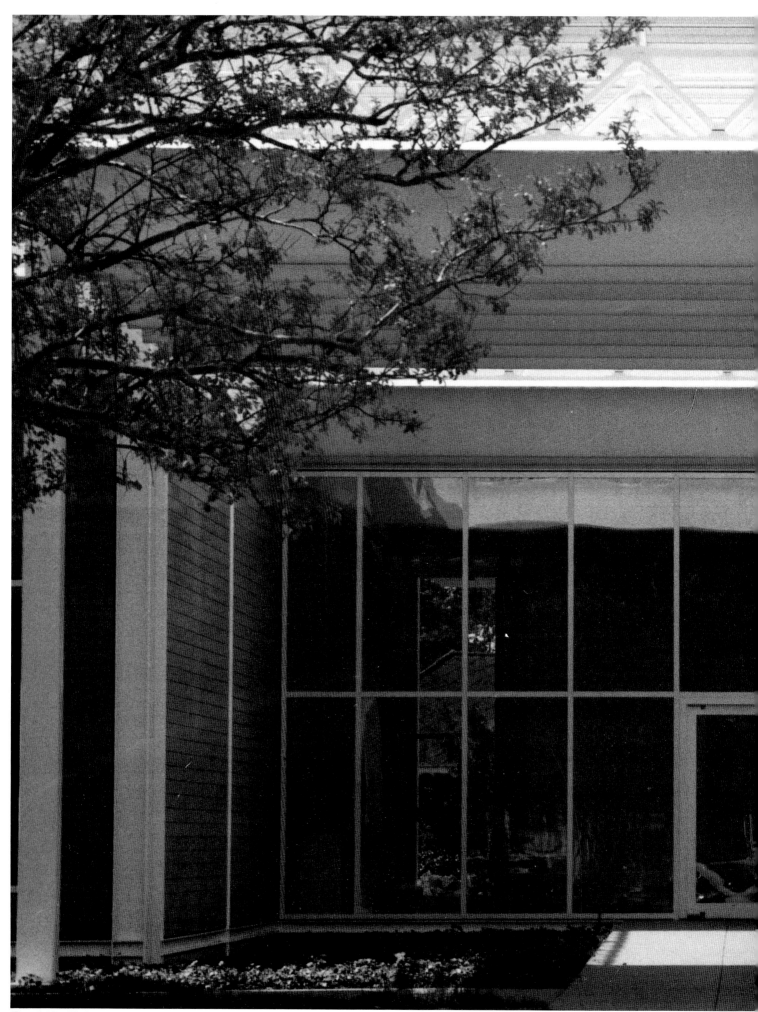

Fig. 143. Main entrance

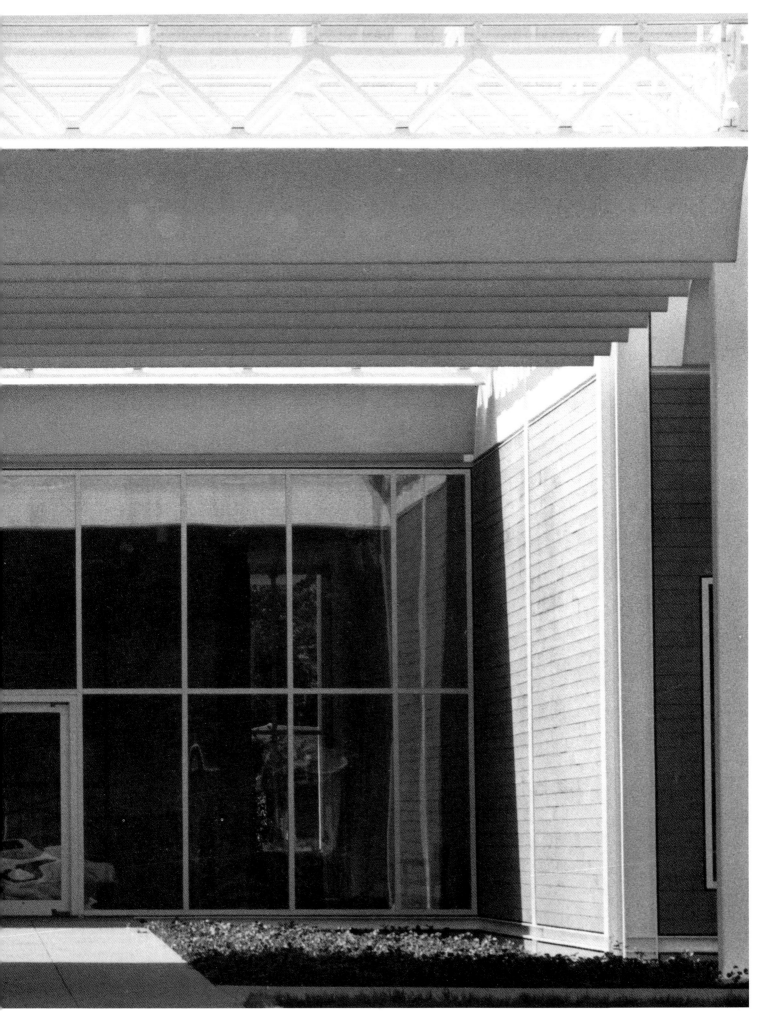

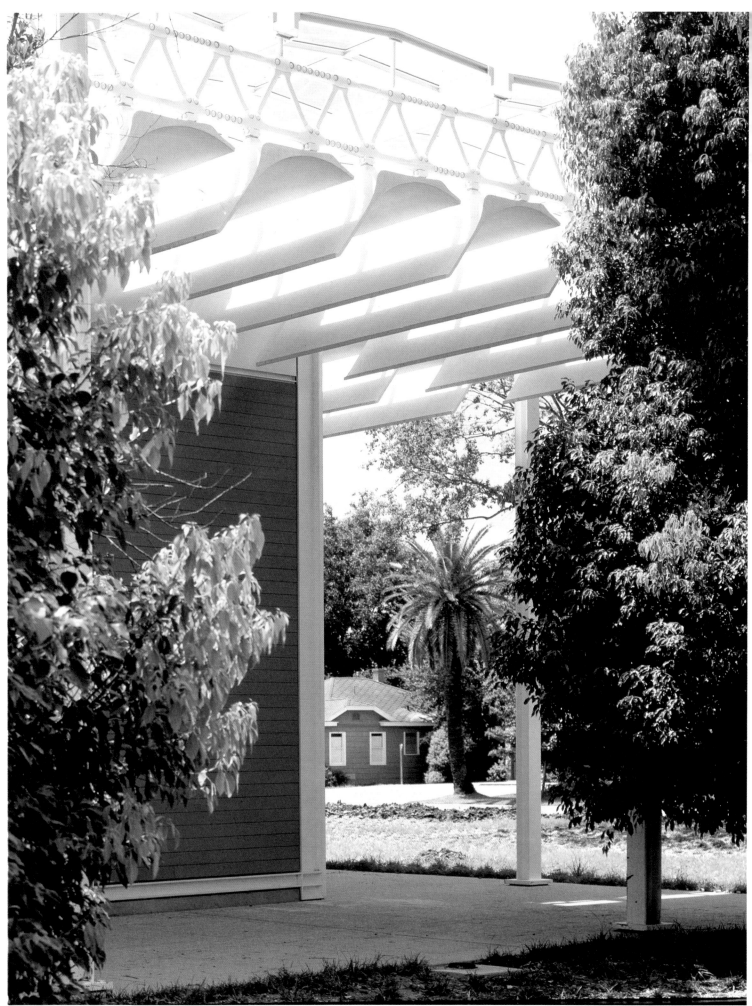

145

146

147

Fig. 144. The museum, with a foreshortened
view of the "Village Museum"
Fig. 145, 146, 147. Preexisting houses
surrounding the museum

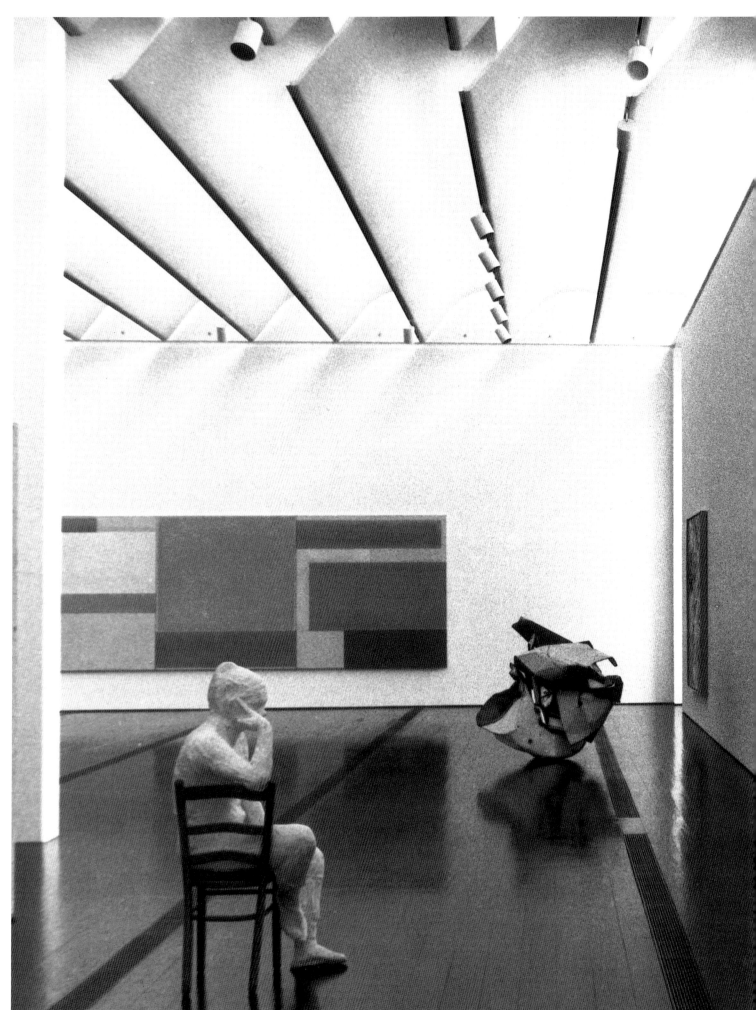

Fig. 148. One of the galleries

Fig. 149. One of the galleries

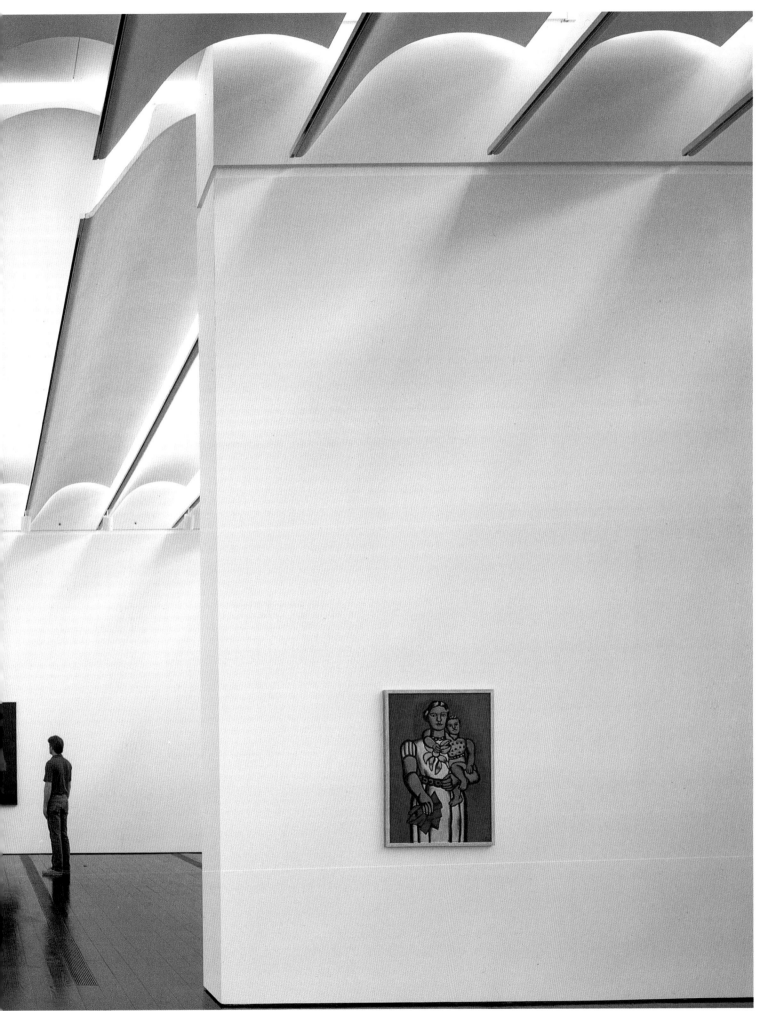

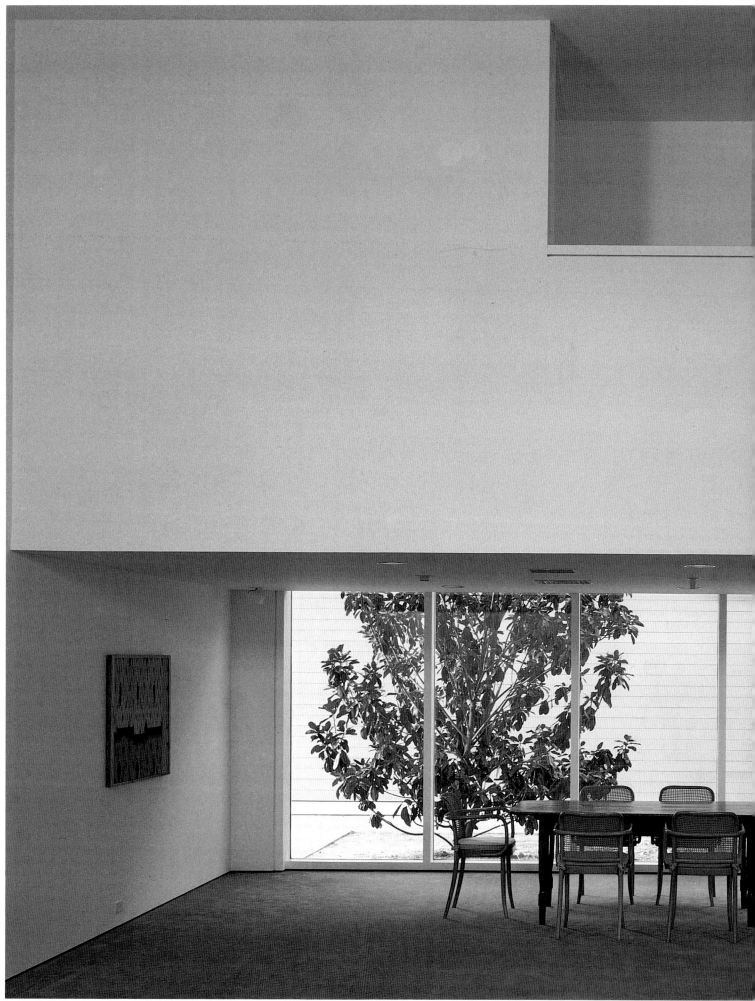

Fig. 150. The library

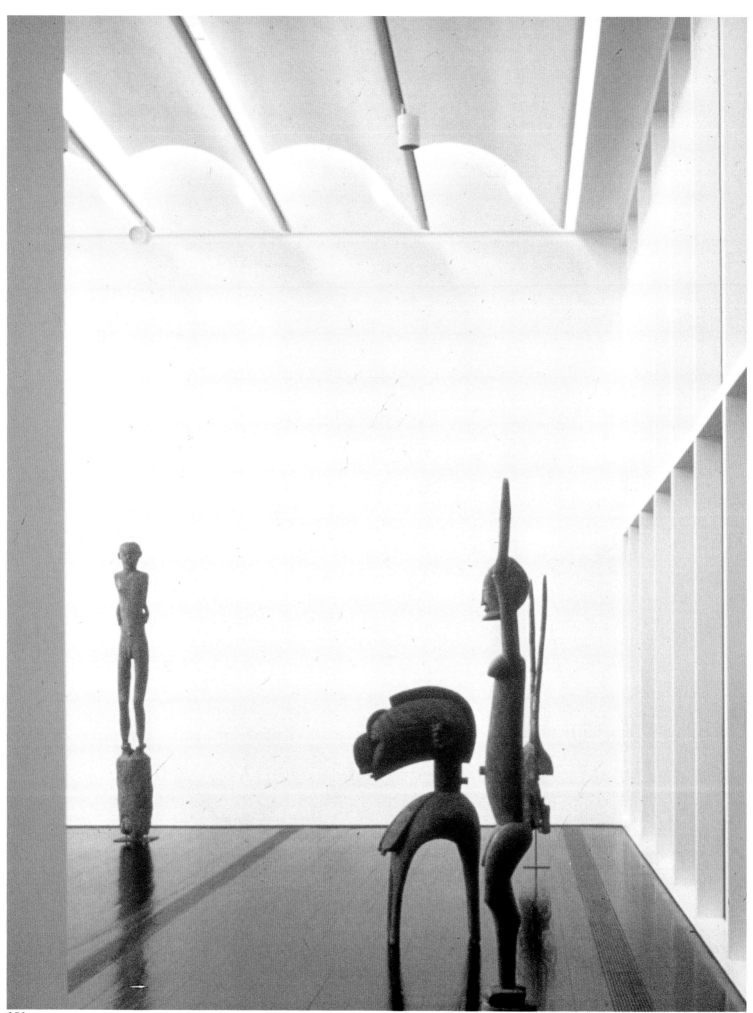

151

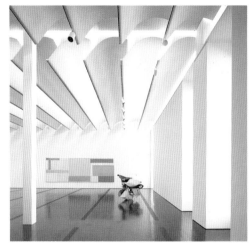

152

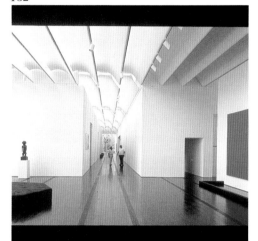

153

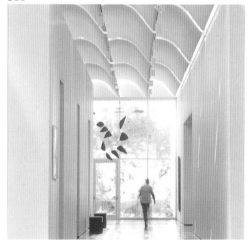

154
Fig. 151. One of the galleries
Fig. 152, 153, 154. Interior views of the
museum

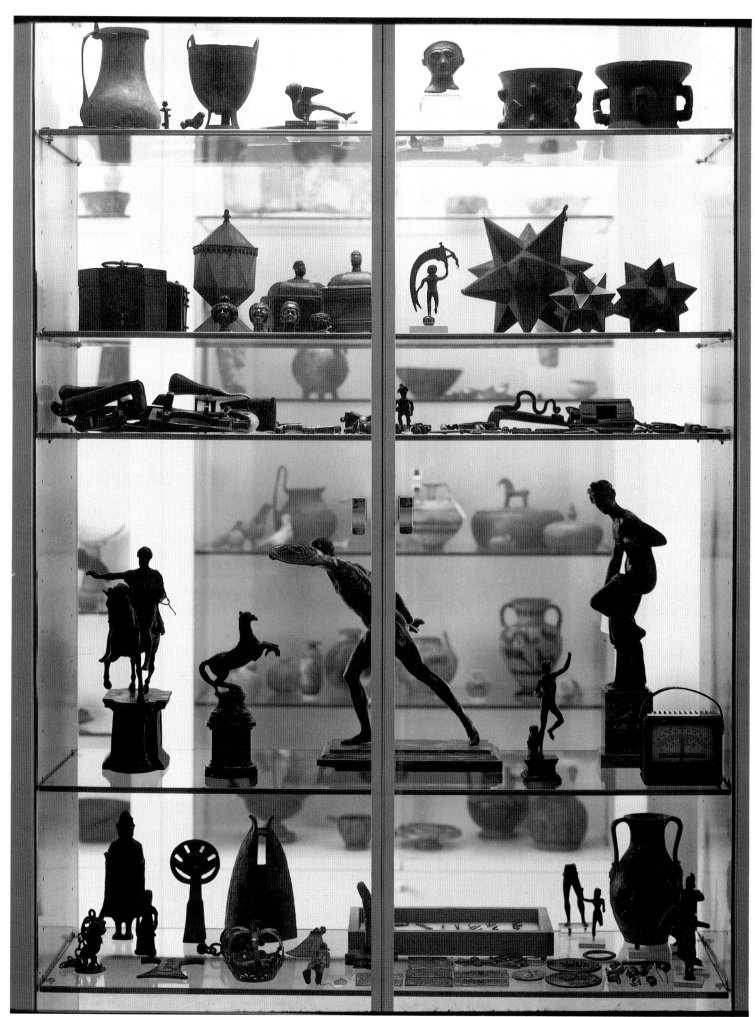

Fig. 155. Ancient and primitive art objects in the Treasure House

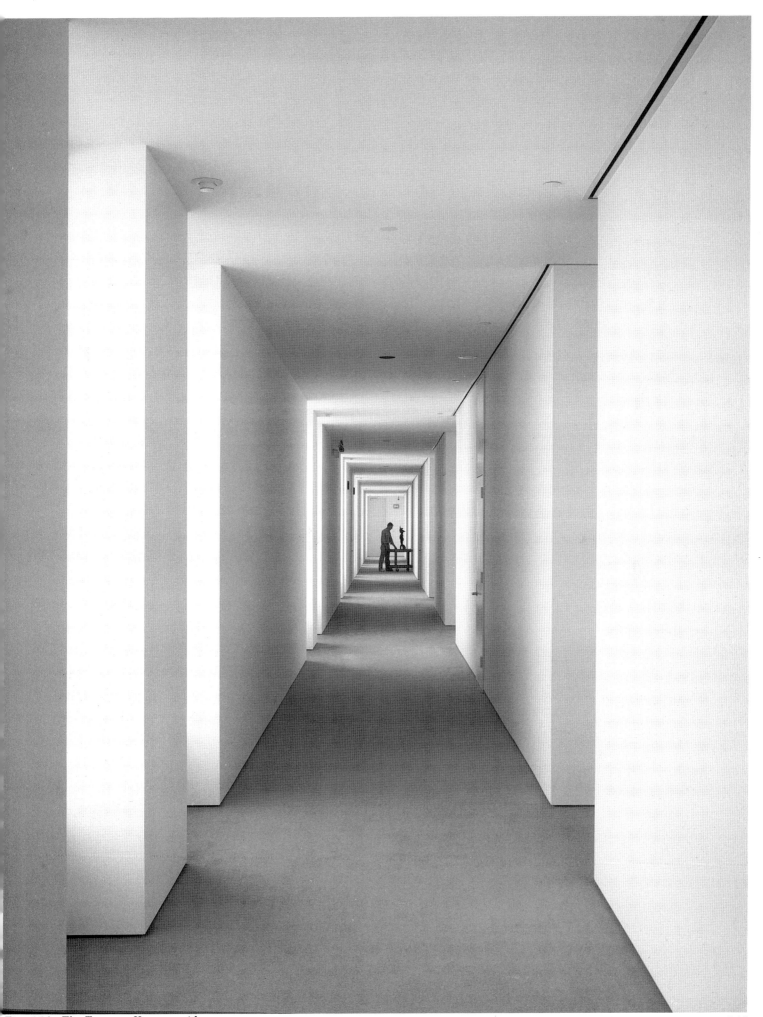

Fig. 156. The Treasure House corridor

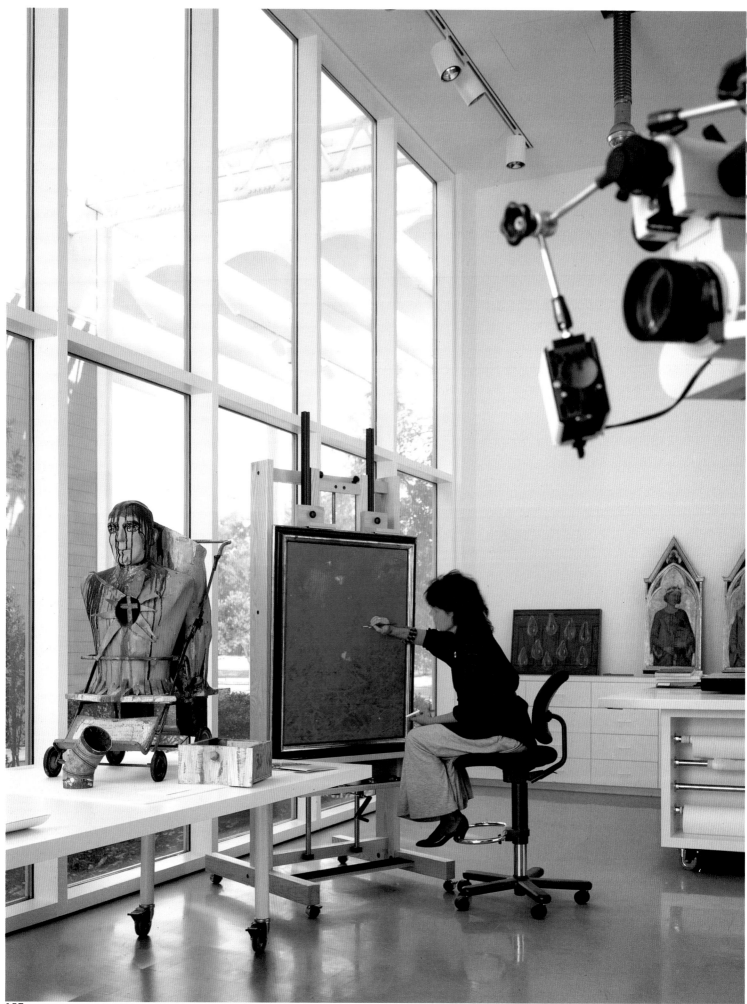

158

159

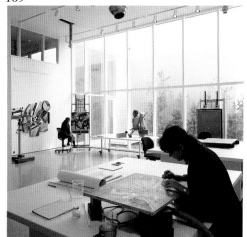

160

Fig. 157, 158, 159, 160. The conservation laboratories

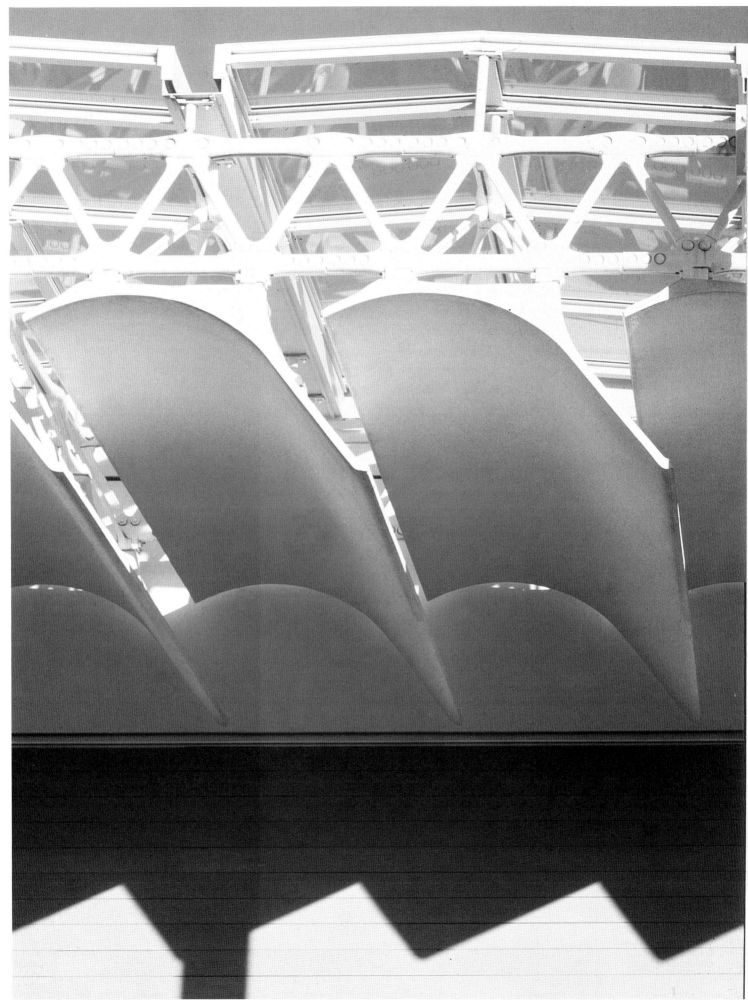

Fig. 161. Close-up view of the ferrocement "leaves"

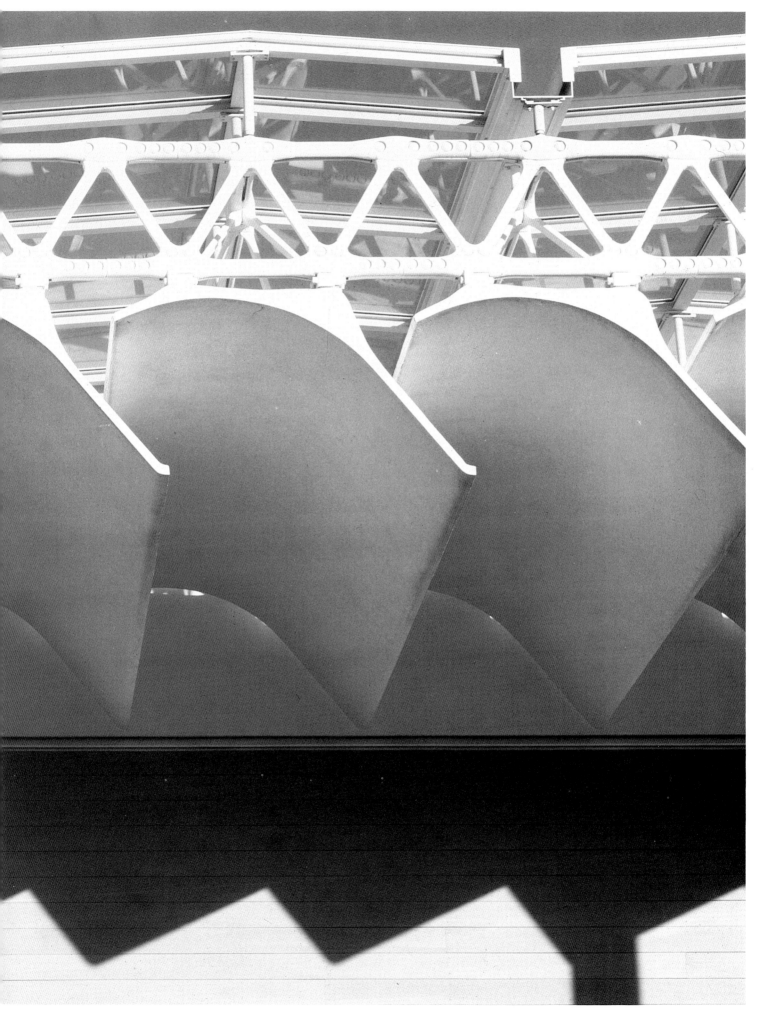

Reuse of Palazzo a Vela for the Calder Exhibition

Turin, 1982

162

163

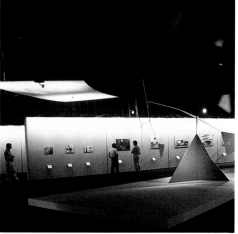

164

This project for the reuse of the wide hall of Palazzo a Vela in Turin made it possible to organize a retrospective exhibition of Alexander Calder's works. Rather than working out an architectural project, the idea was to exploit the existing space by acting directly on immaterial elements such as lights, sounds, and routes.

The project consisted of achieving a sort of microcosm wherein Calder's mobiles could move without restraint to give freedom to the oscillatory movements of the constellations of wire and metal leaves.

In architectural terms, the point was to change the perception of space inside the building by eliminating the excessive light from the large glass windows, thus obtaining a dusky atmosphere. Mobiles hanging from the ceiling, raised from the floor, or laid in showcases could then be clearly seen, illuminated by beams of light of a given intensity so as to obtain specific effects. A further idea was to blow fresh air from the floor toward the ceiling in order to make the mobiles oscillate gently.

The routes for visiting the exhibition—starting and ending in the park— followed a sort of fan shape divided into segments, each of which corresponded to a different production stage of the artist.

In the central focus were two huge revolving mobiles that acted as reference points for visitors, facilitating tours of the exhibition.

Fig. 162. View from the top of the Palazzo
A Vela
Fig. 163, 164. Interior views
Fig. 165. Site plan
Fig. 166. Comprehensive view of the
exhibition

165

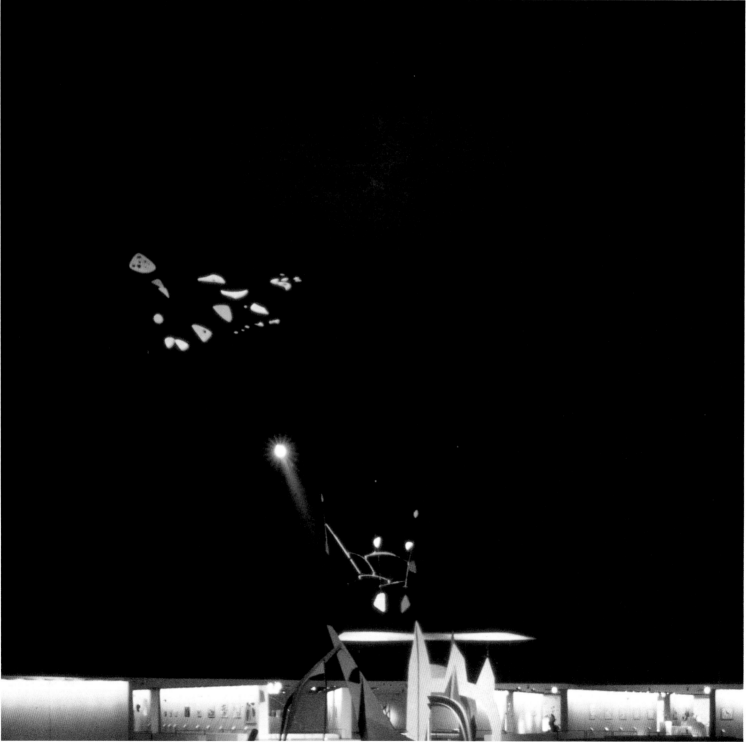

166

An Office Building
Montecchio, Maggiore (Vicenza), 1984–1985

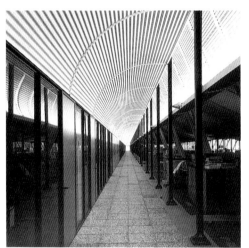

Fig. 167. Reflected and indirect lighting in the corridor
Fig. 168. Exterior at night

Lowara is an Italian firm manufacturing electric pumps. Its new headquarter offices are conceived of as an open space enhancing contacts among employees at work.

This principle is perfectly represented by an open work place where people can easily cooperate and compare their work without physical barriers.

The office environment is placed at the same ground level as the manufacturing bays. On the rectangular-shaped open space the offices are arranged according to their functions. The sector dealing with external relations has been located near the entrance, while the technical sectors needing greater privacy have been arranged at the very end of the premises.

The ceiling (23 ft. at its highest point, 8 ft. at its lowest point, 48 ft. span) looks suspended.

The assembly system adopted is such as to let the light flow in, thus increasing the sense of lightness of the building.

The roofing is supported by a number of V-shaped steel columns. It is completely independent of the existing building (approx. 492 ft. long).

A simple corrugated steel sheet, normally used for bridge building, was adopted for the roof, the steel sheet being used as a form into which the concrete can be poured. It thus became part of the total structure itself and at the same time acted as inside finish to the ceiling. The upturned eaves running along the low elevation that faces the garden help to frame the view of the landscape with a Palladian villa in the background.

The natural light entering the building at this elevation is softened and amplified by the corrugated steel sheeting of the ceiling. Such a gently curving ceiling helps confer a richer quality on the interior environment. The air-conditioning supply duct runs high, thus exploiting the dynamic space created by the suspended form of the roof. The return has been obtained through the raised floor.

The reception area (conference room, discussion rooms, dressing rooms, and toilets) has been placed parallel to the circulation. A reflecting panel was inserted into the gap at the top of the roof in order to soften the light coming from the south facing side to make a more pleasant corridor. Sprinklers have been fitted along the roof edge (key element of the whole project) in order to cool it by evaporation.

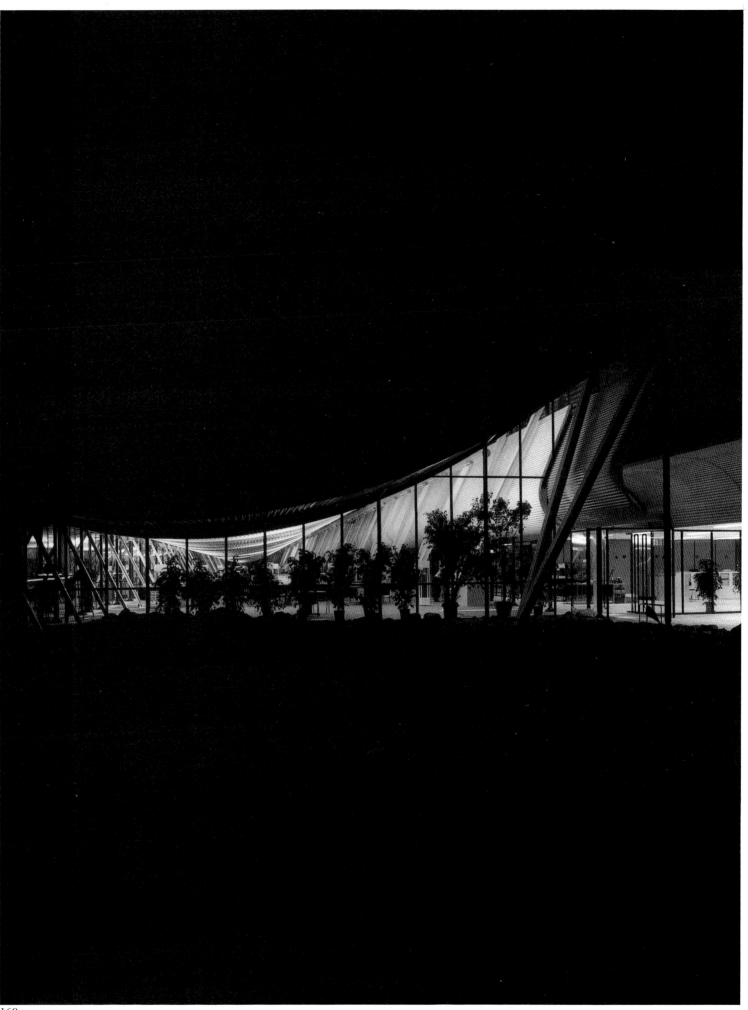

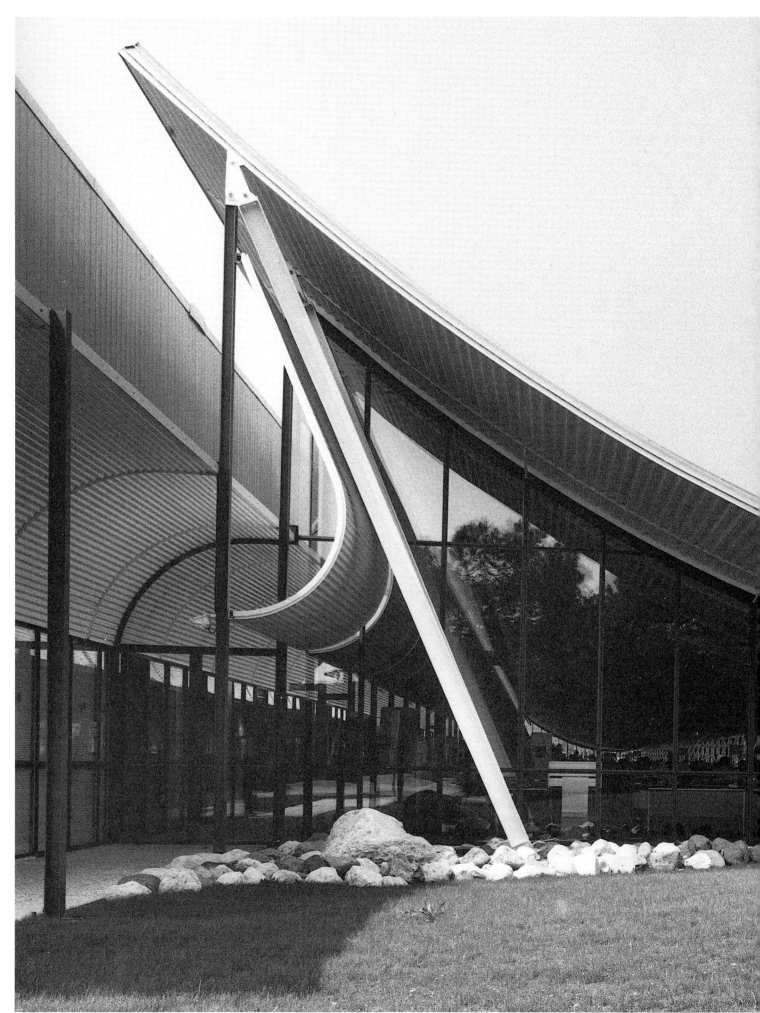

Fig. 169. Exterior, showing "suspended" corrugated steel roof

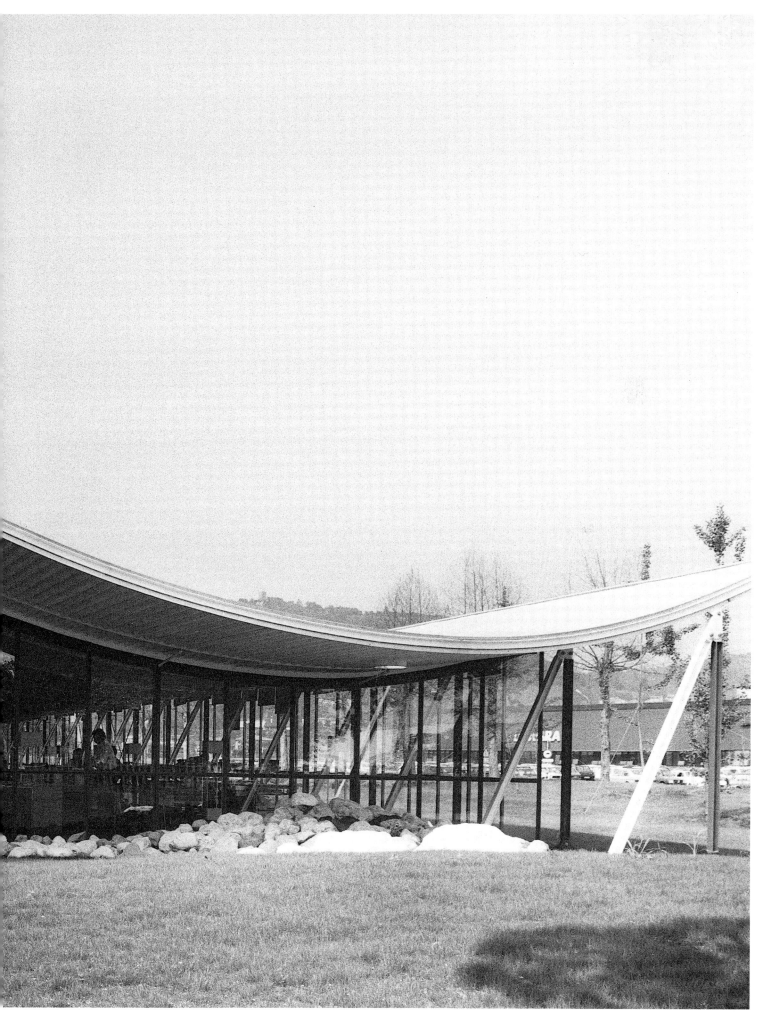

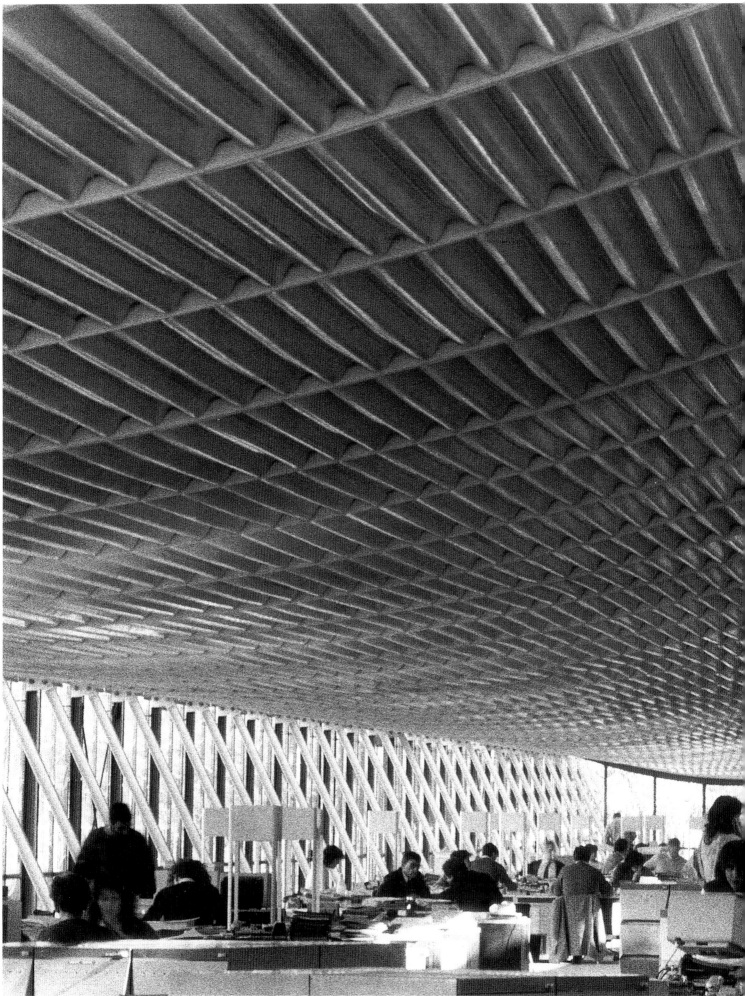

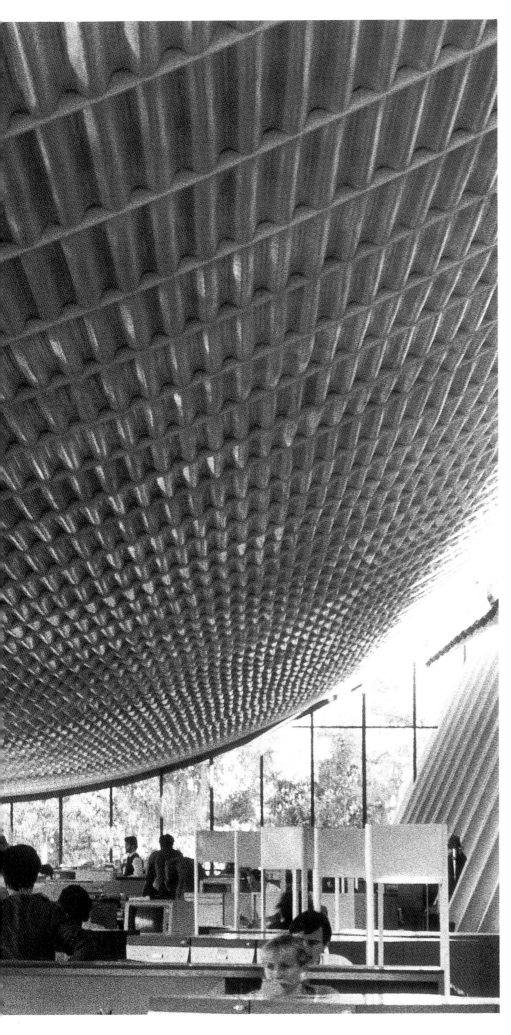

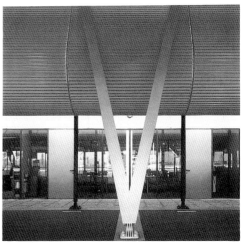

171

172

Fig. 170. An office space
Fig. 171. "V" shaped steel column
supporting the roof
Fig. 172. Column joint, detail

161

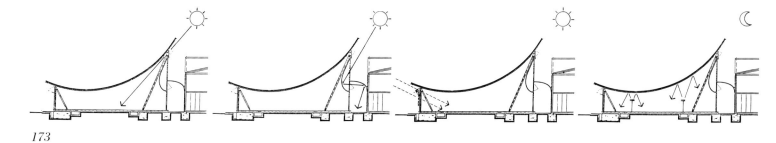

173

*Fig. 173. Ambient-light and natural-
climate-control diagrams
Fig. 174. Section*

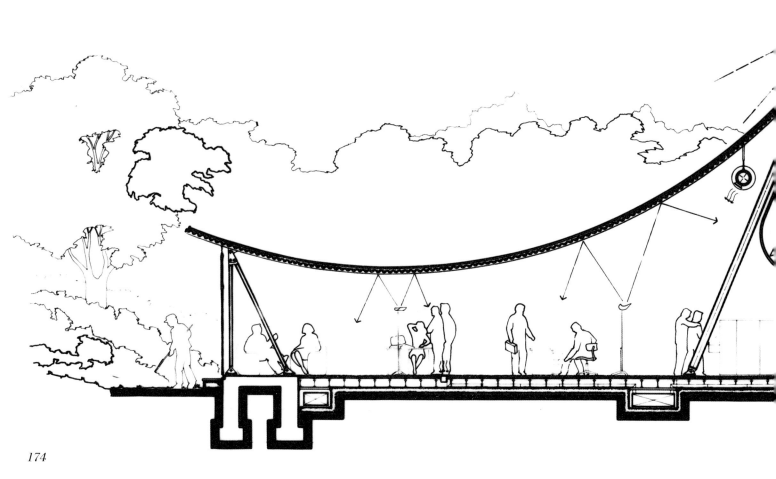

174

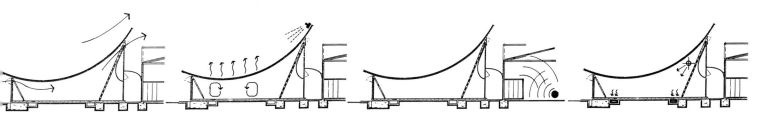

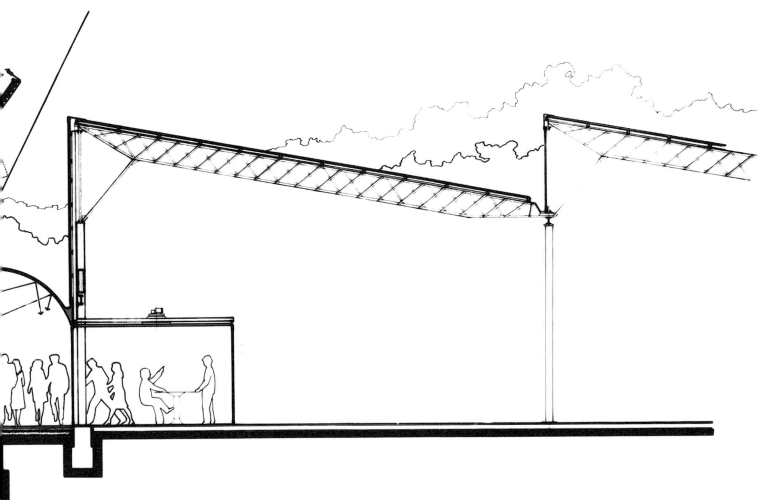

UNESCO-BW Joint Research Program on Natural Structures

Vesima, Genoa, 1986

175

176

This project, begun in collaboration with UNESCO, aims at researching plants with given characteristics, studying their fibers, and suggesting their possible use in construction systems.

The climate characteristics of Vesima, lying on a hill west of Genoa, are ideal for experimental cultivation of plants typical of the Mediterranean Basin.

The experimental research is oriented essentially toward those plants whose characteristics and properties are still unknown for new construction purposes. (New structural uses for easily cultivated plants could be of great use along the African coast of the Mediterranean.)

The site is a chunk of south-facing, steep semi-cliff sloping from the Genoa-Savona motorway down to the Ligurian Sea. It is already terraced with old retaining walls. These will be elaborated and shelter belts will be planted on the east and west boundaries.

Experimental crops like bamboo, agave, maize, ficus indica, and canna will be grown on the terraces.

Their structures and properties will be examined beneath a tensile tent structure at the top of the site. In wintertime activities will retreat into the new greenhouses and the existing small house.

A small monorail has been designed in order to allow access from the shore road. The same monorail will be used to take researchers into the sea in order to extend research to the growing of plants and organic agglomerations in sea water.

177

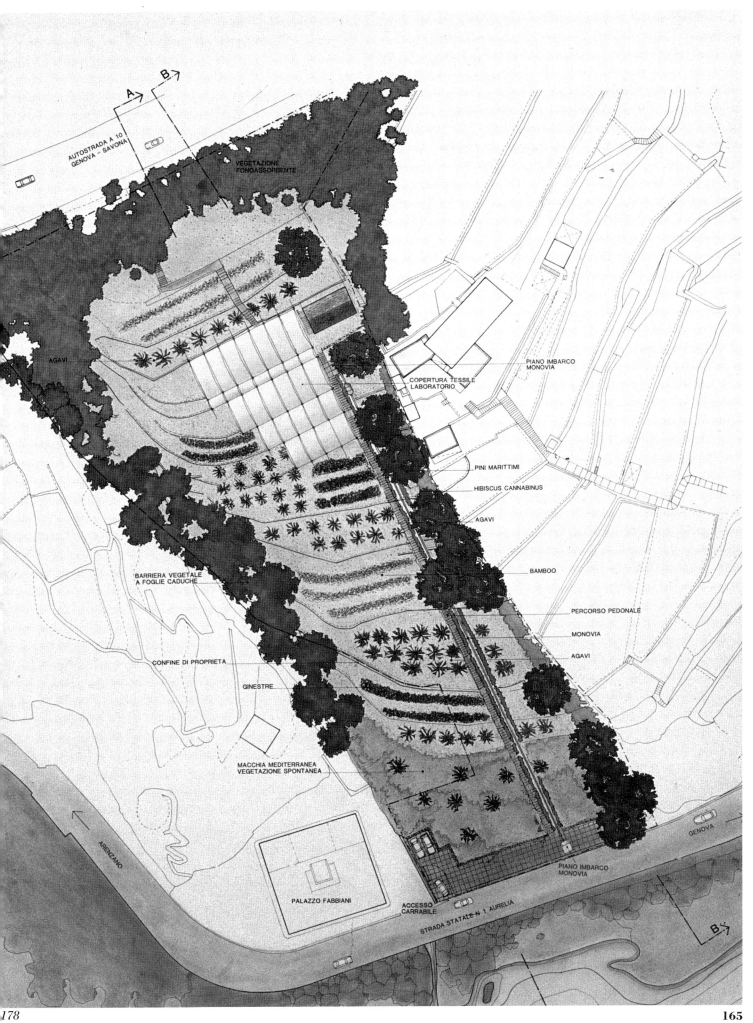

AUTOSTRADA A 10
GENOVA - SAVONA

A >
B >

VEGETAZIONE
FONOASSORBENTE

AGAVI

PIANO IMBARCO
MONOVIA

COPERTURA TESSILE
LABORATORIO

PINI MARITTIMI

HIBISCUS CANNABINUS

AGAVI

BAMBOO

BARRIERA VEGETALE
A FOGLIE CADUCHE

PERCORSO PEDONALE

MONOVIA

AGAVI

CONFINE DI PROPRIETA

GINESTRE

MACCHIA MEDITERRANEA
VEGETAZIONE SPONTANEA

ARENZANO

GENOVA

PALAZZO FABBIANI

ACCESSO
CARRABILE

STRADA STATALE N. 1 AURELIA

PIANO IMBARCO
MONOVIA

B >

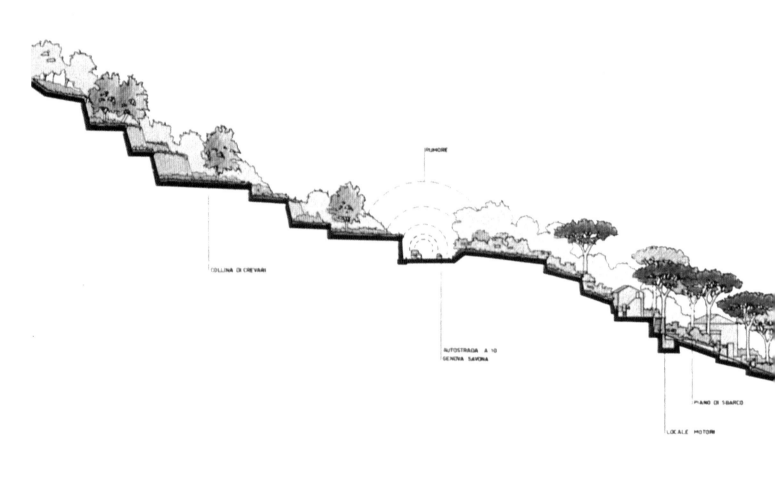

RUMORE

COLLINA DI CREVARI

AUTOSTRADA A 10
GENOVA SAVONA

PIANO DI SBARCO

LOCALE MOTORI

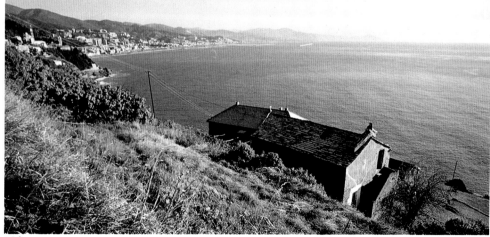

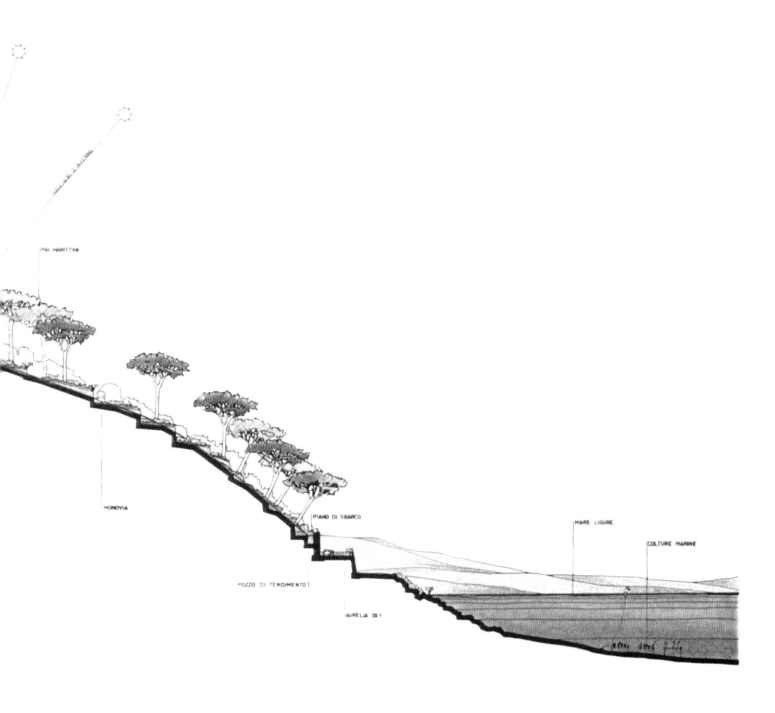

181

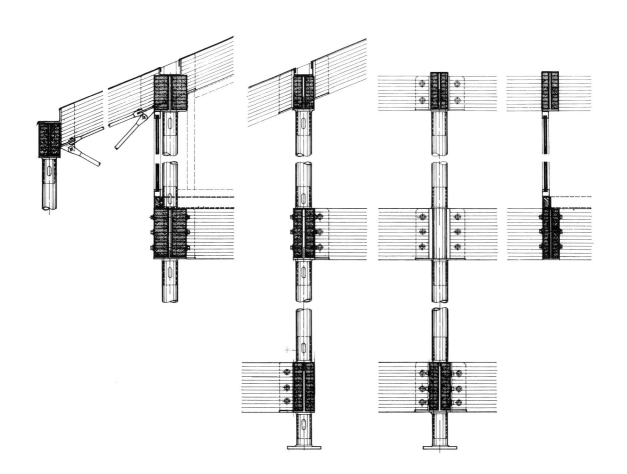

182

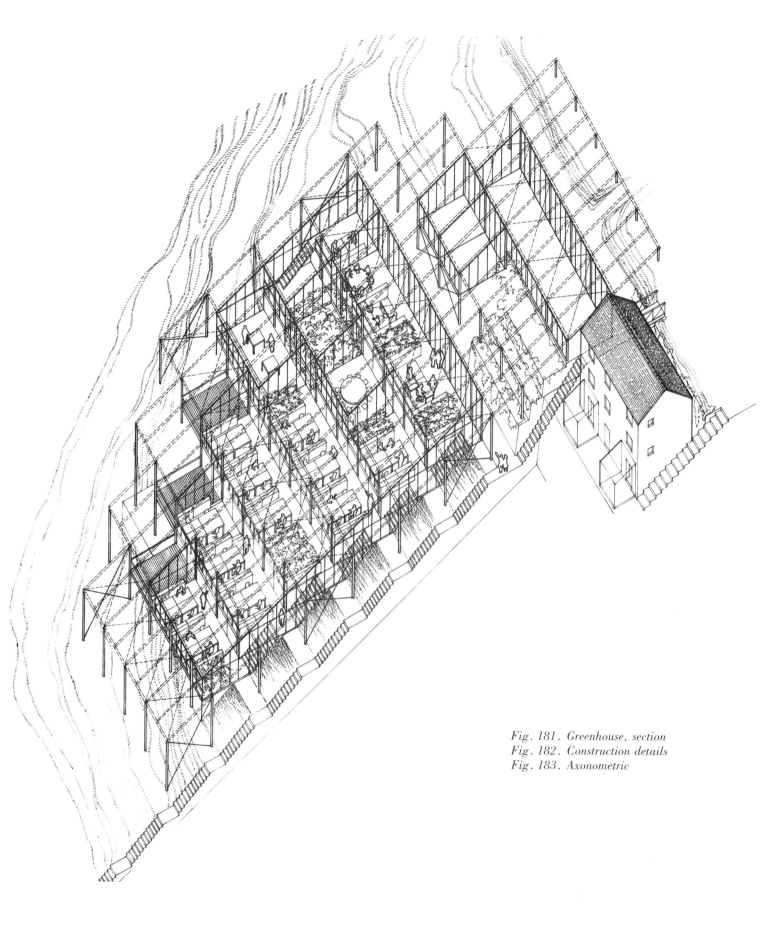

Fig. 181. Greenhouse, section
Fig. 182. Construction details
Fig. 183. Axonometric

Rehabilitation of the Moat of the Ancient Town

Rhodes, 1986

Rhodes fell to the Turks in 1523, since then the wide, dry moat that surrounds the fortifications has become mostly overgrown and in places the landward edge has fallen in.

Renzo Piano was asked by UNESCO and the Greek government to make proposals for turning the fortifications into a positive element of the town, binding the old town to the new urban elements surrounding it.

The Building Workshop answer was to suggest the moat be turned into a two-mile long botanical garden, the "garden of wonders," in which all the plants growing on the Mediterranean coast (including of course the plants typical of Rhodes) could easily develop because of the microclimatic zones obtained by the position of the walls to the sun. Fertile earth would cover the base of the moat, and water would also be brought to it. Rhodes's historical incidents would also be exploited, as the landslide at the outer edge of the southern side of the moat would be turned into an open-air theater, using the incline of the fallen earth as the ramp for the seats and the walls as the backdrop of the stage.

New connections are proposed to link the old town to the new town through the moat. The linking structures would be a series of "archaic war machines," timber structures with steel joints reminiscent of medieval siege towers. They are movable and can be adapted to accommodate stairs, lifts, and service elements. These towers will allow visitors to walk in and out of the ditch and climb to the top of the ramparts, which, duly reinforced, would become suitable for splendid historical walks.

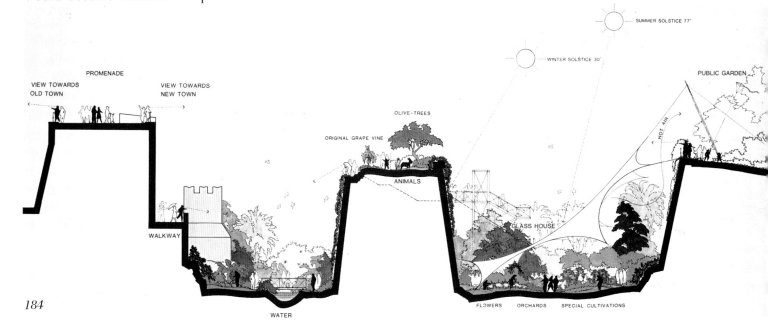

Fig. 184. Site section
Fig. 185. The moat at Rhodes
Fig. 186. Site plan

185

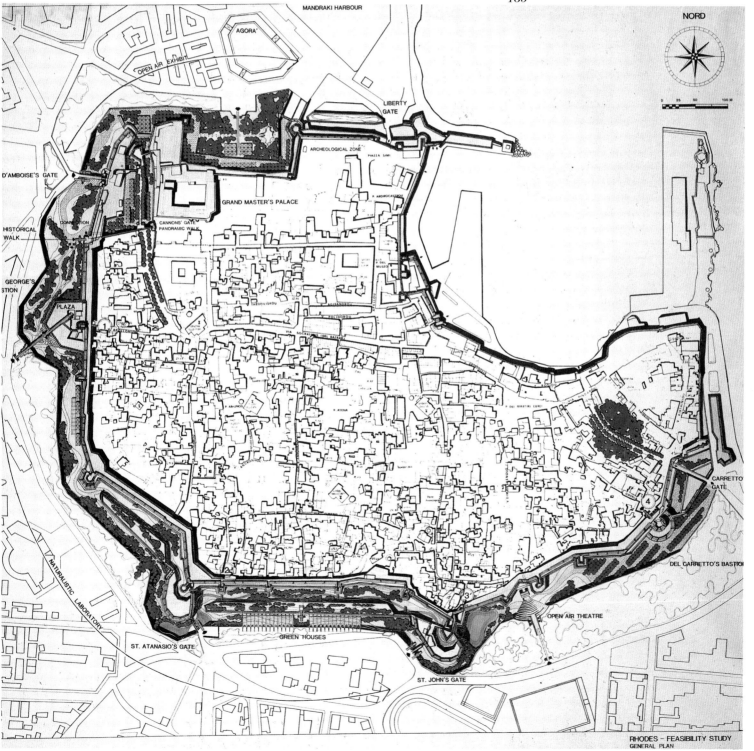

186

Rehabilitation of the Lingotto Factory Area
Turin, 1985

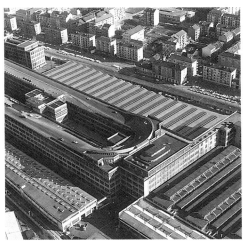

Fig. 187. Aerial view of Lingotto factory
Fig. 188. The southern access ramp

Lingotto is the name of the place where in the 1920s an engineer named Motté Trucco was hired to erect "the huge FIAT factory" (quoting Le Corbusier in *Vers une architecture*): "a 1640 ft. long front on a five story building whose windows multiply like a play of grids so that they eye cannot count them anymore. The top is like the taffrail of a warship with its flowing curve lifted at both ends, its bridges, funnels, hatchways, and gangways. . . . Certainly one of the most impressive views offered in the world of industrial architecture. . . ."

It became world famous because of a long test track on the roof used to test the performances of the cars manufactured below.

The total area of the building is approximately 3,000,000 square feet.

In 1982, nearly sixty years after its construction, it was decided that the Lingotto factory should cease its productive activity because it did not suit the requirements of the new car manufacturing process.

A plan was then promoted by FIAT to find a new use for the Lingotto factory, as it clearly belonged to the Italian architectural and industrial heritage.

As envisioned by Renzo Piano, the Lingotto factory is a polyvalent center housing two main branches of activities: tertiary activities (exhibitions, congresses, etc.) and research activities (universities, laboratories, etc.), having technology as their point in common.

The goal is to transform the Lingotto factory into an intelligent building. Housing telematic cable systems, connected with data banks all over the world, and governed by computers in its vital functions, it will be a place where memory, experience, and intelligence are exchanged.

Lingotto will become "part of the town," an element capable of promoting a brilliant exchange of culture and image with its surrounding territory.
Continued on page 180

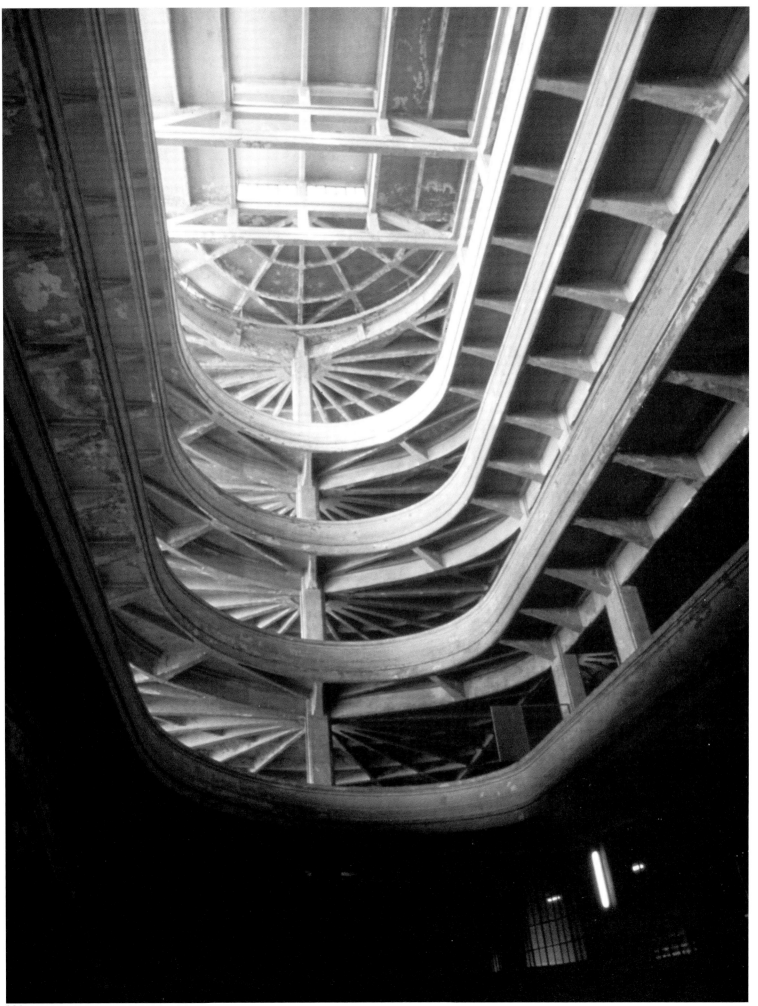

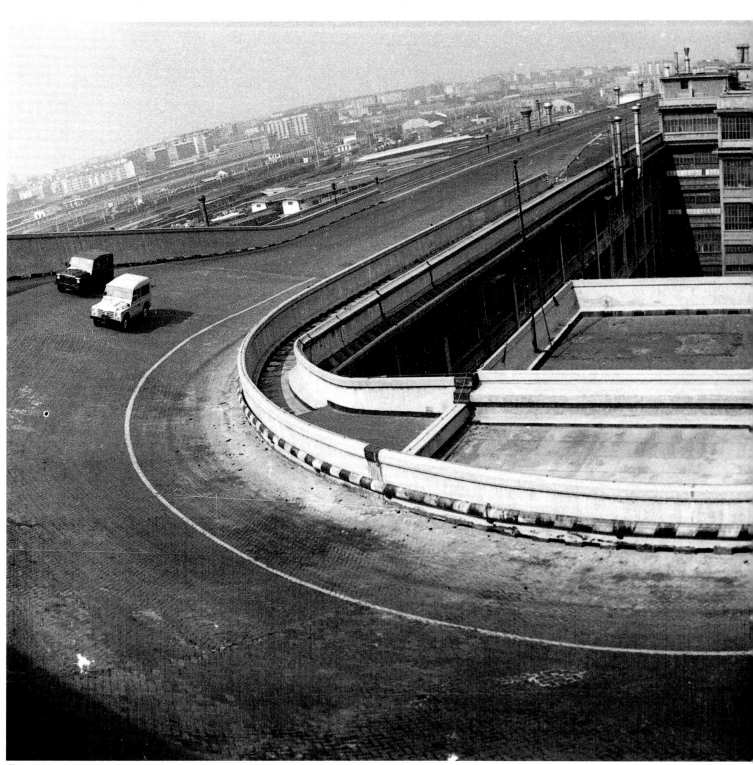

Fig. 189. Archival photo of the test track

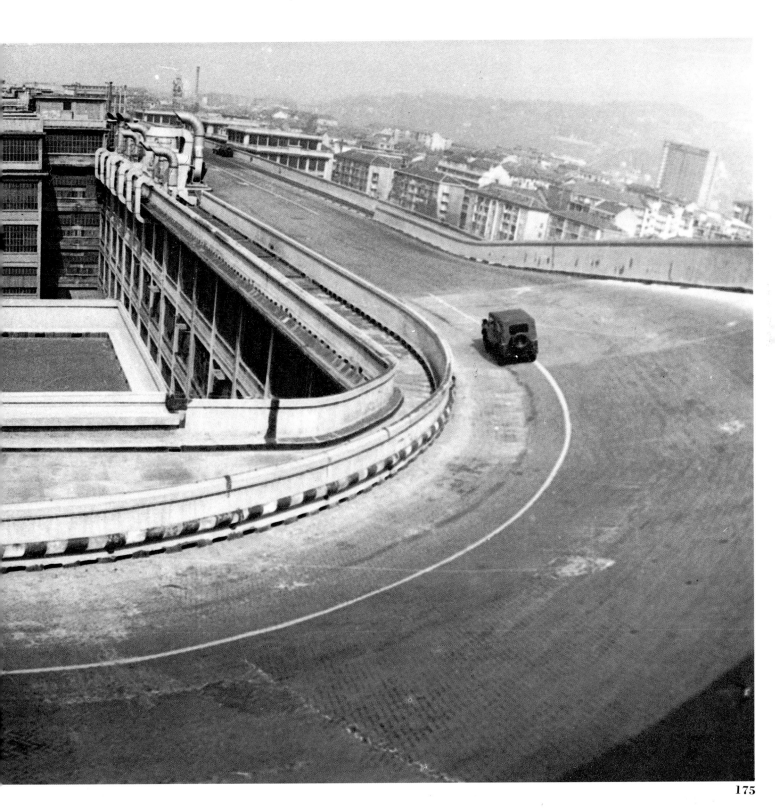

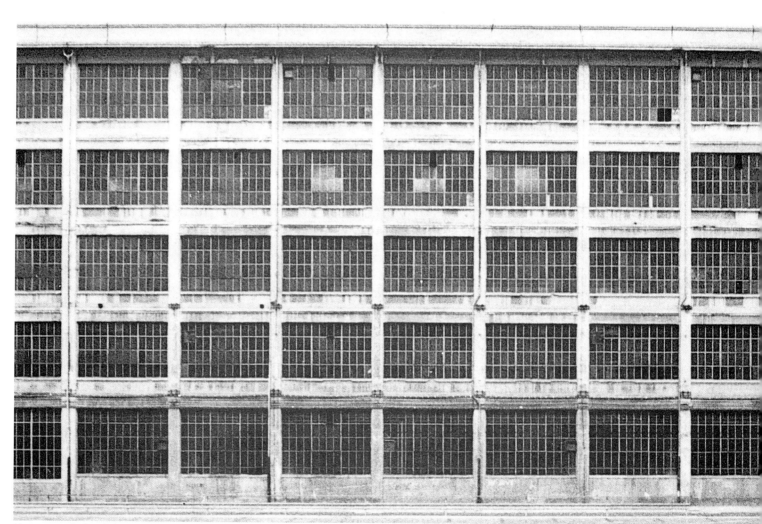

Fig. 190. Side of factory, showing the building frame on the exterior

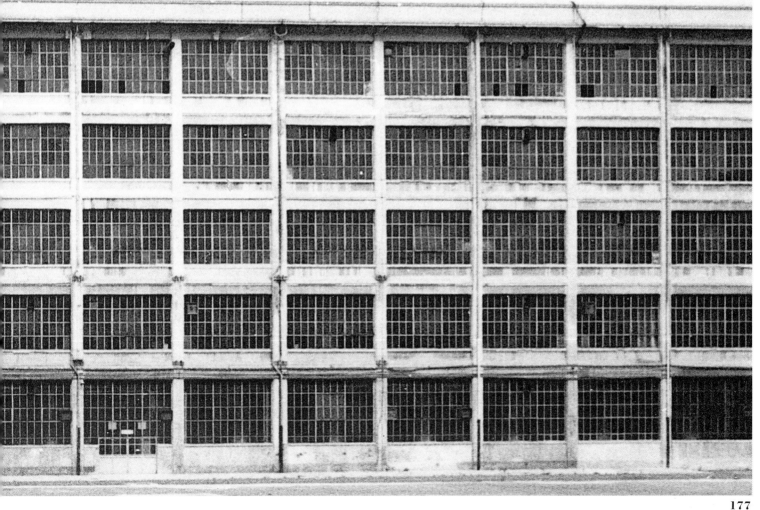

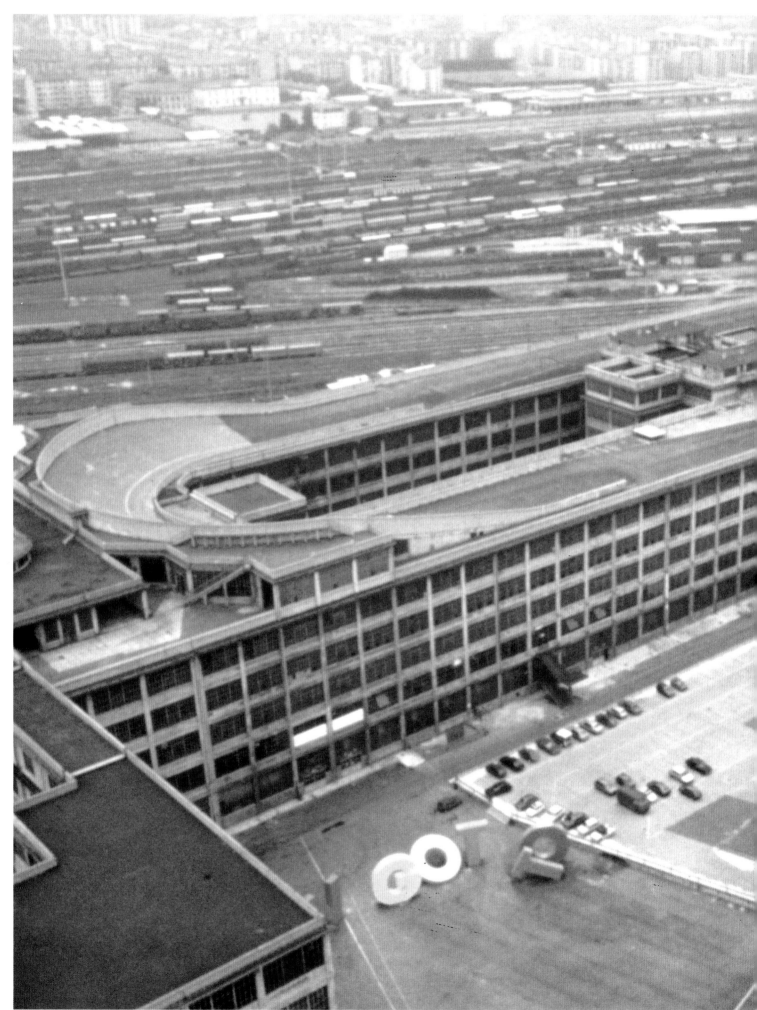

Fig. 191. Aerial view of the roof test track

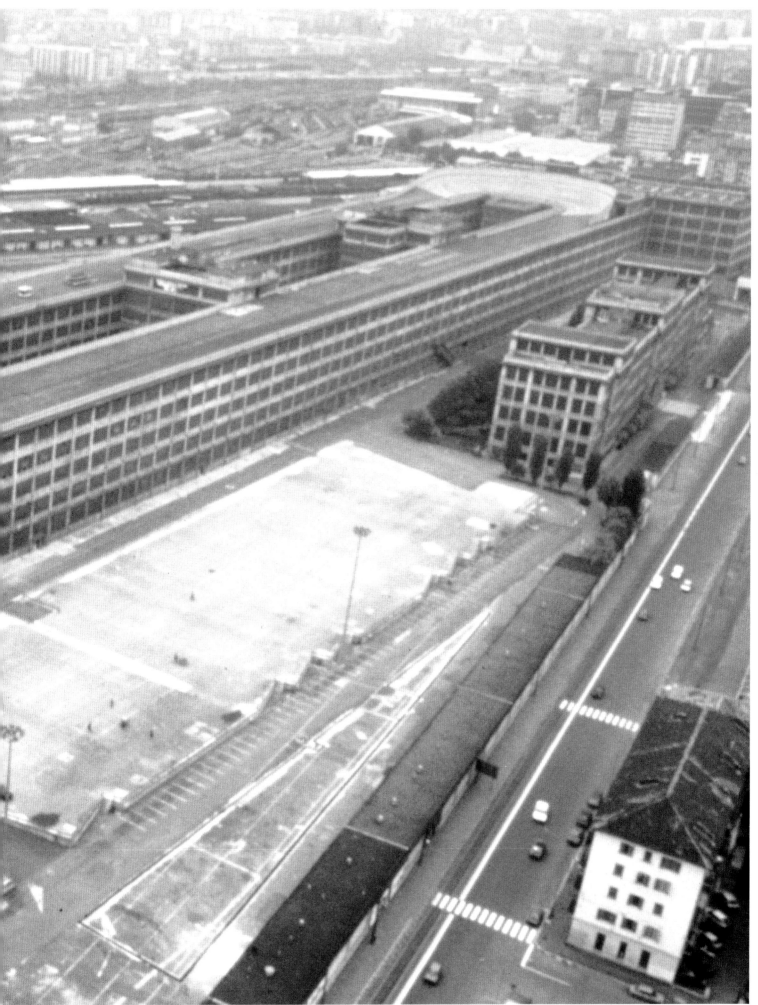

Fig. 192, 193. Various details of exterior
framing system
Fig. 194. Foreshortened view of the frame
Fig. 195. View of the inner courtyard

192

193

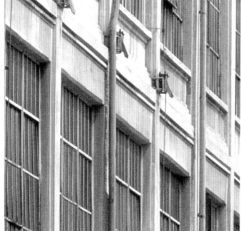

194

The built-up area includes a number of buildings, some of which will be demolished, leaving only the buildings originally designed for the old Lingotto factory, so that it can be reinserted in the town texture not as a factory but as a structure open to by the public.

This objective should be achieved more easily because of the well-known shape of the building. The industrial memories it evokes are impressed in the minds of all those who have always looked at Lingotto as a part of the landscape: its test track, its access slopes, its modular structure, and its almost monumental volumes belong to this landscape and to everybody's memory.

The idea of transforming Lingotto—Turin's major reference point—into a new center with multiple functions undoubtedly represents a unique opportunity for a thorough renewal of the whole surrounding urban area.

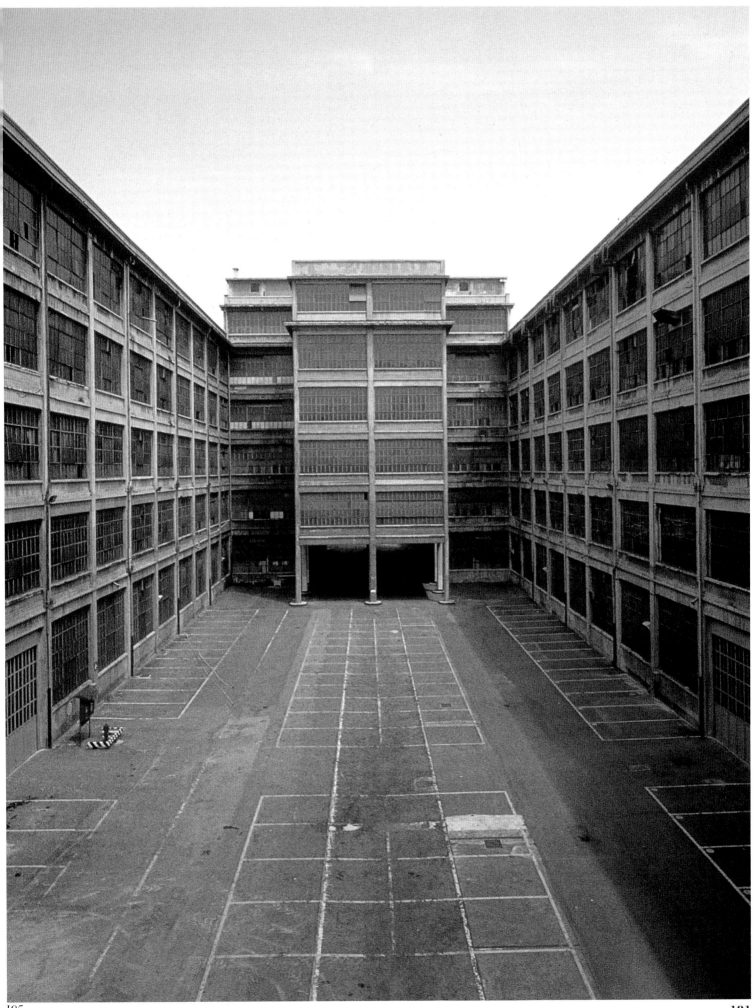

Fig. 196. Section
Fig. 197. Elevation
Fig. 198. Section through "wonder garden"

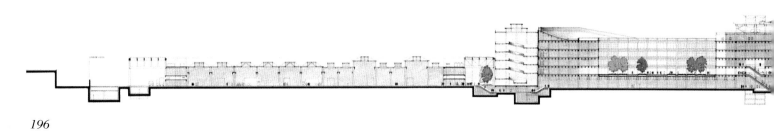

196

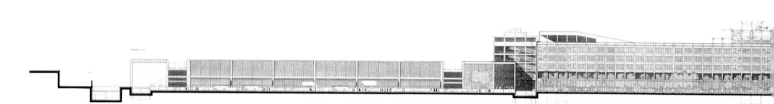

197

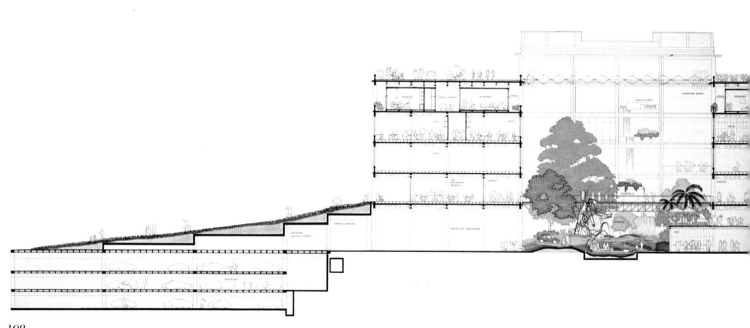

198

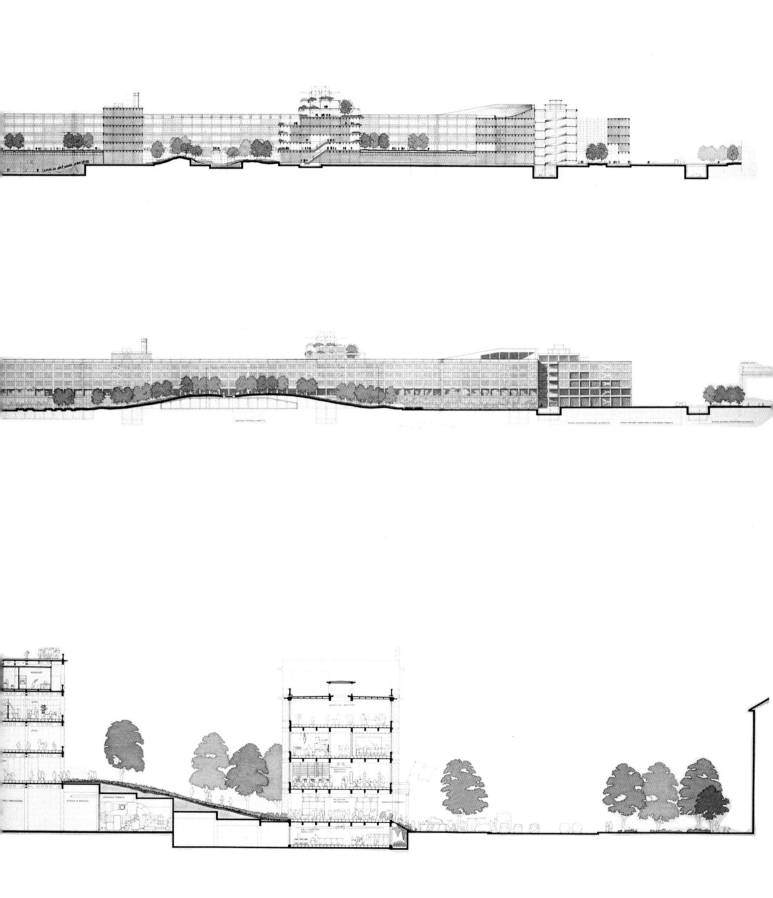

Fig. 199. The Centro presse

Fig. 200. Axonometric, congress center

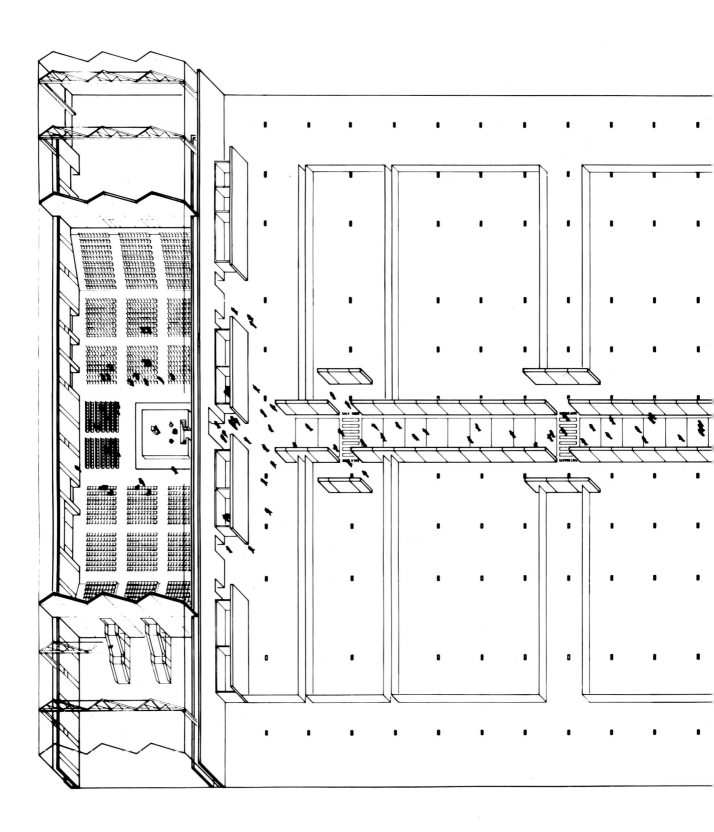

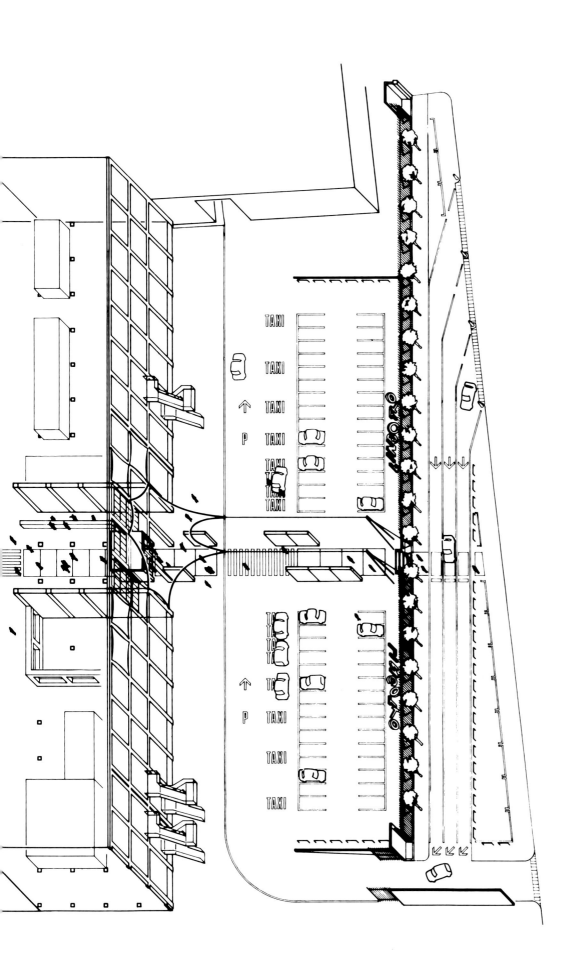

Fig. 201. The Congress Center during a symposium

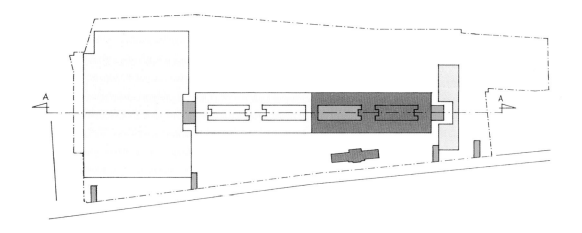

Fig. 202. Ground floor

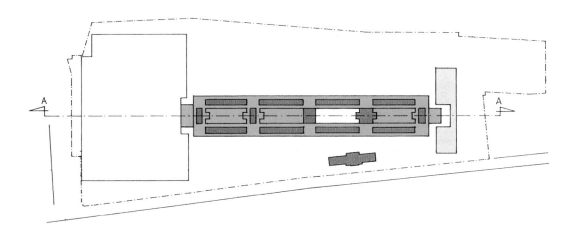

Fig. 203. Second floor

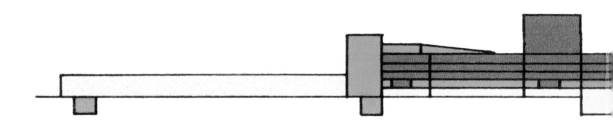

Fig. 206. Section

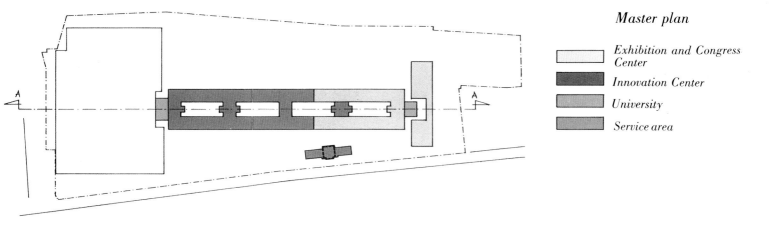

Master plan

▢ Exhibition and Congress Center
■ Innovation Center
▨ University
▨ Service area

Fig. 204. Third, fourth, and fifth floors

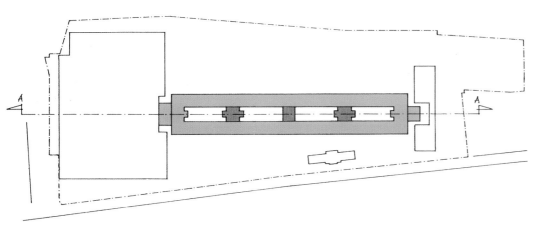

Fig. 205. Plan of coverings and last floors
of transversal buildings

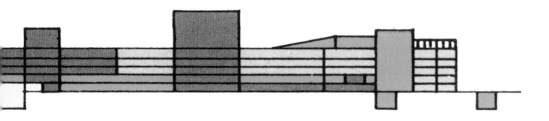

207

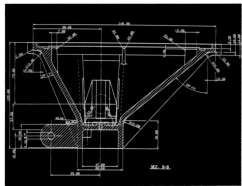

208

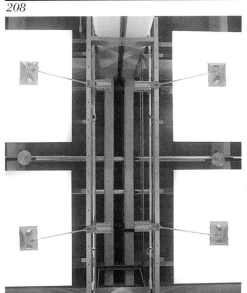

209

Fig. 207. Car showroom inside the Lingotto factory
Fig. 208. Computer drawing of the lighting system
Fig. 209. Detail of lighting system

Project for the Rehabilitation of the Palladio Basilica and City Hall

Vicenza, 1986

Fig. 210. Aerial view of the Palladio Basilica
Fig. 211. Wooden model

This building was never a religious monument. The term "basilica" was given to buildings devoted to the practice of law and business transactions in ancient Rome. It thus became the seat of the Consiglio dei Cinquecento and the Tribunal. Andrea Palladio, who at the age of thirty-eight won the competition that was to bring him fame, merely modified the external skin of the medieval building.

Piano's project of rehabilitation (together with Ove Arup and Partners, London) focuses on the immaterial elements of the space, such as the air movement patterns within the basilica at different times of year. The acoustical qualities and the reverberation time of the fourteenth-century hall were measured and found to be ideal for performances of Renaissance music.

Experiments in lighting have been carried out inside the basilica, taking into account the intensity, color, and temperature of the light so as to avoid damaging the existing structure and to obtain the desired effect by maximizing the qualities of the superb space.

The project will restore all the uses to the basilica without compromising the integrity of the monument.

The cultural and civic centre will cover 60,000 sq. ft.: 24,000 sq. ft. for cultural activities and 36,000 sq. ft. for administrative and civic activities.

The complex will include a large dance hall, a theatre, exhibition and dance rooms, a study center, a library, shops and restaurants, municipal offices, and small meeting rooms.

Other buildings linked to the structures, such as the Domus Conestabilis, the tower of Piazza delle Erbe, and the offices of the municipality will assume new functions, thus creating a small but lively civic and cultural center that will become the permanent heart of the town.

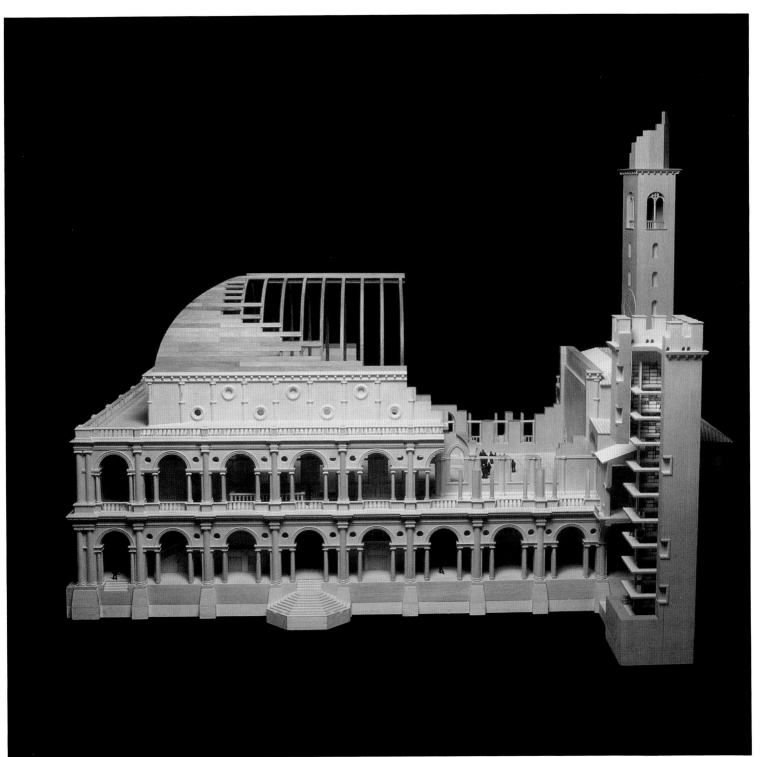

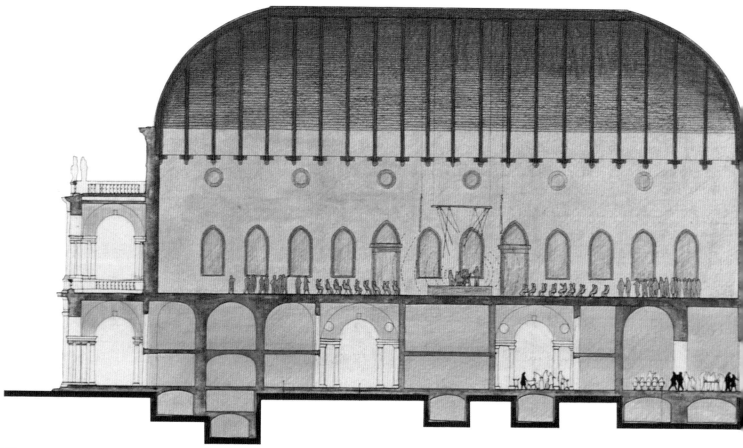

Fig. 212. Ground floor plan, showing
pedestrian paths and sightlines
Fig. 213. Longitudinal section

212

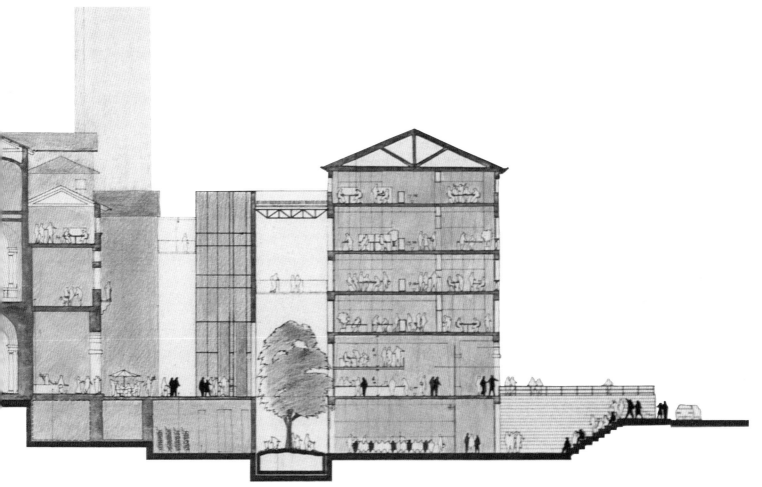

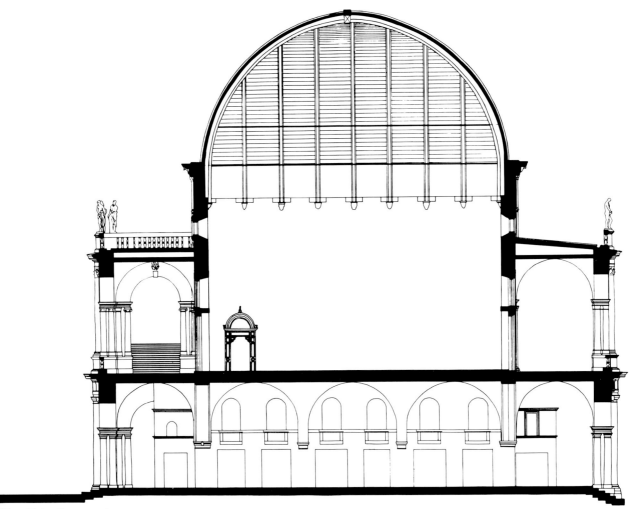

Fig. 214. Cross section

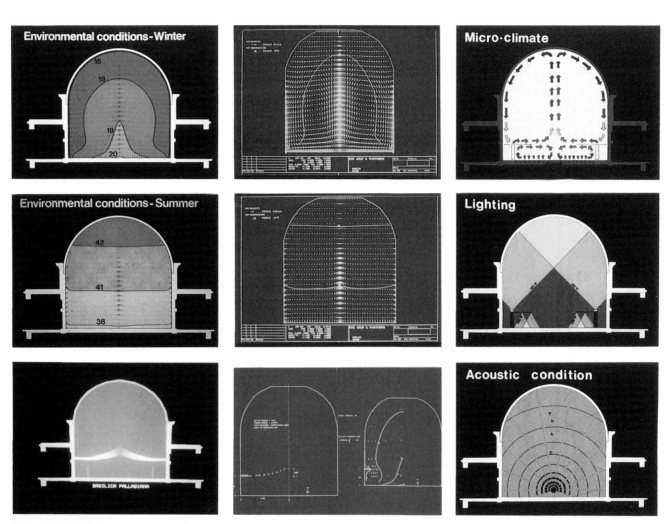

Fig. 215. Lighting, acoustic and air conditioning diagrams

Bercy-Charenton Shopping Center

Bercy, France, 1987

Fig. 216. Aerial view of the site
Fig. 217. Site plan
Fig. 218. Computer drawing

The Bercy-Charenton shopping center will include large stores and small-to-medium shops. Located at the junction of the ring road with the eastern highway, the building in its shape appears as a response to the high-speed world it borders. A giant, polished aluminum pebble, it has nothing to detract the eye from the immediacy of its reflections and its full, rounded contours. Once inside, however, the vision changes, with the levels of shops rising up around a central axis. Here nature and architecture blend together as a planted area lit from above. The simplicity of the shape nevertheless belies the complexity of the mathematics and computerized technology employed.

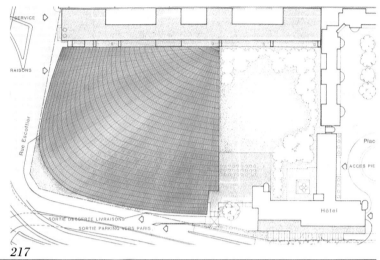

217

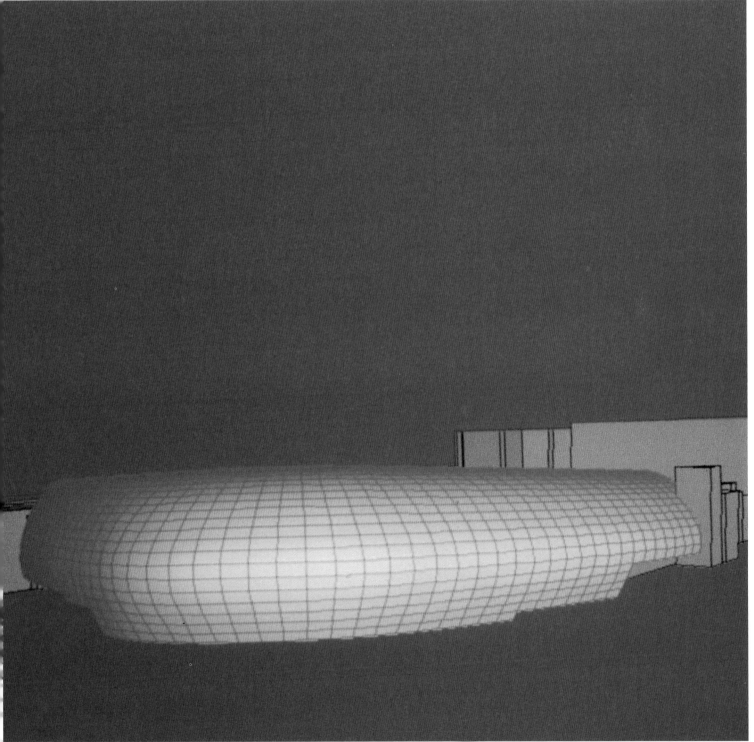

218

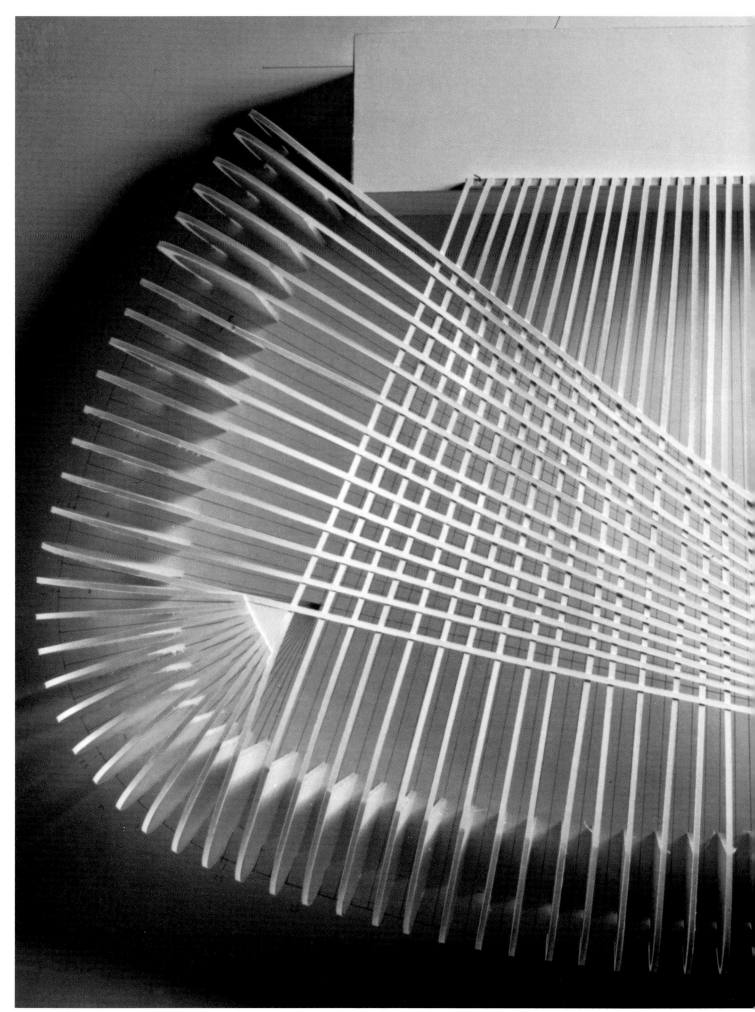

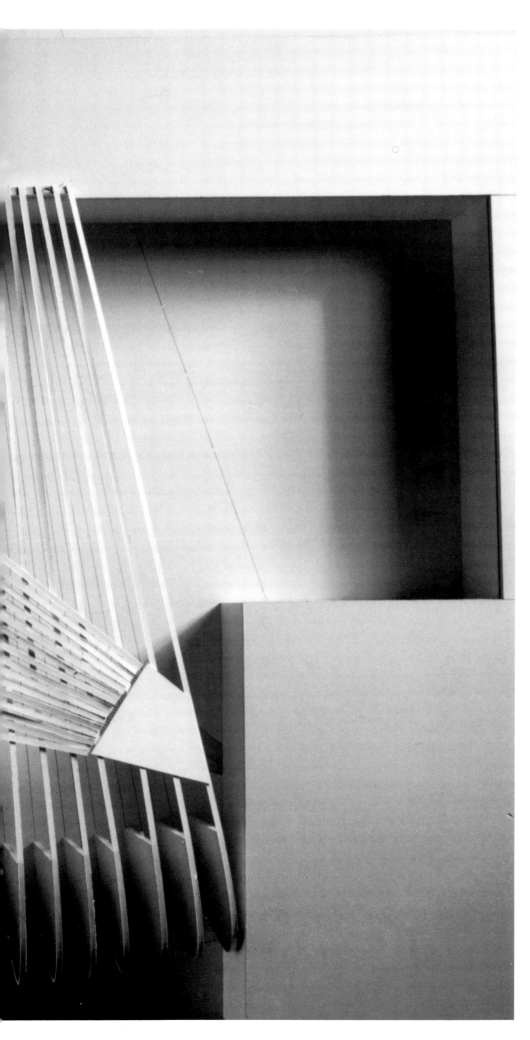

Fig. 219. Working model

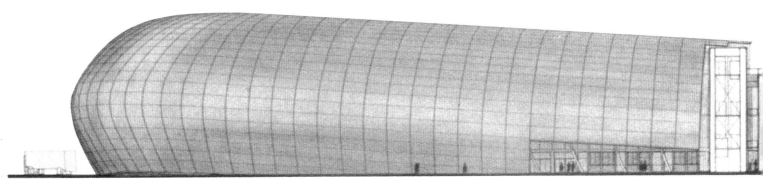

221

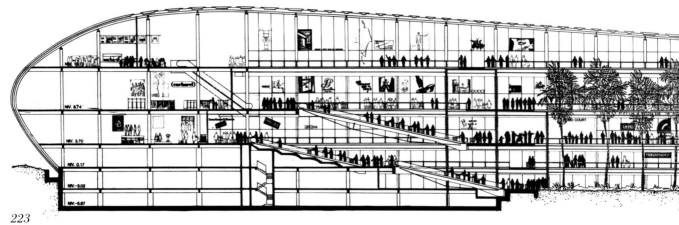

223

220

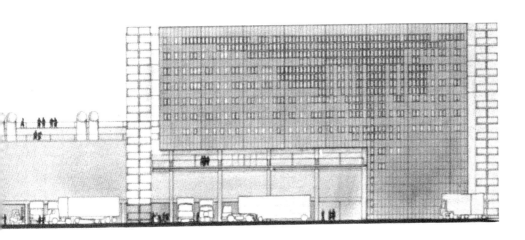

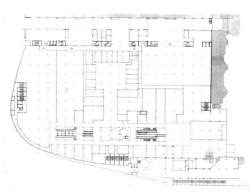

222

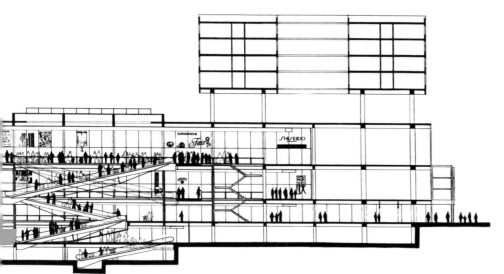

Sports Center
Ravenna, 1986

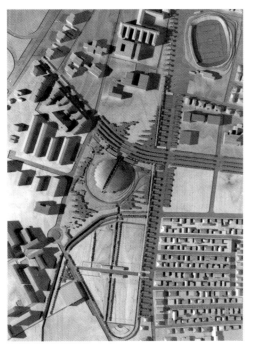

Fig. 224. Aerial of planimetric model
Fig. 225. First working model

The project for a sports center to seat 4,000 people is planned for the outskirts of Ravenna, Italy.

The complex comprises a multipurpose hall with associated facilities located in a block that follows the main road and maintains continuity with the surrounding urban texture.

The entrance is located at the junction of these two systems, where the main structure spreads along the axis of the roof.

The roof structure, made of modular ferrocement members, clearly refers to the natural structure typical of scallop shells. Natural lighting and ventilation are introduced into the building through the central section, where the two shell structures come together.

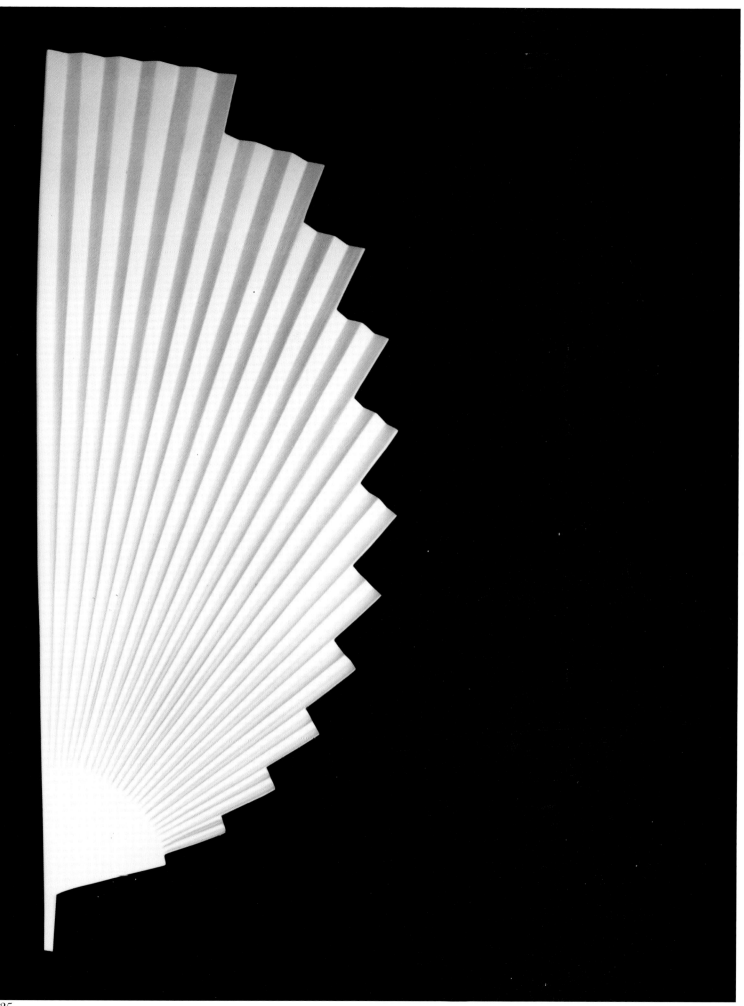

Fig. 226. Longitudinal section
Fig. 227. Plan of roof covering
Fig. 228. Plan at 10.60 elevation

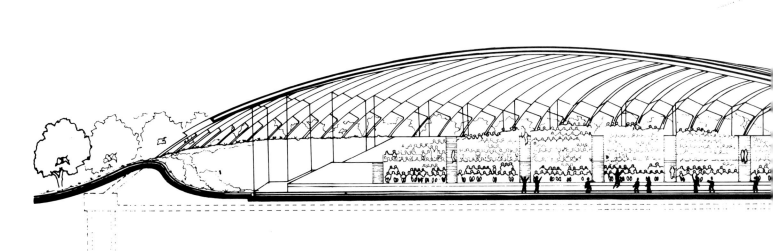

226

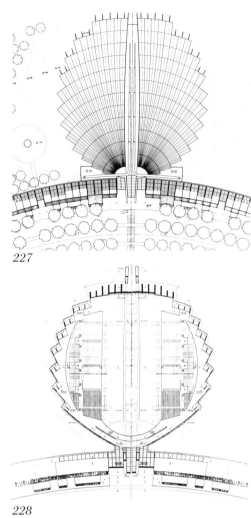

227

228

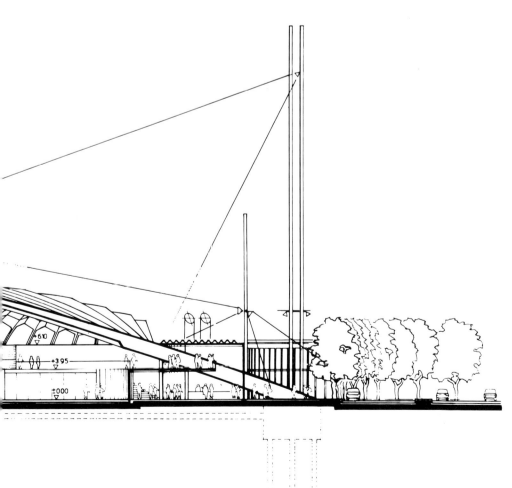

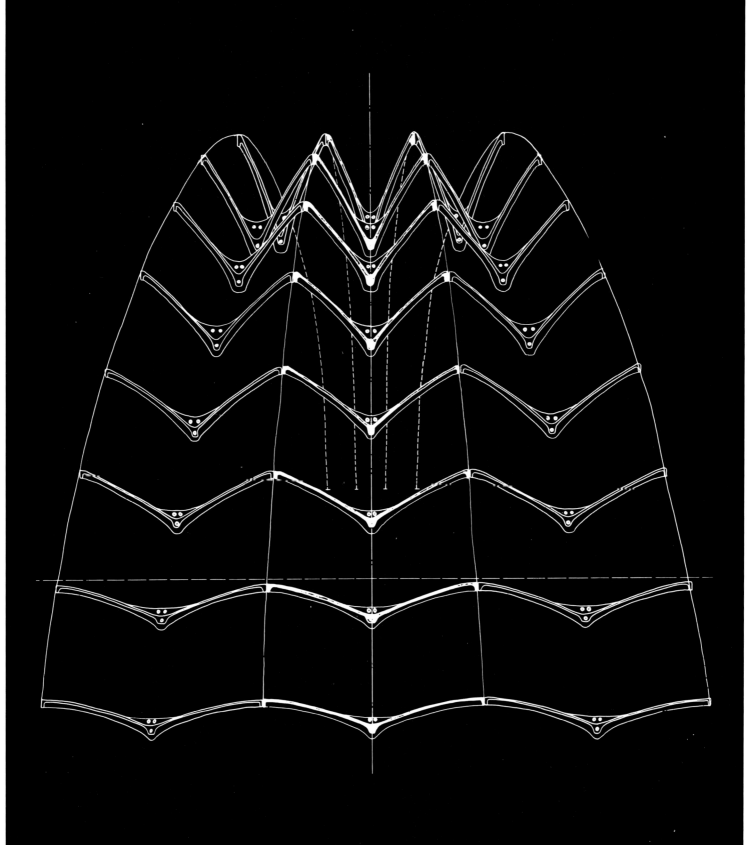

229

230

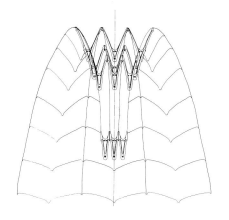

231
Fig. 229. Structural section 1
Fig. 230. Geometry of coverings
Fig. 231. Structural section 2
The sharp "V" shape of concrete structural
sections is meant to stiffen the covering shell

Football Stadium
Bari, 1987

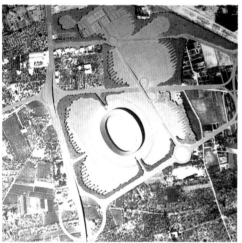

Fig. 232. Aerial view of planimetric model
Fig. 233. Aerial view of site

Set in the Mediterranean landscape of the region, the new Bari stadium rises on a crater in the land of Puglia. It is only partially seen from the surrounding countryside as it is hidden by vegetation.

In form, it appears a ring-shaped spaceship set around a central stage, with a football field and an encircling track for athletics sunken into the ground and surrounded by grandstands at ground level.

The geometric design consists of a radial system of 26 axes to ensure greater safety and allow the people to exit more easily to and from the parking lots.

The stadium is designed to hold 60,000 people, all on individual seats. The large, teflon roof is joined to the upper stands, to which the lights are secured in a continuous line. The upper tribune is made of 312 large, precast crescent-shaped elements, assembled on-site with a concrete casting.

Other functions, like toilets, box offices, bars, information desks, and services are located on top of the hill under the "portico" created by the upper tribune. The press services are housed in separate buildings directly connected to the tribunes reserved for the press.

Under the stands runs an internal corridor that acts as emergency exit and along which are housed the dressing rooms, the four gymnasiums, and the physical plant.

The stadium appears enveloped and suspended by vegetation: sunk into an artificial crater, the upper part of the complex is linked to the ground by a green crown.

The public does not have direct access to the tribunes from the parking areas. One must cross an intermediate green zone in a slight slope. This, apart from creating a vast green park with a large pine forest, tends to neutralize the negative effects of the overheated asphalt in the parking places, with a considerable influence also on the climatic conditions inside the stadium itself.

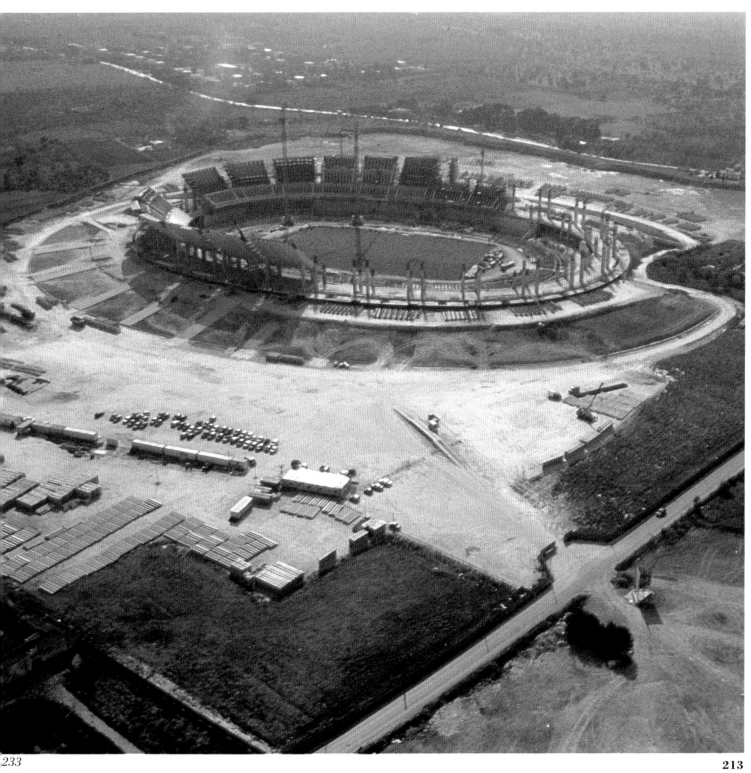

Fig. 234. Elevation
Fig. 235. Historical reference: Castel del
Monte, a medieval castle near Bari

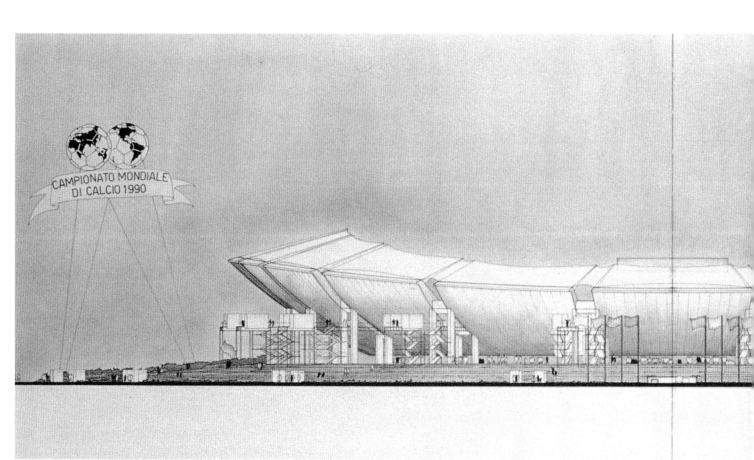

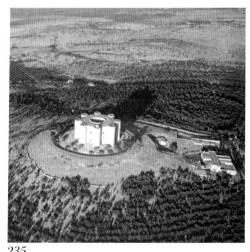

235

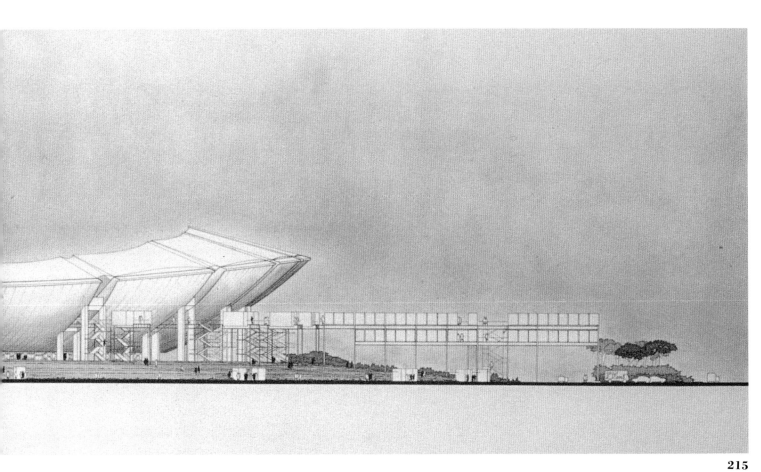

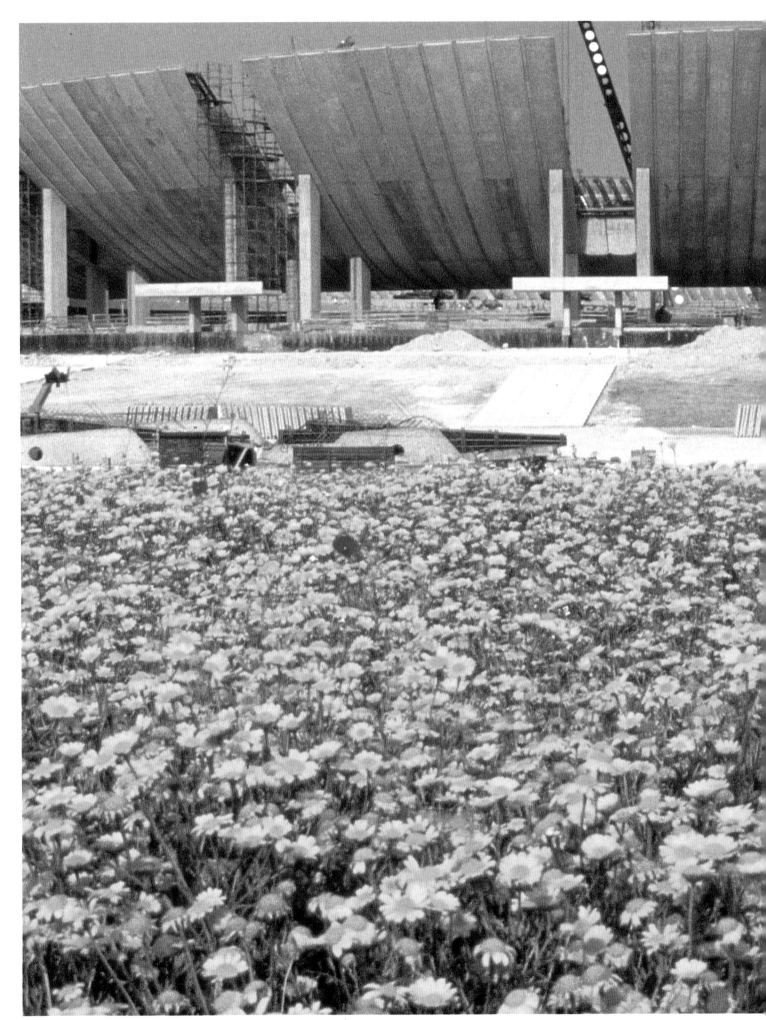

Fig. 236. Initial phase of construction

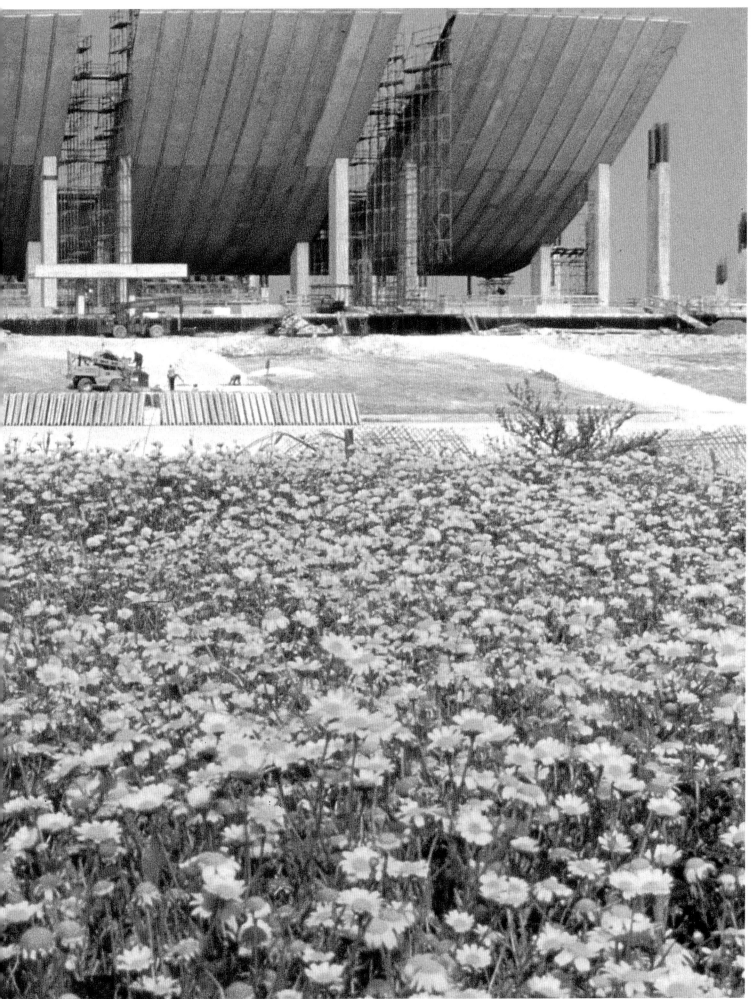

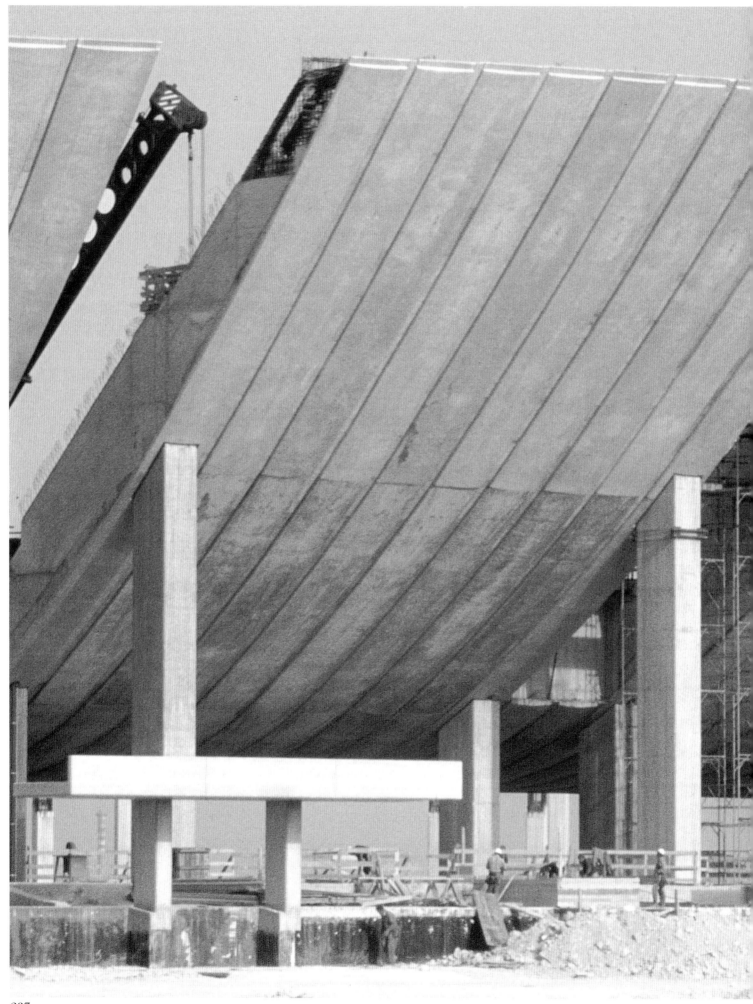

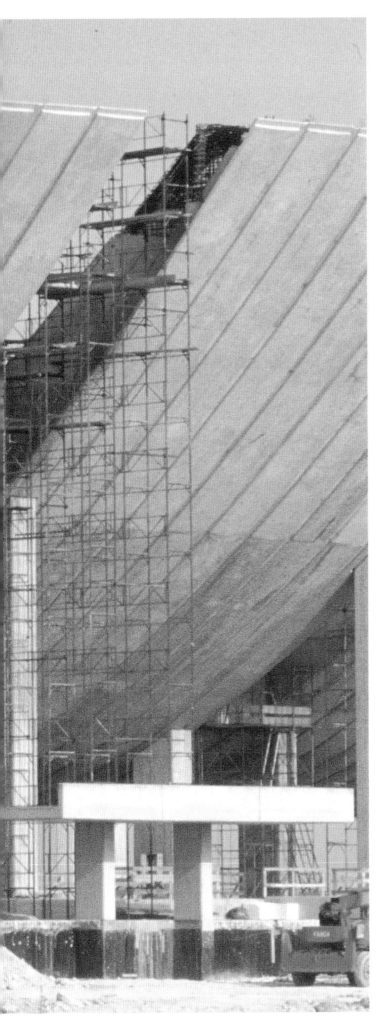

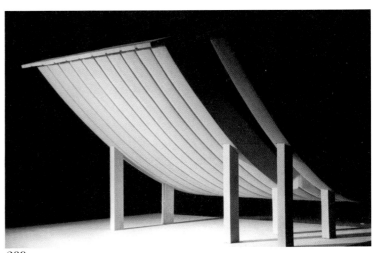

238

Fig. 237. Initial phases of construction
Fig. 238. Working model of the shell

Fig. 239. Section
Fig. 240. Computer drawing

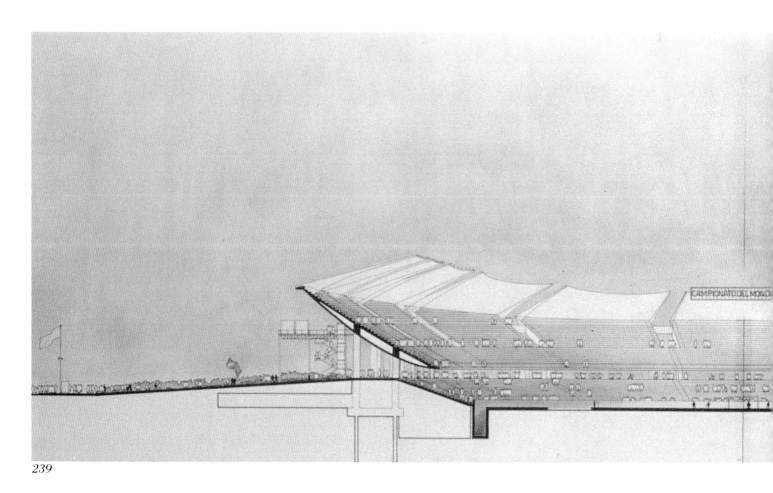

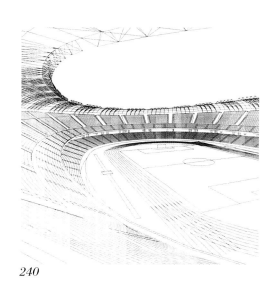

240

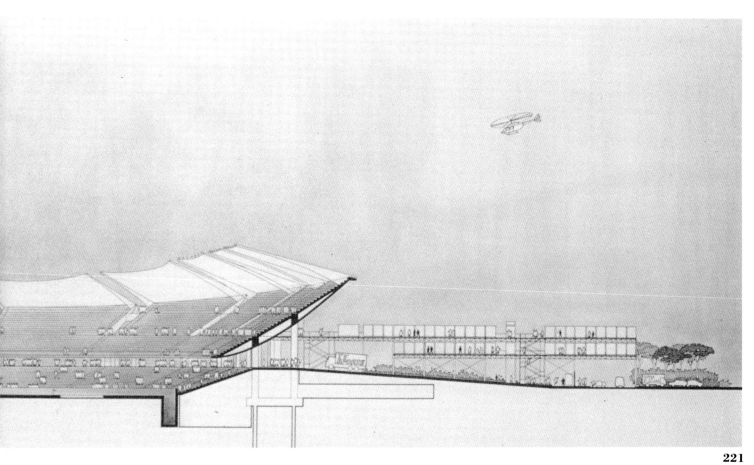

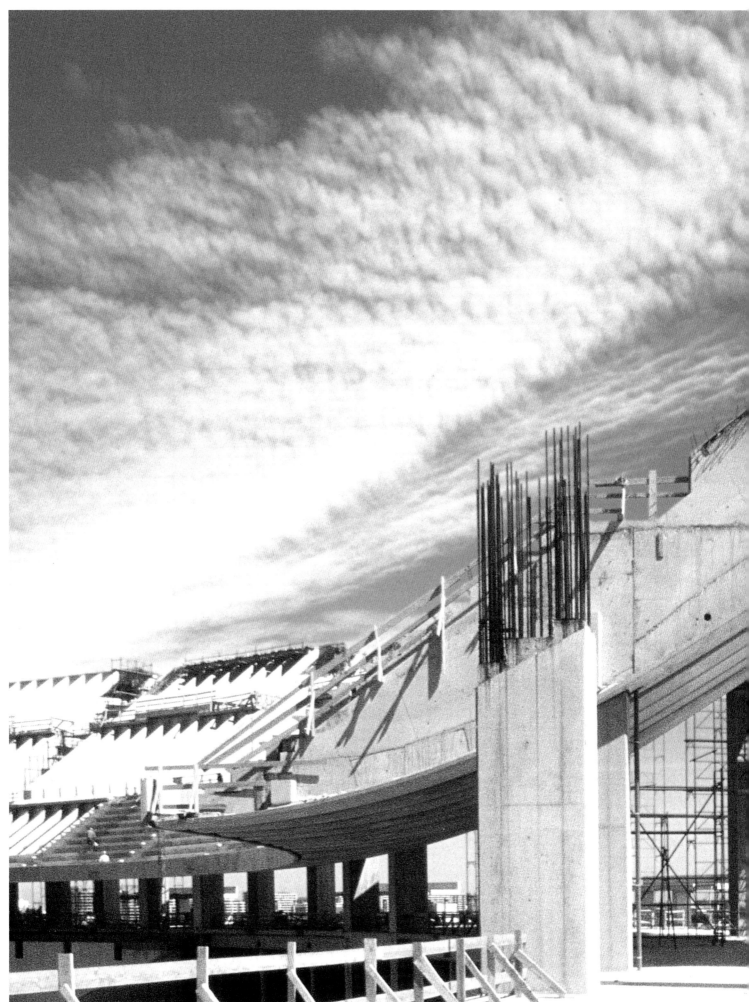

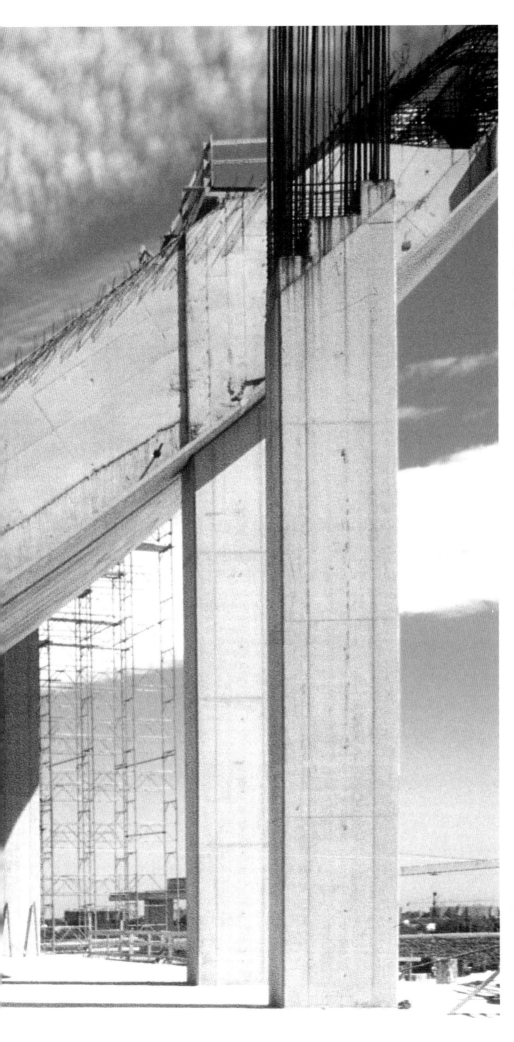

242

Fig. 241. Initial phases of construction
Fig. 242. Standard section

Kansai International Airport Competition
Osaka, Japan, 1988

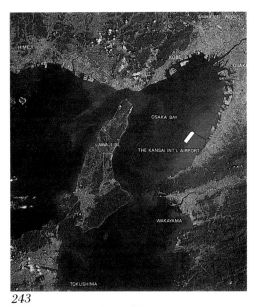

243

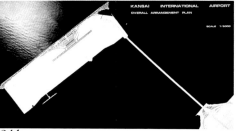

244

Fig. 243. Aerial view of the Osaka bay
Fig. 244. The island viewed from the air
Fig. 245. The island during construction

Although this island is man-made, nature will have a free hand; the reality of runways, airplanes, technology, and science will exist harmoniously with nature.

The terminal itself is where the transition between science and nature occurs. Inside it are two "valleys" full of daylight, penetrated by nature, one on the land side and the other on the air side of the station. Within the protected environment of the building, these two valleys echo external nature and become an instinctive destination for passengers moving across the building. Movement through the terminal must be simple and direct.

The structure of the main hall will be visible at level three, from the first and second levels, through the open spaces. This sense of space and form will remain with the traveller walking from land to air, and back. The structure, especially of an air terminal, should be a "diagram" of people moving through it, and all the atmospheric elements of the space—the light, the sound, the movement of the air—should contribute to the logic and intention of their movement.

The areodynamically curved section of the roof coincides with the dynamic of the ventilation air blowing from the land side toward the air side of the building. Between the arches, the scooplike form of the roof assures laminar flow and separation between adjacent air zones.

Maintenance is provided directly by rails and small trolleys at beam levels to give direct access to all roof equipment, lighting, and smoke extraction, and for cleaning the glass.

The structure of the arches, with their longitudinal brackets, reminds us of an aircraft fuselage with the skin peeled off to let in light and to give a glimpse of the underlying construction. In the wings at the entrance, light, repetitive, braced arches (alternate arches strutted and supported) remind one of early biplanes, while the prestressed cable mullions and the suspended glass facade speak of technology of today. The whole ensemble will be a structure at once sensitive and fragile, strong but not overpowering, subtle and technically derived—a celebration of today, rooted in past images.

This building can be the achievement of the best that is possible at the end of this century, a mature and totally new balance between technology and nature, machine and man, the future and tradition.

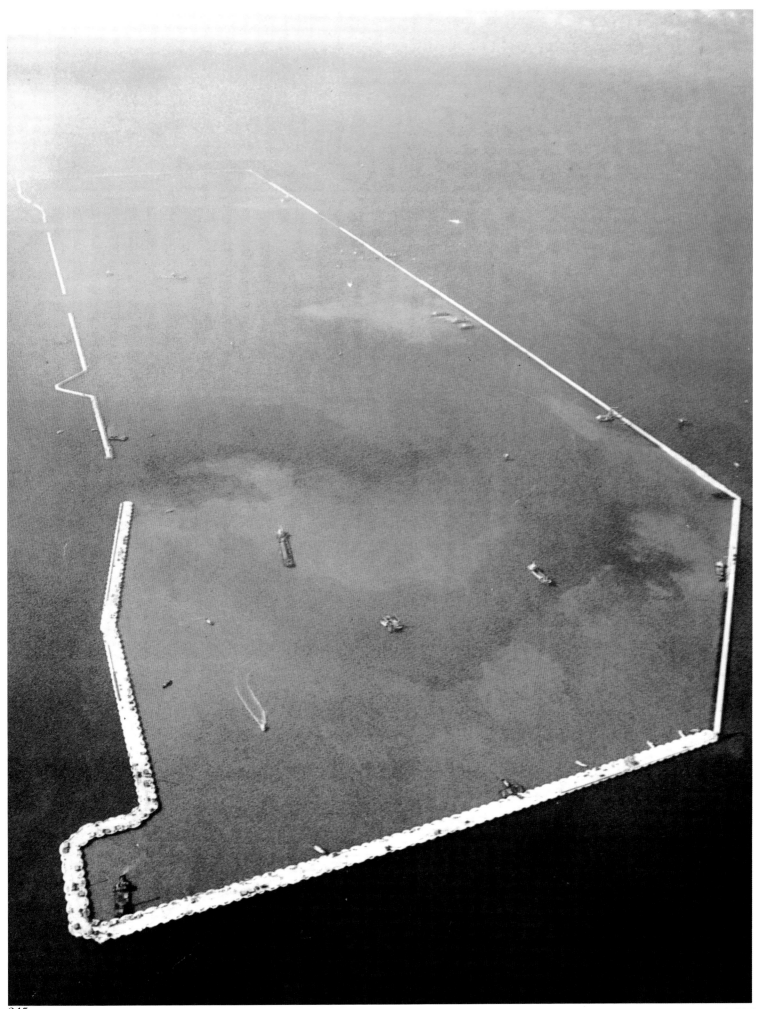

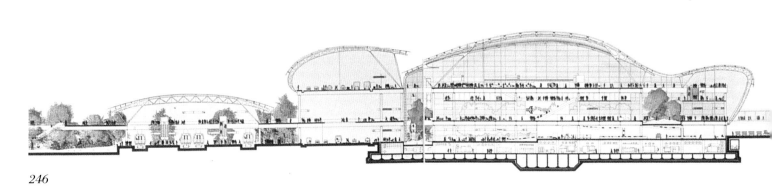

246

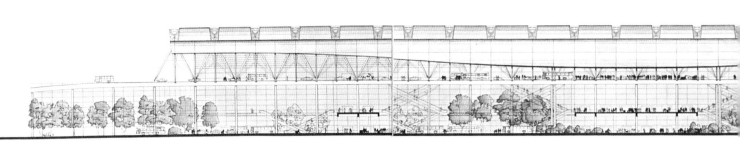

247

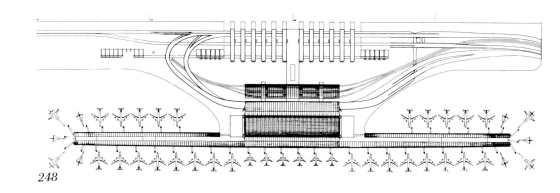

248

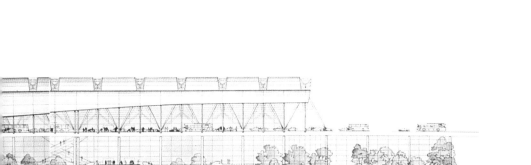

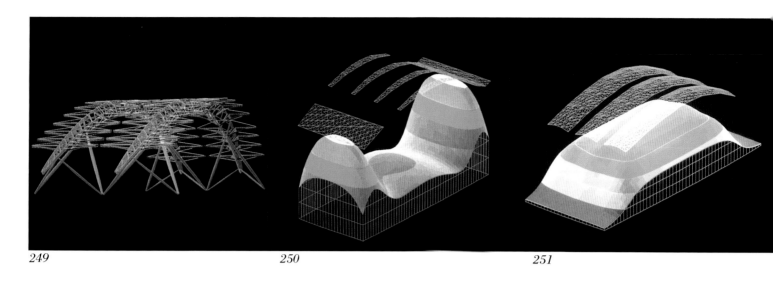

249　　　　　　　　　　　250　　　　　　　　　　　251

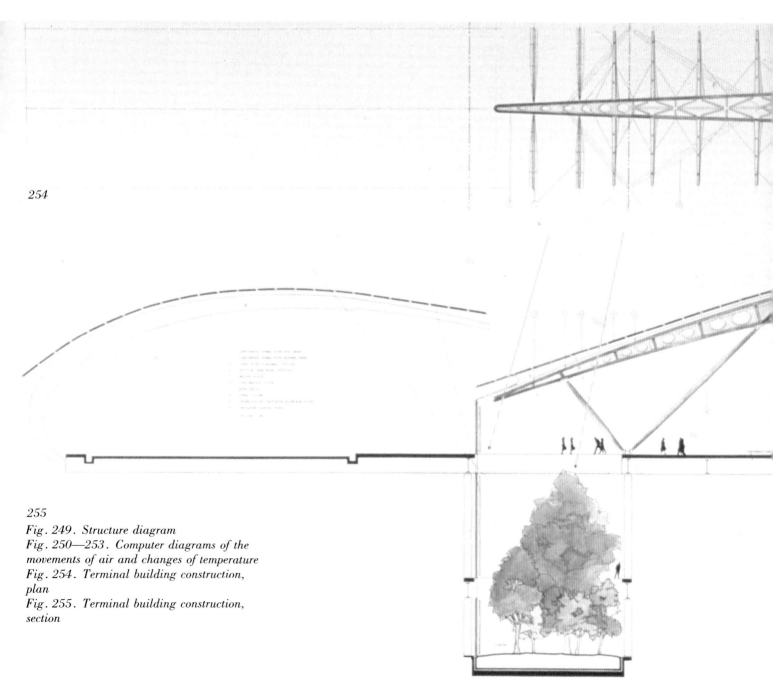

254

255

Fig. 249. Structure diagram
Fig. 250—253. Computer diagrams of the
movements of air and changes of temperature
Fig. 254. Terminal building construction,
plan
Fig. 255. Terminal building construction,
section

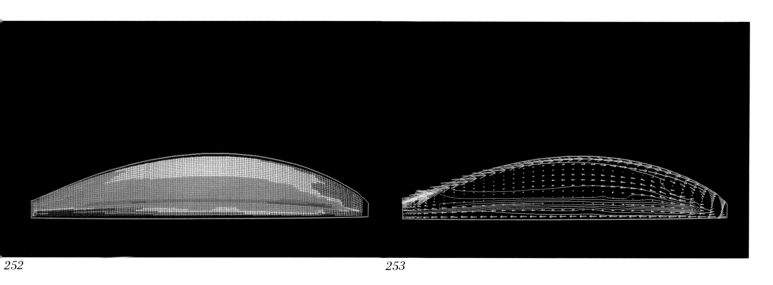

252

253

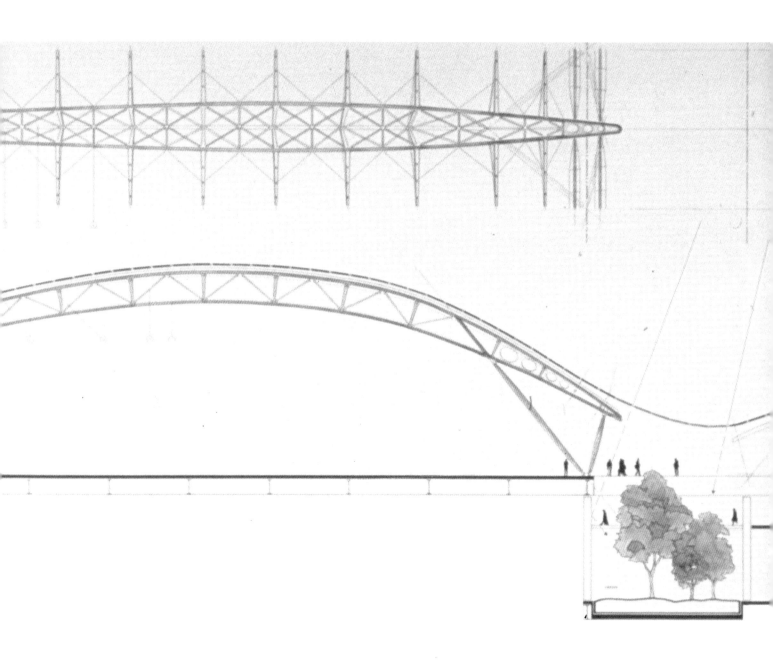

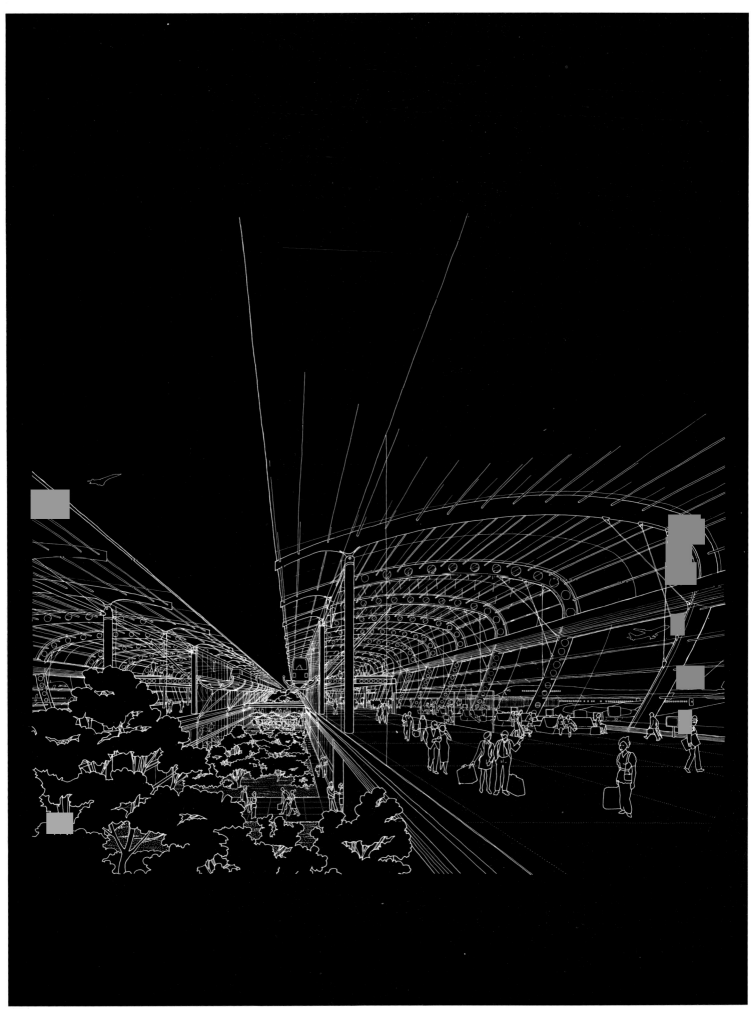

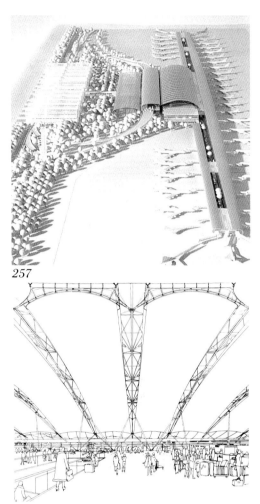

257

258

Fig. 256. View of the holding lounge
Fig. 257. Competition model
Fig. 258. International departures hall

Interviews

Architecture and Workshop
Vittorio Gregotti, Renzo Piano

Gregotti: . . . you often talk about craftmanship in architecture. How important is it for you to experiment with materials, to physically play with them?

Piano: It is an instinctive taste within me, since I came to architecture through the building site rather than through the intellectual route. My first five years of professional activity were in effect "playing around in the water"; my buildings were designed in this way, they were not really architecture. Then I discovered with satisfaction—but only at a later date I must admit—that my approach to the craft of architecture was one of the ways of tackling the profession, in a diverse and primitive manner. This allowed me to overcome the dissociation that prevails in the profession between thinking and doing.

Gregotti: Which is your favorite architect of the past?

Piano: Clearly, Brunelleschi, also because he designed his own tools.

Gregotti: Therefore, Brunelleschi versus Alberti.

Piano: Certainly. I detest the distance and detachment of Alberti, while I prefer Brunelleschi's close relationship with the building site. I also enjoy designing the tools to make architecture. For example, for the Menil Museum in Houston we designed some of the tools for the architecture, such as the molds for the ferrocement elements and the supporting structure. This seems very similar to the production chain of a motor vehicle, but it is not high technology, it is simply the appropriate way of making a slightly complex object.

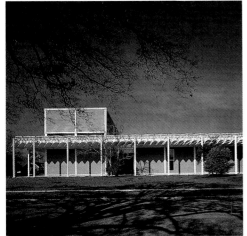

Menil Collection Museum

Gregotti: How do you square your interest in craftmanship, and hence in experimentation, with the question of providing a theoretical foundation to your work, a problem that faces all designers today. Such theoretical foundations are extremely hard to define, because we would all love to be able to take them for granted and work within a given framework.

Piano: I must confess that I am not sure to what extent I am able to do this. As you have said, I really interrogate myself and am always ready to receive. But invariably I cannot start a project from its theoretical framework and then work my way to the detail. I always follow a double process, I try to comprehend the ideological reasons for the project, what lies behind it, what constitutes its social and formal innovation, its functional requirements, the context within which one works with respect to fellow practitioners, and at the same time I find it difficult to divorce these issues

Extracts from a discussion that took place in Milan on 4 June 1986 between Renzo Piano and Vittorio Gregotti, published in the 9H Gallery catalogue for the Piano exhibition held in the gallery in 1987.

from my initial design sketches on grubby bits of paper that I take everywhere, with designs of junctions, bolts, and the smallest details. I cannot separate the two. Normally I start at this level, where I have the excuse of artisan experimentation, which I greatly enjoy.

Gregotti: I would like to better understand your idea of enjoyment, which you seem to define as a motivating force for your work. Does it have to do with the satisfaction of resolving a problem or with exchange with other people?

Piano: The exchange with others also matters. One of the disasters of our profession is that there is much talk of interdisciplinary activity, but in effect it does not exist. There is a cascade relationship between different disciplines, so that one expert does something, then passes it on to someone else, and so on, but rarely does one experience a "coming and going" relationship. I like to enjoy this relationship and to discover the elasticity of reasoning with others. I feel that this reciprocal process between different disciplines has worked seriously in many of my projects. Should you ask me who came up with a particular solution, I would no longer know in the end. Clearly, I am always involved, in so far as I am responsible for the team, but this way of working is in effect quite complex. Undoubtedly, there is great pleasure in discovering things with others.

Gregotti: You have a professional practice, you do not write or teach. Do you miss these activities or do you find them a bit superfluous?

Piano: I have reached the conclusion that if there is any didactic role at all that I can carry out, it is to continue what I am doing, as well as possible, focusing on the problems and then discussing them with others, such as yourself, from which publications and books will emanate.

Gregotti: Therefore, your office takes on the didactic role of a workshop?

Piano: There is no point in trying to teach something to those who come to the workshop, because we cannot take more than two new persons in each office per year. Clearly, whoever has spent three or four years in the workshop leaves with a certain "baggage." Furthermore, it is the reputation of the workshop itself, outside its own walls, through the press, that performs a didactic role.

Gregotti: In other words you see the workshop as some sort of substitute for teaching. What about the problem of writing?

Schlumberger Factories

Piano: I really do not know how to write. I write badly, and my ideas turn out to be confused. I write principally through my work.

Gregotti: I put this question to you to establish the importance that you give to the office, to the workshop, in relation to contemporary institutional instruments of communication within the profession.

Piano: I find this an important theme because a number of things have changed in our profession since the nineteenth century. We certainly live within a different type of scientific-technological culture. But you must accept that a systematic process of culturization, of "digestion" of this new mode of operating and of building, has not been done well. I am not suggesting that I do. Building is about putting together material elements. I feel that one needs to invent something new but at the same time quite old within our craft; to return to the close association between thinking and doing, to return to architecture as a service. I therefore believe that it is not only important but also right and proper to experiment with the world of languages that derives from the use of new materials, even if this incurs the risk of being labelled high tech or fashionable.

Gregotti: You lived without this preoccupation for many years . . .

Piano: Certainly, also because the physical mode of making architecture has never been revolutionized so much.

Gregotti: I have a different view on this subject. I believe that nowadays this great acceleration in the transformation of the mode of making architecture does not exist. There is a superficial acceleration, an acceleration of techniques . . .

Piano: It does exist, but is highly mystified. Take timber, for example. Nowadays it is used in a completely different and more reliable way than before. Adhesives constitute the revolution in materials that soldering constituted in the nineteenth century. There is no doubt that we are handling marvelous new materials.

Gregotti: Nowadays we experience transformations that are not very structural, to use an out-of-date term. . . . We invest much effort in updating technological themes because we have been stripped of grand problems, of real grand objectives. Basically there is a great crisis of objectives, and we end up being preoccupied with secondary issues with respect to these objectives.

Piano: Yes, it is true that we have lost these aims and objectives, but there is no reason why we cannot invent things in this sense. You are saying that the workshop operation should not only be carried out on physical aspects of architecture but also on invention, on the functional dimension, on ideological invention in architecture, in other words, on what architecture is for. . . . This is what I call starting from the particular. Probably I am better at starting from the particular, but I never forget the general.

Gregotti: You are often referred to as a "non-architect." How do you see your "not being an architect" as part of your professional framework? Sometimes it seems that you consider it a positive factor.

Piano: You know, life has its up and downs. At times I consider myself totally as an architect, and it gives me some pleasure to be seen as being outside the "church" because of my origins and ways of practicing architecture. At other times, though, I feel the lack of sensitivity and attention to historical references that probably are of great importance. But this does not imply that I am insensitive to history, because my interest in historic city centers is most genuine.

Gregotti: You claim that you are outside a certain "church" of architects—a claim I strongly disagree with—but on the other hand you are professionally very successful, and, above all, many of your clients are quite well off, not ordinary working-class folk. Do you therefore think that there is a sort of ideal coincidence between your approach and a high-level, advanced, even enlightened industrial class?

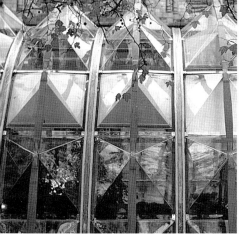

IBM Travelling Exhibition

Piano: I think not, and I have often wondered about it. I have never discriminated against clients. My attitude is quite generous and not too calculating. Some of my clients, as you say, are extremely well off, but I also work for public authorities, and UNESCO, whose budgets are practically nil.

Gregotti: Yes, but it is not this that matters so much. It is more a question of the ability to represent a certain type of society rather than a question of spending power.

Piano: De Menil, Schlumberger, FIAT, and IBM are not my only clients . . .

Gregotti: No, but they are identified with your architecture. Do you feel that this has happened by chance or because you stand outside the "church" of architects, that you are more comprehensible, or that they trust more in you because you are, so to speak, less intellectual?

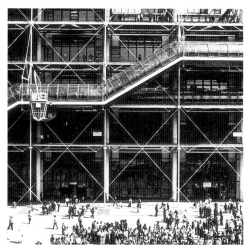

Centre Georges Pompidou

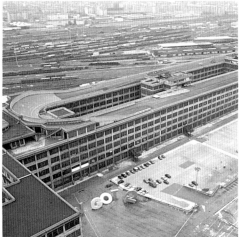

Lingotto Factory

Piano: No one has ever said this to me, but often—I must confess—some have openly said that they trust me because I am less neurotic.

Gregotti: You are also neurotic, but a compensated neurotic. What I mean is that your apparently, and only apparently, anti-intellectual stance—intellectual in terms of the convention of intellectuality—provides the vehicle that permits a certain type of relationship with these social circles. What do you think?

Piano: It is possible that my image is more professional that intellectual.

Gregotti: Another question that relates to your identification with the idea of the architect is that of your relation to the question of duration, to use Braudel's definition of the term, a question that concerns many architects today.

Piano: I have built many temporary structures for the simple reason that my approach, experimental as it is, is by its very nature temporary. It is difficult to do anything experimental, especially if you are young, unless it is temporary. If, for example, you consider the IBM building, it was possible to realize it as we did only because it was supposed to travel to twenty different European cities, including countries where building regulations are crazy, but we succeeded because we were dealing with a temporary structure. Therefore, the idea of experimentation in my work fits well with the concept of temporariness. But I have also had to deal with the problem, still quite unresolved to my mind, of buildings that are to last 300 years but that one treats as an aspect of temporariness, such as the Beaubourg.

Gregotti: But the Eiffel Tower, to which your building has often been compared, will last for several centuries, and it is structurally a temporary construction. It can therefore take on meanings in the much longer term that were not intended in the first place. Nowadays, the extremely complex problem of the urban fabric confronts many architects. How do you attempt to resolve this contradiction in your urban projects, such as the Lingotto area in Turin, or the Bicocca area in Milan? The question of the duration of an urban structure and its transformation is fundamental, even though the problem today is not one of urban expansion but of internal transformation.

Piano: Certainly this is a problem, a contradiction that I experience and feel. But I would not like to hide the fact that ours is a difficult craft.

Subversion, Silence, and Normality

Vittorio Magnago Lampugnani, Ermanno Ranzani, Renzo Piano

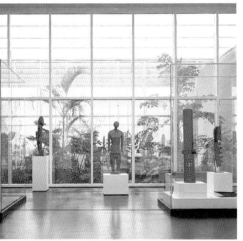

Menil Collection Museum

Originally published as "Sovversione, silenzio e normalità" in Domus, no. 688 (Nov. 1987): pp. 17–24.

Piano: What I'm interested in is "doing architecture." I try to work in a completely normal way, one that is not governed by any high moral standard. It's unusual for me to start on a project straight away. I feel bound by a kind of discipline to restrain myself and allow elements to accumulate for a while, sometimes over quite a long period. It may even take a year.

When the projects are of a highly complex nature, they need to be "assimilated slowly"; knowledge has to be stored up, and you must know how to wait in silence, perhaps wandering around the chosen site with your hands in your pockets. During this period of silence, something else is happening: the historical and climatic aspects, which have conditioned the surroundings through the centuries, are absorbed and linked together. I've never had, even from my best organized clients, a clear and precise plan. Often where there is one you need to be careful. This is the moment in which systematic disobedience is called for: not a stupid but an urbane form of disobedience. On other occasions, however, there's no plan whatsoever, just a vague idea. I have in mind the project for the Museum of Houston (the Menil Collection). My client came up with it after passing through several stages lasting twenty years. She started off with Philip Johnson. Then she contacted two other designers before Kahn. But when he died, the whole thing came to a halt. Since the idea of the museum existed in her mind, I had to understand the woman in order to interpret her proposition. For an entire year I reflected on this idea of a museum that exhibits everything but at the same time is a sort of strongbox in which everything is conserved in a perfect state. A museum with a view to safeguarding everything there is for future generations. Also, every so often some exhibit or other is to be "taken out" and placed within a given context. All of this I gradually came to apprehend during the periods of my and my client's silence. You must know how to listen, to make this effort to understand what your clients want and come up with the right answer on the basis of their tastes, aspirations, and needs. I'm not saying this for moralistic reasons but because I'm deeply convinced that only by successfully going through this normal stage is it possible to become an architect who can invent something significant today. The question of listening and silence is very important and complex; it is not one of absolute blind obedience. It is similar with *participation*, which consists in disobeying, but in the sense that we strive, understand, and at a certain point carry out our diabolic task of bringing together everything that has been understood and in the way it has been understood. This is the magic moment, so important and complex, in which, as understanding dawns on you, you start off gradually by doing a few small drawings, jotting down some work notes (what Calvino called his making preparations) and then you "stitch" it all together. I don't believe in the effectiveness of participation understood as so many people around a

table, each voicing his own opinion. The architect can never abandon his specific role of providing the form. This kind of participation involving several persons doesn't work, because almost all of them have been conditioned disastrously by the mass media, by existing models. On the other hand, I also believe that the lack of participation, the inability to listen, is at the root of the vices in our profession. Participation is almost a dirty word. It's been much mystified and abused. Many wild experiments have been tried that have never produced any architecture!

Lampugnani: So, for you, participation means listening, trying to understand, evaluating and then deciding on the basis of what you know and the ideas you accumulate by questioning other experts.

Piano: Yes. And then you find yourself all alone and you make a decision.

Lampugnani: And it's at that point that the project gets under way.

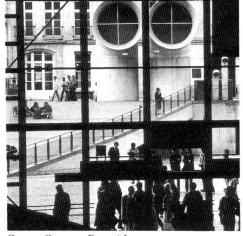

Centre Georges Pompidou

Piano: It's not the case, however, that everything works without a hitch, that it all comes together "as if by magic." In my way of working, I never start a project merely on the basis of just a philosophy. Right from the first moment I think about materials, modes, "tekhnē," about which process to adopt and the right material for it. There are two reasons for this: first, because one of the elements related to climate, history, and context is the material and, second, you may want to reverse the connection (an absurd and uncivil example is the Beauborg in the middle of Paris). Then you begin working on these aspects almost at once. In addition, there is the budget to be considered. To me, the start of a project is a magic moment in which nothing has as yet been designed, but the design encompasses everything. I proceed on two parallel levels: one starts from what is general and the other from what is particular. These two areas meet and, thereafter, remain linked together. This process of getting under way is important, just as it is not to disjoin the two areas later on, not to separate the phase of conception from that of design. I have also succeeded in *creating* a relationship with the builder—traditionally one of hostility—in which I immediately bring him over to my side by using his skills as the organizer, coordinator, and person who looks into matters of technique and budget problems. We work in tandem from the very outset.

Lampugnani: Among the various design requirements we've listed, are there any to which you give priority? Like, for example, the technological and constructional side? I believe there's a kind of architecture in which the method of building is not so important, whereas in your architecture it is strictly connected to the way of designing.

Piano: That's true, even though I don't have a fixed attitude. In the last twenty years it's changed a great deal regarding many things. I came to architecture by being the son and brother of builders, for the simple joy of building. Later professional involvement and experience, including the Beaubourg, led me to combine these aspects with functional, even polemical and provocative, inventiveness. They have progressively modified my attitude. I'm aware of a change between what I did before and what I'm doing now. Now, for example, greater importance is attached to context. At the start of my career, all the pleasure consisted of making an object, in manipulating it. It's true what you say, in my architecture the way something is built is important. That explains why it often slips into decoration and a taste for high tech, the pure delight of exhibiting . . .

Lampugnani: . . . technological formalism . . .

Piano: . . . which, at least, is just as terrible, ingenuous, and academic as the historicist variety. This risk always exists—one I don't always manage to avoid because the practice of design, its language and mode of expression, which lie behind what I've been saying, are impervious. So a few slip-ups occur. But I want to make it clear that I now understand the point at which building in a certain way turns into self-decoration, gratuitous exhibitionism. I don't want to be taken for a moralist when I say that we must listen to our client and become great, skillful designers. I insist on the need to engage in a multi-disciplinary activity based on handicraft. When I speak of the need to listen I don't mean just to clients or colleagues but also to the engineer and scientist working with you. In talking about new craftsmanship and about reacquiring the design process in its integrity, I view this capacity to combine different experiences in the creative process, not in a theoretical but in a serious manner, also as a stage that must be gone through for one to achieve sincere architecture. I'm deeply convinced of this. It all makes possible the realization of an architecture that is an expression of language. This language is examined, invented, and tried out by systematically reinventing materials and certain processes, uses, or functions, which are coerced or turned inside out. It's not an easy task, but it's the only possible way to try to create a language that is an authentic expression of our century, a century that is drawing to a close, which has revolutionized everything, especially society but also materials and processes and old beliefs, such as that in the modular system, for reasons of economy, now rendered obsolete by informalized systems. I have taken some heavy falls throughout my career. This is also part of venturing over unfamiliar ground. I'm aspiring to the same professional dignity that, perhaps, the architect as designer enjoyed in the sixteenth century: the architect as *machinatore* who invents and designs something, as well as the instruments to make it with,

and then builds it down to the last detail. A dignified figure with a place in life, a real figure.

Lampugnani: Do you think it possible to recuperate this integral figure of the artist despite everything that occurred in the nineteenth century, despite specialization and technological progress?

Piano: In my own case it has been possible, even though I'm a totally normal person. Perhaps, to be able to to it, you need vigorous skills, very strong bargaining power, and also a large team—mine is deliberately composed of forty to fifty persons, the widest range that allows a creative relationship with each individual. You may also need a fairly international structure, an office with a telex and telecopier and staff who know foreign languages. The jobs you do may also have to be on a very large scale. At the moment we have four projects with a budget of over 200 thousand million Italian lire ($150 million). This allows us to "experiment," because the pacing up and down and hard thinking I boast about is not possible when the job has to be done quickly; otherwise you won't get paid. So it is possible, but we must also return to the architect's former role. And this brings us back to the well-known line about the craft nature of our profession, in the former noble sense of the word but also in its modern connotation. Our tools are no longer the plane and the saw. They are the computer and experimental systems regarding which we know to whom to turn for the basic tests that permit a project to move forward. Handicraft yes, but well equipped for a complex and hazardous journey.

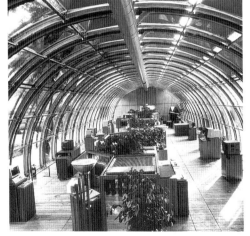

IBM Travelling Exhibition

Lampugnani: In my opinion, your projects are all characterized by a high degree of innovation that derives from this whole series of experiments. When it's a pavilion for IBM, it's more than obvious that innovation is required, since it's a construction invented *ex novo* with an entirely new technology and with completely new requirements; you have to devise an entire series of details. Why is it that this also applies to a museum like the one in Houston, which as an architectural type is now well established? And why does it also apply to dwellings like those you built near Milan?

Piano: You mean, might one not take pleasure in creating a problem each time in order to be able to discover a "more clever" solution than the last?

Lampugnani: Or isn't it one of your obsessions as an architect to find the stimulus to make objects that are always new?

Piano: After the Beaubourg, after that act of loutish bravado, I realized that the limit to a certain kind of attitude had been reached, fortunately a

somewhat ironic one. I insist that the Beaubourg is ironic. Don't talk to me of high tech; that's not high tech but a machine, a submarine, a Jules Verne ship. It's not high technology but a joke, the irony of technology. At that time I started to perceive in a systematic fashion the *dangers* of high tech, because through the Beaubourg people associated me, perhaps mistakenly, with a certain kind of architecture. I was indulging a bit self-critically in the pleasure of devising something complicated and then solving it. That's the way it often turned out, but now it's much rarer because I'm aware of it.

Lampugnani: So the irony disappeared after the Beaubourg?

Piano: Perhaps it's now more of a self-critical irony: viewing things with a certain detachment. One of the most important things I keep in mind when starting a project is to have sufficient detachment to be ironic about myself.

Lampugnani: Do you think that irony is a necessary quality for living in the post-modern age?

Piano: Yes. Irony is also a defensive weapon. It would be quite dreadful not to give it expression in one's work. I believe as well that our profession has been terribly solemn and taken itself too seriously . . . the whole modern movement . . . I find what the post-modern movement has taught the younger generations distasteful and dangerous. They no longer understand anything and think practicing architecture involves simply quoting from others. The refusal to take oneself seriously at all costs is sacrosanct, a kind of disobedience! Unfortunately, however, the post-modern movement often relapses into the same "seriousness." What's needed at the present historical moment in architecture, in this last part of the century, is to undermine some of the rules. I would like to think I've made a contribution, even a small one, to subverting rules, but in the right direction, the direction of normality, that is, as part of a world of humanists that—and this must be admitted—has provided science with much creativity.

The enjoyment in making, for example, a junction in a particular way is also the desire to render a process comprehensible. In the last century welding was invented to hold materials together. In ours, through the revolutions in chemistry especially in the last twenty years, a new technique is being developed, that of welding together different types of material. One takes pleasure, therefore, in using the latest adhesive or chemical invention from Germany, but the absurdity is that they are stuck to beechwood or aluminum. I don't know whether this is irony, but it's certainly enjoyable to bring out these elements and make them legible.

Lampugnani: Does the possibility also exist to free oneself from always having to use the latest technology available? Can one choose between the latest technology and the oldest, the most traditional, so as to obtain an increasingly appropriate result?

Piano: Yes. For a project we're doing in Cagliari we're using both stone and glass. Glass is one of the most fantastic materials; it can even be bent at right angles. Never mind carbonates and plastics! It's true, there's enjoyment in the contradiction that is not eclectic.

Lampugnani: Do you share the quite widespread opinion in philosophy, and in architecture as well, that a utopia is impossible to realize?

Piano: I'm not a utopian. The dream lies in what has been said so far. In it there is a strong wish to dream. This desire of mine to contribute toward dissolving this great confusion and to construct a kind of architectural language, also composed of memory through both materials and forms, is a sort of utopia.

Lampugnani: Returning to what you said at the start about your endeavor to keep up with the present times in your work, which fellow-travellers do you find around you at the moment?

Piano: I pay careful attention to what everyone else is doing, and I manage to learn something from almost all of them. But regarding fellow-travellers, there's no one in particular. It may be that I'm not able to see them. Often, despite the respect I feel for everyone, I fail to identify the myriad forms of ferment that definitely exist. I'm astonished they're not visible, that they haven't coagulated. In fact, I confess I'm surprised that it hasn't become normal practice to seek out a line of expression that, toward the end of the century, may end by "assimilating" its inventions, including those in the social area. Everything needs to be invented. However, it's true that there's the problem of how to express this dislocated world of ours and its language, too. This work needs to be done; if we don't get started, we won't find a solution. There's also the concept of memory. I don't spend all my time just joining two pieces together, I also reflect on themes such as rhythm and cadence, keeping in mind as well the fact that one translates ideas through a certain type of material. I'm much more reluctant to understand the concept of memory as the quoting, even intelligently, of a form.

Ranzani: How do you think your method can be passed on?

Piano: This is a problem I've thought about quite recently. I don't put my

thoughts down in writing, because I'm not able to. So, regarding the didactic aspect, I'd need a lot of time to do it seriously. I believe that the best and most honest thing for me is to immerse myself totally in work as I do now, full-time without any shortcuts, and then on some occasions to try to test myself through writing and interviews. How do you talk to a youngster about methodical approach, patient playful activity, building up skills, the art of listening and of silence. It's no good just talking to him about such matters; you must make him see them, experience them with him. Take him to your workshop, make him sit down for a while and see how you remain silent. The important thing is for him to live through the experience.

Bibliography

Magazines

R. Piano, R. Foni, G. Garbuglia, L. Tirelli, M. Filocco, "Una struttura ad elementi standard per la copertura di medie e grandi luci," *La Prefabbricazione* (1/1966).

Z. S. Makowski, "Structural Plastics in Europe," *Arts and Architecture* (8/1966), pp. 20–30.

M. Scheichenbauer, "Progettare con le materie plastiche," *Casabella* 316 (1967).

"Ricerca sulle strutture in lamiera e in poliestere rinforzato," *Domus* 448 (3/1967), pp. 8–22.

Il grande numero, *Domus* 466 (9/1968).

"Nuove tecniche e nuove strutture per l'edilizia," *Domus* 468 (11/1968), p. 6.

"Uno studio-laboratorio," *Domus* 479 (10/1969), pp. 10–14.

R. Piano, "Progettazione sperimentale per strutture a guscio," *Casabella* 335 (1969).

R. Piano, "Experiments and Projects with Industrialised Structures in Plastic Material," *PDOB* 16/17 (10/1969).

Z. S. Makowski, "Plastic Structures of Renzo Piano," *Systems, Building and Design* (2/1969), pp. 37–54.

R. Piano, "Nasce con le materie plastiche un nuovo modo di progettare architettura," *Materie plastiche ed elatometri* (1/1969).

Z. S. Makowski, "Les structures plastiques de Renzo Piano," *Plastique batiment* 126 (2/1969), pp. 10–17.

R. Piano, "Italie recherche de structure," *Techniques et Architecture* (5/1969), pp. 96–100.

Z. S. Makowski, "Strukturen aus Kunststoff von Renzo Piano," *Bauen + Wohnen* (4/1970), pp. 112–21.

"Un cantiere sperimentale," *Casabella* 349 (1970).

R. Piano, "Il Padiglione dell'Industria Italiana all'Expo 70 di Osaka," *Acciaio* (11/1970), p. 1.

A. Cereda, "Alcune recenti esperienze nel campo della industrializzazione edilizia–tre architetture di Renzo Piano," *Lipe* (3/1970), pp. 1–12.

"Renzo Piano: *Architecture and Technology*," (translated by T. M. Stevens), *AA Quarterly* (7/1970), pp. 32–43.

"Renzo Piano," *Architectural Design* (3/1970), pp. 140–45.

"Italian Industry Pavilion, Expo 70, Osaka," *Architectural Design* (8/1970), p. 416.

"Il poliestere rinforzato protagonista del padiglione dell'industria italiana," *Materie plastiche ed elastometri* (5/1970), pp. 470–77.

"Rigging a Roof," *The Architectural Forum* (3/1970), pp. 64–69.

"Renzo Piano verso una pertinenza tecnologica dei componenti," *Casabella* 352 (1970), p. 37.

"L'Italia a Osaka," *Domus* 484 (3/1970).

"Industrialisierung," *Deutsche Bauzeitung* (4/1971), pp. 405–7.

"Industrial Building," *Architectural Forum* (4/1971).

"Piano e Rogers: Beaubourg," *Domus* 503 (10/1971), pp. 1–7.

R. Piano, "Per un'edilizia industrializzata," *Domus* 495 (2/1971), pp. 12–15.

R. Piano, "L'acciaio nell'edilizia industrializzata," *Acciaio* (11/1971), pp. 1–4.

"Le materie plastiche nella produzione edilizia per componenti," *Materie plastiche ed elastometri* (5/1971).

"Grand Piano," *Industrial Design* (10/1971), pp. 40–45.

M. Cornu, "Concours Beaubourg, 'Est-ce un signe de notre temps?' " *Architecture, Mouvement, Continuité* (11/1971), pp. 8–9.

"Projects de lauréats," *Techniques et Architecture* (2/1972), pp. 48–55.

"Le projet lauréat," *Paris projet* 7, pp. 48–57.

"Paris, Centre Beaubourg," *Deutsche Bauzeitung* (9/1972), pp. 974–76.

"A Parigi, per i parigini l'evoluzione del progetto Piano + Rogers per il Centre Beaubourg," *Domus* 511 (6/1972), pp. 9–12.

"Aktualitat: Esso Tankstellen Wettbewerd in Italien," *Bauen + Wohnen* (6/1972), p. 280.

"Padiglione dell'Industria Italiana all'Expo 70 di Osaka," *Casabella* 3/1972).

"Centre Culturel du Plateau Beaubourg," *L'Architecture d'Aujourd'hui* 168 (7/8/1973), pp. 34–43.

"Piano + Rogers," *L'Architecture d'Aujourd'hui* 170 (11/12/1973), pp. 46–58.

"Centre Plateau Beaubourg," *Domus* 525 (8/1973).

"Edificio per gli uffici B&B a Novedrate," *Domus* 530 (1/1974), pp. 31–36.

"Beaubourg en transparence," *Architecture intérieure* 141 (6/7/1974), pp. 72–77.

"Piano," *Zodiac 22*, pp. 126–47.

"Centre Beaubourg a Paris," *Techniques et Architecture* 300 (9/10/1974), p. 58.

"Factory Tadworth, Surrey," *The Architectural Review* 934 (12/1974), pp. 338–345.

"Piano e Rogers, B&B Italia Factory," *Architectural Design* (4/1974), pp. 245–46.

"Le Centre Beaubourg," *Chantiers de France* 68 (1974), pp. 1–6.

"Expressive Einheit von Tragkonstruktion und Installationsanlagen," *Bauen + Wohnen* (2/1974), pp. 71–74.

"A Parigi musica underground," *Domus* 545 (4/1975), pp. 9–12.

R. Bordaz, "Le Centre Georges Pompidou," *Construction* (9/1975), pp. 5–30.

"Etablissement publique du Centre Beaubourg, Paris," *Werk oeuvre* 2/1975), pp. 140–48.

P. Rice, "Main Structural Framework of the Beaubourg Center, Paris," *Acier, Staahl, Steel* (9/1975), pp. 297–309.

"Piano + Rogers," *Architectural Design* 45 (5/1975), pp. 75–311.

F. Marano, "Una struttura tubolare per un nuovo edificio per uffici a Novedrate," *Acciaio* (2/1975), pp. 1–7.

P. Rice - L. Grut, Renzo Piano: la struttura del Centre Beaubourg a Parigi," *Acciaio* (9/1975), pp. 3–15.

K. Menomi, "Nel prato una struttura policroma. Edificio per uffici B&B," *Ufficio stile* (6/1976), pp. 76–79.

"Piano + Rogers: Architectural Method," *A + U* 66 (1976), pp. 63–122.

"L'IRCAM, Institut de recherche et coordination acoustique/musique," *Chantiers de France* (9/1976), pp. 2–13.

"IRCAM Design Process," *RIBA Journal* (2/1976), pp. 61–69.

"Strukturen und Hullen," *Werk oeuvre* (11/1976), pp. 742–48.

"Piano & Rogers, Beaubourg Furniture Internal System Catalogue," *Architectural Design* 46 (7/1976), pp. 442–43.

"Novedrate Italia, Edificio per uffici," *Architecture Contemporaine* (4/1976), pp. 35–37.

"Centre National d'Art et de Culture Georges Pompidou, Paris," *Domus* 566/575 (special issue) (1/10/1977), pp. 5–37.

"P. Restany, C. Casati, Parigi: l'oggetto funziona!," *Domus* 575 (10/1977), pp. 1–11.

"Le défi de Beaubourg," *Architecture d'Aujourd'hui* 189 (2/1977), pp. 40–81.

"Frankreichs Centre National d'Art et de Culture Georges Pompidou Paris," *Bauwelt* 11 (3/1977), pp. 316–34.

"Piano + Rogers," *RIBA Journal* 1 (1/1977), pp. 11–16.

"Centre National d'Art et Culture Georges Pompidou," *Domus* 566 (1/1977), pp. 3–37.

"Centre Georges Pompidou," *AD Profiles* 2 (1977).

"Piano & Rogers 4 progetti," *Domus* 570 (5/1977), pp. 17–24.

"The Pompidolium," *The Architectural Review* 161, no. 963 (5/1977), pp. 270–94.

M. Fadda, "Dal Beaubourg al progetto collettivo," *Laboratorio 1*, no. 1 (4–6/1977), pp. 69–73.

"G. Neret, Le Centre Pompidou," *Connaissance des Arts* (1977), pp. 3–15.

"J. Futagawa, Centre Beaubourg: Piano + Rogers," *GA Global Architecture* 44 (1977), pp. 1–40.

"Le Centre Beaubourg," *Ministère des Affaires Culturelles Ministère de L'Education National* (1977).

"Staatliches Kunst und Kulturzentrum Georges Pompidou/Paris," *DLW - Nachrichten* 61 (1977), pp. 34–39.

"Intorno al Beaubourg," *Abitare* 158, (10/1977), pp. 69–75.

R. Piano, "Mobilités de hypothèses alternatives de production," *Werk-Archithese* 11–12 (11–12/1977), p. 32.

C. Mitsia, M. Zakazian, C. Jacopin, "Eiffel vs Beaubourg," *Werk-Archithese* 9 (1977), pp. 22–29.

J. Bub, W. Messing, "Centre National d'Art et de Culturé G. Pompidou ein Arbeitsbericht von zwei Architekturstundenten," *Bauen + Wohnen* 4 (4/1977), pp.132–39.

R. Piano, "Per un'edilizia evolutiva," *Laboratorio* (9–11/1977), pp. 7–10.

"Piano & Rogers," *Architectural Design* 47, no. 7–8 (1977), p. 530.

G. Lentati, "Centro Beaubourg, un'architettura utensile," *Ufficio stile*, 10, no. 5 (1977), pp. 74–87.

P. Chemetov, "L'Opera Pompidou," *Techniques et Architecture* 317 (12/1977), pp. 62–63.

M. Cornu, "Ce diable Beaubourg," *Techniques et Architecture* 317 (12/1977), pp. 64–66.

A. Darlot, "Le centre national d'art et de Culture G. Pompidou," *Revue Francaise de l'electricité* 50, no. 259 (12/1977), pp. 48–55.

R. Continenza, "il centro nazionale d'arte e cultura G. Pompidou a Parigi," *L'ingegnere* 53, no. 6 (6/1978), pp. 187–98.

A. Paste, "Il Centro d'Arte e di Cultura G. Pompidou," *L'industria delle costruzioni* 76 (2/1978), pp. 3–30.

"Centro Beaubourg Paris," *Informes de la Construccion* 30, no. 299 (4/1978), pp. 13–23.

G. Biondo, E. Rognoni, "Materie plastiche ed edilizia industrializzata," *Domus* 585 (8/1977), pp. 25–28.

"Tipologie evolutive," *Domus* 583 (6/1978), pp. 12–13.

"Esperienze di cantiere. Tre domande a R. Piano," *Casabella* 439 (9/1978), pp. 42–51.

"Tipologie evolutive., lo spazio costruito deve adattarsi all'uomo," *Domus* 587 (10/1978), pp. 30–31.

"IRCAM," *AA* 199 (10/1978), 52–63.

"Da uno spazio uguale due cose diverisissime," *Abitare* 171 (1–2/1979), pp. 2–21.

"Wohnboxen in Mailand," *MD.* (6/1979).

L. Wright, "Heimatlandchaft," *The Architectural Review* 166, no. 990 (8/1979), pp. 120–23.

R. Continenza, "L'opera di Piano & Rogers," *L'Ingegnere* 54 (10/1979), pp. 469–85.

"Mobiles-Quartier Laboratorium," *Bauen + Wohnen* (9/1979), pp. 330–32,

"Per il recupero dei Centri storici. Una proposta: Il Laboratorio di quartiere," *Abitare* 178 (10/1979), pp. 86–93.

"Una recentissima proposta di R. Piano: Laboratorio mobile per lavori di recupero edilizio," *Modulo* 7/8 (1979), p. 855.

"Il Laboratorio di quartiere a Otranto," *Domus* 599 (10/1979), p. 2.

L. Rossi, Piano + Rice + Ass., "Il Laboratorio di quartiere," *Spazio + Società* (8/12/1979), pp. 27–42.

"Renzo Piano. The Mobile Workshop in Otranto," *ILA & UD Annual Report Urbino 1979*, pp. 60–63.

"Operazione di recupero," *Casabella* 453 (12/1979), p. 7.

"R. Continenza, Architettura e tecnologia aspetti dell'opera di R. Piano e R. Rogers," *Costruttori Abruzzesi* 2 (1979), pp. 15–18.

"Free-Plan Four House Group," *Toshi Jutaku* (2/1980), pp. 14–23.

"Enveloppes identiques-diversité interne Milano-Cusago I," *AC 97*, no. 25 (1/1980), pp. 6–11.

"Fiat's Magic Carpet Ride," *Design* 379 (7/1980), p. 58.

"Centre Georges Pompidou," *Nikkei Architecture* (8/1980), pp. 83–85.

Contemporary Design in Two Cities," *Building & Remodelling Guide* (7/1980), pp. 108–13.

"La technologie n'est pas toujours industrielle," *AA* 212 (12/1980), pp. 51–54.

"Art News," *The Geiutsu Sheischo* (9/1980).

"C. G. Pompidou," *AA* 213 (2/1981), pp. 92–95.

M. T. Mirabile, "Centro Musicale a Parigi," *L'industria delle costruzioni* 114 (4/1981), pp. 68–69.

"Sul mestiere dell'Architetto," *Domus* 617 (5/1981), pp. 27–29.

"Wohnhausgruppe bei Mailand," *Die Kunst* (6/6/1981).

P. Santini, "Colloquio con R. Piano," *Ottagono* 16, no. 61 (6/1981), pp. 20–27.

"Pianoforte," *Building Design* 556 (7/1981), pp. 11–14.

R. Pedio, "Renzo Piano Itinerario e un primo bilancio," *L'Architettura* 11 (11/1981), pp. 614–62.

G. Lentari, "Quale ufficio?" *Ufficio Stile* 6 (1981), pp. 60–69.

R. Piano, "Renzo Piano, Genova," *Casabella* 474/475 (11/12/1981), pp. 95–96.

Ranieri e Valli, "Progetto e partecipazione," *Edilizia Popolare* 163 (11/12/1981), pp. 66–68.

"Piano in Houston," *Skyline* (1/1982), p. 4.

"Renzo Piano monografia," *AA* 219 monographic issue, (2/1982).

"Fiat vettura sperimentale e sottosistemi," *Abitare* 202 (3/1982), pp. 3–9.

"Italia," *Nikkei Architecture* (2/1982), pp. 52–56.

M. Dini, "La città storica," *Area* 5 (6/7/1982), p. 47.

S. Fox, "A Clapboard Treasure House," *Cite* (8/1982), pp. 5–7.

"Renzo Piano Still in Tune," *Building Design* 606 (8/1982), pp. 10–11.

"Piano Demonstration in Texas," *Progressive Architecture* 9 (1982).

M. T. Carbone, "Sei progetti e un fuoco di paglia," *Costruire per Abitare* 5 (12/1982–1/1983), pp. 76–78.

"Tecnoarchitettura vettura sperimentale e sottosistemi," *Ottagono* (3/1982).

"People's office e ufficio fabbrica," *Ufficio stile* (4/1982), pp. 49–52.

"Abitacolo e abitazione," *Casabella* 484 (10/1982), pp. 14–23.

"Renzo Piano," *The Architectural Review* 1028 (10/1982), pp. 57–61.

L. Sacchetti, "Si chiude la scena, comincia il congresso," *Costruire per Abitare* 3 (10/1982), pp. 117–20.

"Il Centro Congressi del World Trade Center Italiano," *Ufficiostile* 15, no. 67 (1982), pp. 24–30.

"La macchina espositiva," *Abitare* 212 (3/1983), pp. 90–91.

A. L. Rossi, "La macchina climatizzata," *Domus* 638 (4/1983), pp. 10–15.

P. A. Croset, "Parigi 1989," *Casabella* 47, no. 490 (4/1983), pp. 18–19.

M. T. Carbone, "Renzo Piano: Il molo degli specchi, il cantiere di quartiere," *Costruire* 5 (12/1982–1/1983), pp. 76–78.

G. Ferracuti, "Il Laboratorio di Quartiere," *Recuperare* (3/4/1983), pp. 120–23.

"Tra il dire e il fare," *Costruire* 9 (5/1983), p. 71.

C. Béret, "L-espace-flexible," *Art Press* 2 (6/8/1983), pp. 22–23.

"Design of the Future," *Wave* (4/1983), pp. 51–54.

B. Costantino, "Taller de Barrio: Coloquio con Renzo Piano y Gianfranco Dioguardi," *Modulo* 11 (6/1983), pp. 20–33.

"Des Technologies nouvelles pour l'habitat ancien," *Tecniques et Architecture* 348 (6/7/1983), pp. 51–61.

O. Pivetta, "Postindustriale sarà lei," *Costruire* 12 (9/1983), pp. 100–5.

"Piano Machine," *The Architectural Review* 169, no. 1038 (8/1983), pp. 26–31.

M. Pawley, "Piano's Progress," *Building Design* 23 (9/1983), pp. 32–34.

M. Brandli, "L'allestimento di Renzo Piano per la mostra di Calder," *Casabella* 47, no. 494 (9/1983), pp. 34–36.

J. P. Robert, "Un Chantier experimental a Montrogue," *Le Moniteur* 40 (9/1983), pp. 60–67.

O. Fillion, "Schlumberger a Montrouge," *Architecture Interieur* 196 (9/1983), pp. 118–23.

"Un boulevard flottant," *Urbanisme* 197 (9/1983), pp. 44–45.

S. Boidi, "Io, il mestiere, i miei strumenti," *Costruire* 14 (11/1983), pp. 82, 83, 112.

"Calder a torino," *Domus* 644 (11/1983), pp. 56–59.

"Renzo Piano, artisan du futur," *Technique et Architecture,* 350 (1983), pp. 121–38.

L. Rossi, "La cultura del fare," *Spazio e Società* 6, no. 23 (9/1983), pp. 50–62.

"Piano Rehab," *The Architectural Review* 174, no. 1041 (11/1983), pp. 68–73.

M. Margantini, "Instanbil Sandy Calder," *Modo* 64 (11/1983), pp. 53–57.

R. Pedio, "Retropettiva di Calder a Torino," *L'Architettura* 29 (12/1983), pp. 888–94.

R. Rovers, "Recent Werk van Renzo Piano," *Bouw* 25 (12/1983), pp. 9–12.

G. Plaffy, "R. Piano: Sub-systems Automobile," *Omni* (1/1984), pp. 112–15.

O. Boisière: "Paris x Paris," *Domus* 646 (1/1984), pp. 22–27.

"Una tensostruttura per l'insegna della mostra di Calder a Torino," *Acciaio* 25 (2/1984) pp. 53–57.

M. Fazio, "A Torino Calder," *Spazio e Società* (3/1984) pp. 66–69.

Lingotto, "Piano/Schein," *Building Design* (5/1984), pp. 26–28.

M. Zardini, "Venti idee per il Lingotto," *Casabella* 502 (5/1984), pp. 30–31.

"UUL, Unità Urbanistiche Locali," *Costruire* 20 (6/1984), pp. 36–38.

A. Pélissier, "Renzo Piano, participer, inventer de nouvelles méthodes de travail et des nouvelles maisons," *Histoire de participer* 93 (2/1984), pp. 64–69.

P. Rumpf, "Fiat-Lingotto: Change oder Danaergeschenk fur Turin?" *Bauwelt* 17 (5/1984), pp. 733.

Y. Pontoizeau, "Renovation du site industriel Schlumberger, Montrouge," *L'Architecture d'Aujourd'hui* 233 (6/1984), pp. 14–23.

"Exposition itinerante de technologie informatique," *Techniques et Architecture* 354 (6/7/1984), pp. 144–45.

R. Marchelli, "Un involucro di policarbonato per una mostra itinerante," *Materie Plastiche ed Elastometri* (7/8/1984), pp. 424–27.

"IBM Exhibit Pavilion, Paris Exposition," *Architecture and Urbanism* 168 (9/1984), pp. 67–72.

A. Castellano, "Venti Progetti per il futuro del Lingotto," *La mia casa* 170 (9/1984), pp. 48–51.

"Una mostra itinerante per far conoscere il computer," *Abitare* 227 (9/1984), pp. 4–6.

"The Menil Collection," *Arts + Architecture* (1/1984), pp. 32–35.

C. Di Bartolo, "Creatività e Progetto," *Modo* (10/1984), pp. 36–40.

Y. Pontoizeau, "Projects & Realisations," *L'Architecture d'Aujourd'hui* 235 (10/1984), pp. 59–65.

"Tecnologia: tecnologie leggere," *Modulo* (10/1984), pp. 1003–9.

"L'Expo IBM," *GA Document* (11/1984).

"Beaubourg analogo," *Rassegna* (9/1984), pp. 94–97.

"Un'arca veneziana per i suoni di 'Prometeo," *AD/Mondadori* (11/1984), pp. 48–50.

"Arcadian Machine," *The Architectural Review* 1053 (11/1984), pp. 70–75.

A. Mladenovic, "Renzo Piano," *Nas Dom* (9/84), pp. 26–29.

Boeri e Crosety, "Dinosaur With a Brain," *Blueprint* (11/1984), pp. 12–13.

"Riflessioni sul 'Prometeo,' " *Casabella* 507 (11/94), pp. 38–39.

R. Pedio, "Exhibit IBM, padiglione itinerante di tecnologia informatica," *L'Architettura* (11/1984), pp. 818–24.

A. Castellano, "Renzo Piano e l'Arca del Prometeo," *La mia Casa* 173 (12/1984), pp. 48–53.

"Piano + Nono," *The Architectural Review* 1054 (12/1984), pp. 53–57.

"Renzo Piano and His Methods," *SD 85–01 High-Tech* 244 (1/85), pp. 47–67.

G. Simonelli, "La grande nave lignea," *Modulo* (3/1985), pp. 164–70.

"Prometeo," *Interim* 348 (3/1985), p. 73.

A. Burigana, "Renzo Piano," *Architectural Digest* 47 (5/1985), pp. 32–38.

A. Castellano, "L'architettura sperimentale di Renzo Piano," *La mia casa* 176 (4/1985), pp. 32–53.

G. Sansalone, "Questo gruppo spara su tutto," *Costruire* 27 (3/1985), p. 49.

E. Caminati, "L'arte di costruire," *Costruire* 29 (5/1985), pp. 162–68.

J. Glancey, "Piano Pieces," *The Architectural Review* 1059 (5/1985), pp. 58–63.

J. M. H., "Restructuration d'un site industriel a Montrouge," *Techniques et Architecture* 359 (4/5/1985), pp. 42–53.

"France: Le printemps des musées," *Le Moniteur* (5/1985).

M. Milan, "Il Prometeo," *Acciaio* (4/1985), pp. 166–70.

R. Piano, "Music Space for the Opera 'Prometeo' by L. Nono," *A + U* 118 (6/1985), pp. 67–74.

"IBM," *Architects Magazine* (11/1985), pp. 249–50.

"Il Prometeo," *Daidalos* 17 (9/1985), pp. 84–87.

R. Buchanan, "The Traps of Technology," *Forum* 29 (1985), pp. 138–44.

O. Fillion, "Natura, la revanche," *Archi-Crée* 207 (8/9/1985), pp. 64–69.

E. Hubeli, "Kunstliches und Naturliches," *Werk, Bauen + Wohnen* (11/1985), pp. 23–28.

J. P. Robert, "La Schlumberger a Montrouge di Renzo Piano," *Casabella* 517 (10/1985), pp. 26–29.

"Italia 1984," *Industria delle Costruzioni* 168 (10/1985), pp. 64–73.

"Cité Descartes," *Techniques et Architecture* 362 (10/1985), pp. 135–37.

A. Pelissier, "Entretien avec Renzo Piano," *Techniques et Architecture* 362 (10/1985), pp. 101–11.

"Des chantiers permanents," *L'Architecture d'Aujourd'hui* 242 (12/1985), pp. 12–15.

"Urban Conversion of the Schlumberger Factories," *Global Architecture* 14 (12/1985).

G. Negro, "Un architetto per Lione," *Costruire* 37 (2/1986), pp. 86–89.

"Eine mobile Oper und ein 'Quartierlabor,' " *Werk Bauen* (4/1986), pp. 4–9.

"Reazione spaziale di Renzo Piano negli uffici Lowara a Vicenza," *Architectura* (4/1986), pp. 246–53.

"Un open space trasparente," *Habitat Ufficio* (6/7/1986), pp. 48–55.

"Houston, Texas, De Menil Museum," *Abitare* 247 (9/1986), pp. 382–84.

M. Prusicki, "Renzo Piano, Progetto Lingotto a Torino," *Domus* 675 (9/1986), pp. 29–37.

D. Mangin, "Piano de A à W," *L'Architecture d'Aujourd'hui* 246 (9/1986), pp. 1–37.

F. Zagari, "Progetto Bambù," *Abitare* 248 (10/1986), pp. 28–31.

"Aspettando Colombö," *Costruire* 44 (10/1986), pp. 42–49.

A. Robecchi, "La religiosa attesa dell'atto," *Costruire* 45 (11/1986), pp. 126–30.

Vicenza, "Una mostra di Renzo Piano," *Abitare* 249 (11/1986), p. 111.

O. Boissière, "Il Museo de Menil a Houston," *L'Arca* 2 (12/1986), pp. ·28–35.

"Le Synchrotron de Grenoble," *Le Moniteur* (1/1987), pp. 58–59.

D. Smetana, "Piano and Palladio, Virtuoso Duet," *Progressive Architecture* (12/1986), p. 25 and 33.

M. Vogliazzo, "Conversando con Renzo Piano," *Grand Bazaar* (12/1986), pp. 22–25.

A. Castellano, "Il Forum industriale," *L'Arca* 3 (1/2/1987), pp. 29–37.

"Piano Lessons," *AJ* 21 (1/1987), pp. 20–21.

"Piano Solo," *Building Design* 23 (1/1987), pp. 14–15.

B. Galletta, "Concorso per la Sede del Credito Industriale Sardo, a Cagliari," *Industria delle Costruzioni* 183 (1/1987), pp. 27–33.

"Piano's Sketches for the Final Composition," *Designweek* 23 (1/1987).

E. M. Farrelly, "Piano Practice," *Architectural Review* 1081 (3/1987), pp. 32–59.

Renzo Piano, "La modernità secondo Piano," *L'Arca* 5 (4/1987), pp. 59–65.

"Facciata continua strutturale," *Domus* 681 (3/1987).

B. Nerozzi, "L'architettura ritrovata," *Gran Bazaar* 55 (4/5/87), pp. 47–54.

P. Papandemetriou, "The Responsive Box," *Progressive Architecture* (5/1987), pp. 87–97.

H. F. Debailleux, "Piano à Houston," *Beaux-Arts Magazine* 47 (6/1987), pp. 68–73.

R. Ingersoll, "Pianissimo, the Very Quiet Menil Collection," *Texas Architecture* 3 (5/6/1987), p. 40–47.

Reyner Banham, "In the Neighborhood of Art," *Art in America* (6/1987), pp. 124–29.

M. Filler, "A Quiet Place for Art," *House & Garden* 7 (6/1987), pp. 74–75.

"Trenwand System aus glasfaserverstaktem Beton," *Detail* 27 (5/1987), pp. 1–4.

A. Benedetti, "Ristrutturazione e riuso di un'area industriale a Montrouge, Parigi," *Industria delle Costruzioni* 188 (6/1987), pp. 6–23.

"Renzo Piano, uno stadio per Bari," *Domus* 684 (6/1987), p. 7.

Ranzani/Guazzoni, "Renzo Piano: Museo Menil, Houston," *Domus* 685 (7/8/1987), pp. 32–43.

"Renzo Piano: lo stadio di Bari e il sincrotrone di Grenoble," *Casabella* 536 (6/1987), pp. 54–63.

"Simplicity of Form, Ingenuity in the Use of Daylight," *Architecture* (5/1987), pp. 84–91.

"Renzo Piano: Menil Collection a Houston," *ILAUD* (1986/87), pp. 76–77.

E. M. Farrelly, "The Quiet Game," *Architectural Review* 1087 (9/1987), pp. 70–80.

M. Keniger, "The Art of Assembly," *Australia Architecture* 5 (7/1987), pp. 63–67.

L. Caprile, "Il Museo con la cassaforte sul tetto, una nuova 'contestazione' di Renzo Piano," *Arte* 177 (9/1987), p. 25.

G. K. Koenig, "Piano: la Basilica palladiana non si tocca," *Ottagono* 86 (9/1987), pp. 48–53.

"A Homely Gallery," *The Architect* (9/1987), pp. 38–41.

"Immeuble de bureaux," *Architecture contemporaine* (1986), pp. 182–85.

"Piano, retour près de Beaubourg," *L'Architecture d'Aujourd'hui* 253 (10/1987), pp. 48–50.

"The Menil Art Museum," *SD* (11/1987), pp. 48–50.

"Renzo Piano," *A + U* 206 (11/87), pp. 39–122.

J. F. Pousse, "Renzo Piano: la métamorphose de la technologie," *Techniques et Architecture* 374 (10/11/1987), pp. 146–65.

S. Heck, "Piano's entente cordiale," *RIBA Journal* (11/1987), pp. 28–35.

"The De Menil Collection," *Transaction* (10/87), pp. 44–51.

A. Castellano, "Poesia e geometria per Bari," *L'Arca* (11/1987), pp. 80–85.

V. Magnago Lampugnaghi and E. Ranzani, "Renzo Piano: sovversione, silenzio e normalità," *Domus* 688 (11/1987), pp. 17–24.

"Konstructionen fur das Licht," *Werk, Bauen + Wohnen* (12/1987), pp. 30–39.

"Sammlung Menil in Houston," *Baumeister* (12/1987), pp. 36–41.

C. Ellis, "Umbau eines Industriecomplex und Landschaftsgestaltung in Montrouge, Paris," *Bauwelt* (1/1988), pp. 29–31.

F. Irace, "Destinazione museo," *Abitare* 261 (1/1988), pp. 192–97.

"Wood framing (IBM)," *Progressive Architecture* (2/1988), p. 92.

M. Giordano, "La catarsi genovese del '92," *L'Arca* 14 (3/1988), News.

D. Marabelli, "Leggera e integrata," *Modulo* 140 (4/1988), pp. 478–83.

"L'invention constructive, les avancées technologiques," *Architecture et Informatique* 27 (5/6/1988), pp. 20–23.

"Menil-Sammlung in Houston," *DBZ* (6/1988), pp. 795–98.

"Menil Collection Museum in Houston, Texas," *Detail* 3 (5/6/1988), pp. 285–90.

"Atelier Municipaux, Paris 19ème," *Usine* (1988), pp. 82–85.

Giselles de Bure, "Renzo Piano: l'homme aux semelles de vent," *Decoration International* (2/1988), pp. 110–113.

Renaud de la Nouve and Isabelle Cazes, "Donjon Final. La tour de l'Ircam sera le campanile du beau Bourg," *Sept a Paris* (1/1988), pp. 34–35.

Vincent Borel and Emmanuel Daydé, "L'IRCAM au Faite," *Sept a Paris* (1/1988), p. 35.

"Genua," *WERK, BAUEN* (9/1988), pp. 48–55.

"Il Lingotto," *Rassegna* (9/1988), pp. 110–113.

"Osaka," *Building Design* (1/1989), p. 1.

Gennaro Picardi, "Flying High," *Building Design* (1/1989), pp. 26–28.

Richard Ingersoll, "Pianisimo: La discreta collecion Menil," *Arquitectura Viva* (1/1989), pp. 15–19.

Peter Davey, "Piano's Lingotto," *The Architectural Review* (3/1989), pp. 4–9.

"Il concorso per il nuovo aereoporto di Osaka," *Casabella* (3/1989), pp. 22–23.

Alain Pelissier, "Kansai: la course contre le temps," *Techniques & Architecture* (2/1989), pp. 65–68.

Diane Ghirardo, "Piano Quays: aereoporto di Osaka," *The Architectural Review* (4/1989), pp. 84–88.

Sebastian Redecke, "La cultura del fare," *Bauwelt* (4/1989), pp. 614–617.

"Italy's Brunel," *Blueprint* (4/1989), pp. 52–54.

Books

International Conference on Space Structures, exhibition catalogue (London, 1966).

E. Poleggi and G. Timossi, *Porto di Genova, Storia e Attualità* (Genova, 1977).

IRCAM (Paris, 1977).

Costruire e ricostruire (Udine, Italy, 1978).

R. Piano, M. Arduino, M. Fazio, *Antico è bello*, (Roma/Bari, 1980).

A. Fils, *Das Centre Pompidou in Paris* (Munchen, 1980).

G. Donin, *Renzo Piano, Piece by Piece* (Casa del Libro Editrice, Roma, 1982).

La modernité, un projet inachevé, exhibition catalogue (Paris, 1982).

M. Dini and R. Piano, *Progetti e Architetture 1964/1983* (Electa, Milan, 1983; French edition, Electa Moniteur, Paris, 1983; English edition, Rizzoli International, N.Y., 1984).

Storia di una Mostra Torino 1983 (Fabbri Editori, Milan, 1983).

L. Nono, *Verso Prometeo* (La Biennale/Ricordi editori, Venice, 1984).

R. Piano, *Chantier ouvert au public* (Arthaud editeur, Paris, 1985).

Associazione Industriali Provincia di Genova, *Genova Ieri, Oggi, Domani* (Rizzoli Editore, Genoa, 1985).

1992, Genova città di Colombo: immagini e progetti (Columbus 1992 editore, Genoa, 1986).

R. Piano, *Dialoghi di cantiere* (Laterza editrice, Bari, Italy, 1986).

L. Miotto, *Renzo Piano*, exhibition catalogue (Editions du Centre Georges Pompidou, Paris, 1987).

R. Piano and R. Rogers, *Du Plateau Beaubourg au Centre Georges Pompidou* (Editions du Centre Georges Pompidou, Paris, 1987).

A & U (Monograph), *Renzo Piano—Building Workshop*, (A & U, Tokyo, 1989).

Biography
Renzo Piano

Born in Genoa on September 14, 1937, Renzo Piano currently lives in Paris. He graduated from the School of Architecture of Milan Polytechnic in 1964 and subsequently worked with his father in Genoa. He worked under the design guidance of Franco Albini from 1962 to 1964.

Between the years 1965 and 1970 Piano worked with Louis I. Kahn in Philadelphia and Z.S. Makowsky in London.

His collaboration with Richard Rogers dates from 1971 (Piano & Rogers), with Peter Rice from 1977 (Atelier Piano & Rice) and with Richard Fitzgerald in Houston from 1980; in Genoa he works with Shunji Ishida as associate architect; in Genoa and Paris with Alain Vincent as associate engineer; in Paris with Noriaki Okabe and Bernard Plattner as associate architects.

He has been visiting professor at Columbia University, New York; University of Pennsylvania, Philadelphia; the Oslo School of Architecture; the Central London Polytechnic; and the Architectural Association School of London and has lectured in London, Delft, Bucharest, Paris, Milan, Rome, Naples, Venice, Tokyo, Boston, New York, Houston, and Los Angeles.

Piano has won recognition in various national and international architectural competitions. In 1984 he was awarded "Commandeur des Arts et des Lettres" and the in 1985 "Legion d'Honneur"; in 1978 he was awarded the Union Internationale des Architects in Mexico City, and in 1981 he was awarded the Compasso d'Oro and the AIA Honorary Fellowship; in 1986 he was awarded the RIBA Honorary Fellowship in London, and in 1989 the Royal Gold Medal of RIBA.

Exhibitions devoted to his work have been mounted by the Architectural Association, London; the Musee des Arts Decoratifs, Paris; the Milan Triennale; the RIBA, London; the Paris Biennale; in 1982 by IN-ARCH, Rome; the Tre Oci, Venice; the Palazzo Bianco, Genoa; in 1983 by the Sottochiesa di San Francesco, Arezzo; SAIE DUE, Bologna; Castello Svevo, Bari; Museo di Capodimonte, Naples; the Architectural Museum, Helsinki; in 1984 by the MASP, San Paolo; Columbia University, New York; Rice University, Houston; University of Southern California; Pennsylvania University, Philadelphia; in 1985 by the Italian Cultural Institute, Tokyo; the Italian Cultural Institute, Kyoto; the Internationale Bauausstellung, Berlin; the CNAC, Nice; the European Iceberg, Toronto, Canada; MIT, Boston; in 1986 by the University of New South Wales, Sidney; the Palladio Basilica, Vicenza; the Vancouver Museum, Vancouver; in 1987 by the 9H Gallery, London; the Chapelle de la Sorbonne, Paris; the Menil Museum, Houston; the Istituto Italiano di Cultura, Toronto, Canada; in 1988 by La Vieille Charité, Marseilles, and in 1989 by RIBA in London.

Piano's Current Collaborators

Genoa office (Building Workshop s.r.l.)
Shunji Ishida, associate architect;
Alain Vincent, associate engineer;
Flavio Marano, engineer;
Emanuela Baglietto, Giorgio G. Bianchi, Mark Carroll, Mario Cucinella, Silvia De Leo, Giorgio Fascioli, Giorgio Grandi, Donald L. Hart, Paola Maggiora, Claudio Manfreddo, Luigi Pellini, Vottorio Tolu, Renzo V. Truffelli, Maurizio Varratta, architects;
With the collaboration of Ottavio Di Blasi, Enrico Frigerio, Milena Mallamaci, Stephanie Smith, Andrea Arancio, Paolo Bodega, Kenneth McBryde, Ivan Corte, Susanne Durr, Marion Goerdt, Gregg Hall, Marcella Michelotti, Takeshi Miyasaki, Shinichi Nakaya, Alberto Piancastelli, Daniele Piano, Enrico Piazze, Alessandro Pierandrei, Fabrizio Pierandrei, Milly Rossato, Olivier Touraine, Mark Turpin, architects; Massimiliano Lusetti, engineer;
Carla Garbato, publicist;
Secretarial department, Rosella Biondo and Emanuela Minetti;
Administration, Gianfranco Biggi, Sonia Oldani, and Angela Sacco;
Model Maker, Dante Cavagna.

Paris office (Building Workshop)
Alain Vincent, associate engineer;
Noriaki Okabe, Benard Plattner, associate architects;
Jean François Blassel, Antoine Chaaya, Jean Lelay, Johanna Lohse, Ronnie Self, Paul Vincent, Anna O'Carrol, Dominique Rat, architects; Michel Desvigne, landscape architect; Francois Bertolero, publicist;
Secretarial department, Heliette Houizot;
Administration, Helene Teboul;
Model maker, Olivier Doisy.
Permanent collaboration with Ove Arup & Partners of London; Peter Rice, structural engineer; Tom Barker, services engineer.

Osaka office (Building Workshop)
Noriaki Okabe, associate architect; Kogi Hirano, Akira Ikegami, Masami Yamada, architects.

Collaborators of the Last 25 Years

Abbot, L., Accardi, M., Agazzi, E., Allevi, M., Alluyn, M.,
Appleby, S., Arancio, A., Ardilley, C., Arduino, M., Auger, V.,
Avagliano, C., Avvenente, R., Badi, A., Baglietto, E., Balassone,
A., Barat, F., Bardsley, H., Barone, G., Bartz, C., Bassetti, B.,
Battini, S., Beccio, P., Benzeno, A., Bertolero, F., Bianchi, A.,
Bianchi, G., Biggi, G., Bing, J., Biondo, R., Blassone, A.,
Bodega, P., Bojowic, M., Bonino, M., Botschi, P., Brennan, R.,
Breton, G., Brullmann, C., Burckhardt, M., Bysaeth, H., Calosso,
M., Calvi, M., Campo, D., Carmignani, E., Carreri, E., Carroll,
M., Causa, E., Cavagna, D., Celadon, G., Celadon, O., Cereda,
A., Chaaya, A., Chassais, J.L., Chatelain, P., Cherchi, L.,
Clarisse, C., Collin, D., Contardo, G., Corajoud, M., Corish, C.,
Corte, I., Costa, R., Croxato, A., Cucinella, M., Custer, L., Da
Costa, I., Davies, M., De Leo, S., Defilla, D., Descombes, J.,
Desvigne, M., Di Bartolo, C., Di Blasi, O., Di Sopra, M., Diebold,
H., Doggart, J., Donato, E., Doria, F., Dowd, M., Dreissigacker,
K., Dunne, S., Dupont, P., Durr, S., Fascioli, G., Fendard,
Jacques, Ferrari, A., Filocca, M., Fischer, L.M., Fitzgerald, R.,
Flack, P., Foni, R., Fordam, M., Franchini, G., Freedman, N.,
Frezza, M., Frigerio, E., Gaggero, R., Gallissian, A., Garbato, C.,
Gasbarri, G., Ghiotto, A., Gillette, A., Goerdt, M., Goldschmied,
M., Gouinguenet, F., Grandi, G., Granger, C., Gray, D.,
Greenhill, N., Hall, G., Hart, D., Hartman, T., Henneguier, P.,
Henry, M., Hirano, K., Holmes, A., Holt, E., Hubert, B., Huc,
J., Huckabi, E., Hughes, F., Huizot, H., Icardi, F., Ikegami, A.,
Illoul, D., Ishida, S., Jackson, A., Jaklin, T., Joubert, F.,
Kaplicky, J., Karitakis, E., Keiser, R., Kelly, P., Kilaiditi, I.,
Koenig, L., Komiyama, A., Lacoudre, J.B., Laville, D., Lelay, J.,
Lidon, O., Logan, B., Lohse, J., Luccardini, R., Lucci, S.,
Luneberg, C., Lusetti, M., Maggiora, P., Mallamaci, M., Mallat,
N., Manfreddo, C., Marano, F., Marconi, F., Mastragostino, D.,
Mattei, M., McBryde, K., Mehren, B., Melai, R., Mercier, E.,
Merello, B., Metz, P., Michelotti, M., Migone, P., Minetti, E.,
Miola, E., Miyazaki, T., Morris, I., Moussavi, F., Muller, M.,
Musso, A., Nakaya, S., Naruse, H., Nichols, A., Oberhofer, A.,
Okabe, N., Oldani, S., Orcamo, P., Orcamo, S., Osrej, C.,
Ottaggio, P., Ottonello, N., Patel, C., Pellini, L., Peluffo, D.,
Petit, G., Piancastelli, A., Piano, C., Piano, D., Piano, M.,
Piazze, E., Picardi, G., Pierandrei, A., Pierandrei, F., Pietrasanta,
M., Planchez, S., Plattner, B., Prouve, N., Queirolo, G., Rat, D.,
Raymond, J., Renau, L., Rice, P., Richard, J.Y., Rocco, G.,
Rogers, R., Rolland, R., Rossato, E., Ruocco, L., Rupard, K.,
Sacco, A., Saint, J.G., Salerno, M., Santini, M., Santolini, F.,
Schlegel, C., Schmit, J.F., Schuessler, M., Segantini, C., Self, R.,
Senne, P., Serra, A., Simon, C., Sinagra, A., Sircus, J., Smith,
S., Soundy, R., Spielmann, C., Stanton, A., Susstrunk, C.,
Takahashi, H., Teboul, H., Temenides, A.H., Teoldi, C.,
Terbuchte, P., Thom, D., Tirelli, L., Tisseur, E., Tolu, V., Torre,
G., Touraine, O., Traldi, A., Truffelli, R., Turner, L., Turpin, N.,
Ullathorne, P., Valensi, C., Van Oosten, N., Van Santen, J.,
Vaniscott, M., Varratta, M., Varratta, P., Vaudeville, B., Veith,
M., Verbizh, R., Verdona, M.C., Vignale, S., Vignoli, A.,
Vincent, A., Vincent, P., Visconti, M., Winder, N., Xydis, G.,
Yamada, M., Yamada, S., Young, J., Zaccaria, G., Zamperetti, L.,
Zanuso, A., Zbinden, W.

Photography Credits

R. Bryant. 1, 141, 151

Building Workshop Archives. 93, 121, 175, 176, 177, 260

M. Carroll. 163

Fiat Archives. 187, 189

G. B. Gardin. 2, 7, 8, 9, 10, 11, 17, 18, 19, 20, 21, 22, 23, 24, 25, 29, 32, 33, 34, 35, 36, 37, 38, 40, 41, 42, 43, 44, 45, 46, 47, 49, 50, 51, 52, 57, 60, 65, 71, 73, 75, 76, 77, 78, 79, 80, 81, 82, 84, 85, 86, 87, 90, 94, 95, 96, 97, 98, 105, 106, 107, 110, 113, 114, 115, 116, 123, 124, 125, 127, 128, 162, 164, 166, 168, 169, 170, 172, 201, 233, 236, 237, 241, 262, 265, 266

Guzzini Archives. 207, 208, 209

P. Hester. 131, 149, 150, 152, 259

Hickey-Robertson. 132, 133, 142, 144, 155, 156, 157, 158, 159, 160, 161, 264

Alistair Hunter. 153

S. Ishida. 28, 57, 63, 104, 108, 145, 146, 147, 180, 188

Renzo Piano. 185

Piano-Rogers Archives. 26

Publi Foto. 55

H. Riboud. 130, 143, 148

F. Roiter. 70, 83, 132, 261

Schlumberger Archives. 88

M. T. Toffano. 109

G. Trivellato. 167, 171, 267

M. Valinatto. 190, 191, 192, 193, 194, 195, 199, 263

B. Vincent. 12

D. Von Schaewen. 91, 99, 101, 102, 103, 104, 111, 112, 122, 126, 154